For Brenda, for all her
support and encouragement

# Contents

# Illustrations

ILLUSTRATION CREDITS

BFI: 1–3, 5–21, 23. Brian Hopps/Bradford Film Office: 4.
Harrods: 22. Movie Market: 23.

# Acknowledgements

Many people have talked to me about Richard Gere. Many others have written to me with information about his life and his career.

My gratitude is extended to the following individuals for their help and cooperation: Neil Ajmal, Rita Boyce, John Cohen, Graeme Cruickshank, Jim Dale, Keith Driver, Frank Dunlop, Brian Gaylor, Brian Hopps, Ben Horton, Vi Marriott, Jane Millett, Ron Millett, John Skinner, Derek and Pauline Walmesley and Glyn Watson. I also wish to thank Michael Caine for permission to quote from his autobiography *What's It All About?*

Some sources wished to remain anonymous and although they are not acknowledged here, I am grateful to them for their time and contributions.

I also wish to extend my appreciation to members of staff in the following organizations who were of considerable help in providing information and verifying facts: library and information services of the British Film Institute, Buddhist Society, Hertfordshire Library Services (Baldock and Letchworth Garden City branches), *Keighley News*, the Raymond Mander & Joe Mitchenson Theatre Collection, Moviedrome, the Onondaga County Public Library, Syracuse, USA, Spotlight, Survival International, United States Information Service; and to Robert Kandt, Film Liaison Officer, Bradford Film Office, and E.M. Willmott, Specialist Librarian, Local Studies at the Central Library, Bradford Libraries, West Yorkshire.

My particular gratitude is extended to Sandra Batchford, who allowed me access to her extensive and detailed records, documentation and information on Richard Gere and for the meticulous research she carried out on my behalf.

# 1

# Making the Headlines

Rumours had been bubbling for some time and had not been easy to shake off. The most glamorous and the highest profile marriage in the history of Hollywood looked to be in trouble. There was persistent talk of bruising rows, terminal incompatibility and the enticing distractions of competing liaisons. And if all this was not enough, eyes were popping after press reports raised continuing doubts about the sexuality of not just one, but both partners.

He and she hotly denied all accusations. But the rumours would not go away. Then came the dramatic full page advertisement in the London *Times* and intended unequivocal disclaimer in May 1994. At a cost that reportedly could have been in excess of £20,000 this was the spectacular rebuff to, and intended death-blow of, the rising tempo of gossip and innuendo.

'Reports of a divorce are totally false,' thundered the statement. 'There are no plans, nor have there ever been any plans, for divorce. We remain very married.' Furthermore, 'we take our commitment to each other very seriously'. The couple even went so far as to square their sexuality '... we are heterosexual and monogamous', and '... we both look forward to having a family'.

Richard Gere and Cindy Crawford had married in December 1991 after dating regularly for more than three years. They were among the most glamorous personalities on the international showbiz scene. Camera wizard Herb Ritts, reputedly one of the most successful and highest-paid photographers in the world, was the link in bringing Richard and Cindy together. Gere and Ritts had roomed together in the mid-1970s during the earliest days of their respective careers, Gere in the theatre, Ritts concentrating on photography. And back in the early 1980s, during the period of

13

Gere's first big public impact with his films *American Gigolo* and *An Officer and a Gentleman*, the one-time salesman Herb Ritts had accelerated the process of Gere's conversion into a sex symbol by taking pictures of him changing a car tyre in the Californian desert; at the same time advancing his own stellar career as a fashion and celebrity photographer. And he had since also worked with Cindy many times.

So when he hosted a high profile barbecue at his Malibu pad in 1988 in honour of Elton John it was no surprise that Crawford was invited. Gere was also a guest. Herb Ritts's mother is credited with the introductions and in this relaxed, party atmosphere supermodel thus met superstar. Soon they were secretly dating. A stronger romance flourished and, as the well-established script has since repeatedly revealed, the result was a showbiz super-marriage.

That Cindy Crawford was the world's top model and an explosive cover girl was hardly in doubt. Her pictures, even by then, had been featured on the front cover of more than 300 magazines and journals. And while she had also acquired the media tag-lines of the 'world's most beautiful and most bankable woman' with a body that made her 'the world's fantasy figure', she had also rapidly acquired the staunch reputation for having her feet planted firmly on the ground.

There had been a refreshing realism about her career, a positive element in her character that disallowed the system to call all the shots all the time. For instance, that famous mole just above the left side of her upper lip: model or not she simply refused to have it removed. She became the first model allowed even the semblance of a bottom, bosom or tummy. Her scathingly hypocritical critics, having gazed upon the body beautiful, were left floundering, unable to stutter anything other than the rather limp snotty-nosed suggestion that her thighs were perhaps just a little too heavy. In fact, contrary, if not sacrilegious, to conventional model-speak, Crawford even dared to espouse her own slightly fuller (in model terms) figure as being 'more desirable'. Insiders described her as clever, articulate and totally dedicated, with her professionalism renowned throughout both the upper echelons and the rank and file of the business.

After Fonda, Crawford was one of the early entrants into the profitable world of workout videos. But this was more than a synthetic or cynical means of self-promotion. Sure, it was intended as a profitable venture and was always meant to be just that (her first video had grossed more than £20 million by late 1993 and was still

selling fast!), but it fitted four-square with her own outlook. For she was already a dedicated and genuine fitness freak, committing herself to an hour's workout four times a week with the 40-year-old 'Rumanian Rambo' Radu Teodorescu, her high-profile New York personal training guru. She transcended even the topmost echelons of the hitherto international model culture, becoming in the process a strong media personality in her own right without, it seems compromising or betraying her established status within the modelling world.

She did not for instance rush into the recording studio in the misguided belief that her modelling success could somehow miraculously elevate her to the status of an established pop singer. The inevitable big-money film deal which might well have been expected, was a long time coming. Even then, though she admitted for the record an early interest in doing a movie, she was insufficiently wide-eyed to contemplate that she might be talented enough for film-making to become a total replacement for modelling and media work as a top-line career; though it could perhaps be a sensible precaution against the time her figure began to thicken, her eyes started to lose their sparkle, and even her famous mole might have had its day. She did not even, for heaven's sake, join the latest tedious trek of those all-too-numerous media names who, cynically capitalizing on their new-found station in life, mystically unearth an overnight talent for writing, dashing into print with the irksome, though seemingly obligatory these days and almost always ghosted, best-selling novel.

At 5ft 9in she was simply the top model in the world and the highest paid; and that is how at first she largely saw herself. Her annual income was widely reported to be in excess of $3 million. Revlon apparently found it a sensible investment to pay her £1 million for just twenty days work a year. At twenty-seven she need never have worked again.

Little wonder that Richard Gere fell within her spell. Nor indeed that the attraction was mutual for the film actor was himself widely acknowledged as being one of the most exciting of the new movie heroes following his explosive role as Diane Keaton's pick-up in *Looking for Mr Goodbar* in 1977. Crawford later admitted that she had fallen in love with him when she first saw his 1982 film, *An Officer and a Gentleman*, when she was sixteen and could not get him out of her mind. No surprise either that she should continue to be attracted to him, for Richard Gere was never lacking in what is universally known as sex-appeal.

Handsome by any accepted standard; lavishly successful, with a career as the latest movie heart-throb already on the move; and with a certain mystery and intrigue about his person, which only added to his already established reputation as an interesting and fascinating personality, he was perhaps the most hypnotic hunk of modern masculinity to emerge in a long time.

She was twenty-two with impending maternal instincts when she met Richard. He was almost into his forties and, according to Crawford, wanting to go to India and live in a tent, a reference to his devotion as a Buddhist and disciple of the Dalai Lama. Not much compatability there perhaps, but love has been known to transcend quirkier differences in attitude and ambition; and as time went on both Gere and Crawford were able to man battle-stations together as the object of snide reports and malicious gossip about being gay.

In fact both adopted a casual, almost flaunting attitude to continuing rumours of their sexual orientation, which did little to quell the tittle-tattle. 'So what? Who cares?' had been Cindy's almost skittish response after her public showing of affection towards fellow models Christy Turlington and Gail Elliott and the scandalized reaction to her provocative cover pose for *Vanity Fair* with a self-declared lesbian, though she claimed it was all an illusion, all part of the job of being a model; though her cause gained scant credence from her writing of the introduction to a handbook of lesbian and gay parenting.

Gere, for his part, had always steadfastly and dismissively refused to be drawn on the subject, claiming it was no business of anyone else whether he was gay or not. 'If you acknowledge rumours you give them much more power than they deserve, so I really don't take any notice of it,' he declared somewhat loftily.

None the less, together they were the most handsome couple on the block; the most exciting pairing of the day. Sexual chemistry took on a new meaning, for Gere was widely catalogued as having perhaps the most impressively growing box-office in the business and already was an acknowledged sex icon for his breathtaking clinches with Diane Keaton, Debra Winger, Lauren Hutton, Valerie Kaprisky and Kim Basinger in well-publicized steamy scenes in several recent films. He was Hollywood's most eligible, yet at the same time perhaps the archetypal eternal, bachelor; and Crawford would later tell reporters with some pride that she did not think he ever really wanted to get married, but she did a good job of talking him into it.

Marriage for Gere was simply a symbol of everything suburban, boring and normal; he publicly discounted any interest in it, adding that for him it was totally unnecessary. When later asked by the Australian edition of *Vogue* why he waited so long to get married – on his own admission his marriage followed a long period of indecision – he responded lightly, if not altogether flippantly, that there was not the right girl, though already he had been through a number of well-documented relationships. He admitted it was hard for him to make decisions and saw the process as something definite rather than transitory, a situation complicated because of his oppressive tendency to over-analyse. There appears little doubt that in the end he married Cindy because he wanted her in his life and there was every chance that he would lose her if he did not. He was genuinely in love with her and it looked a perfect match.

Certainly their shock marriage made Crawford the envy of millions of women worldwide and heaped more glitter on the fairy-tale nature of their love match. The simple non-denominational ceremony in a Las Vegas wedding parlour, The Little Church of the West (cost in the region of £160), took place at eleven o'clock at night on Thursday 12 December 1991 and was witnessed by just half a dozen close friends including Gere's agent, Ed Limato.

Despite their long-time association the wedding surprised almost everyone, including themselves it seemed. For the casual ceremony took place only half an hour after they had obtained the licence, there was the almost bizarre exchanging of hastily concocted aluminium foil rings for the ceremony (the genuine gold bands came later), Richard said he had forgotten to shave and Cindy wore jeans. Next day, both were back at work.

But after their whirlwind marriage, the first for both of them, who can have been totally surprised when Cindy was soon having to quash another persistent rumour: that she was pregnant. But no baby appeared. The tittle-tattle stopped, but not for long as rumours began to surface that all was not well between them. Earlier suspicions that their marriage had really been a marriage of convenience intended only to scotch rumours about their sexuality and keep them in the frame for full-focus media attention, began to claim wider exposure, angering Gere who, provoked into retaliation, declared: 'Our relationship runs much deeper than that and has always been based on love and respect.'

But Gere and Crawford were still hot news. One journalist asked why, since he was now into his forties, had he not married before? Irritated by what he considered to be a personal question, he

answered curtly: 'I think people get married when they don't think about it too much. They just do it. That's why people were so surprised when Cindy and I got married. We just did it.'

But later Cindy admitted that it was hard for her to watch Richard's movies, to see him in sexy scenes with some of the world's most beautiful women. There was more speculation when Richard hinted that the marriage might be at risk if he refused to start a family. Once pressed on the subject he said that he and Cindy had discussed it, but that the timing had to be right.

There was further media turbulence following a shock report in a French tabloid suggesting that the couple were already living apart and preparing to divorce, together with other discomforting disclosures. Gere and Crawford were once again top of the media agenda as the drip-feed of rumour, scandal and speculation percolated into print. Crawford was said to have been recently romantically linked to both nightclub owner Rande Gerber and actor John Emos during what was now being described as their stormy marriage. She had also been seen at a party in New York when it was reported she did not wear her wedding ring. Gere meantime, in Britain to shoot his latest film, *First Knight*, tried to keep a low profile, but more than one national daily reported that curtains were closed at the house in Chelsea where Gere was staying and at the one next door used by Laura Bailey, a 22-year-old British model said to be the new woman in his life.

Gere was not in the best of moods when he returned to New York after filming in England. For one thing he was still suffering from a painful back as a result of all the broadsword fighting and horseback riding he was required to do for his role as Lancelot during the making of this latest epic about the legend of King Arthur.

Another more important reason became evident within the month. For in December 1994, just five days short of the seven months since their dramatic press announcement in which they had vowed their love for one another, came an equally unexpected and dramatic twist in this high profile human saga. Gere and Crawford issued a joint statement that confirmed that their marriage was effectively over and had been for some five months – though they strongly denied they were getting a divorce. They had been married for three years.

The split was not entirely unexpected. The continuing press and chat-magazine gossip, which had intensified with the passing weeks, had inevitably robbed their relationship of much of its earlier magic. And curiously, prophetically as it turned out, Lauren Hutton had

probably put her finger on it just a few days before. Not always generous in her comments on Gere since they had co-starred somewhat acrimoniously in *American Gigolo* some fifteen years before, the former model-turned-actress had somewhat acidly told a reporter: 'You can only be the sexiest couple alive for so long. It tends to bring out the worst in people.'

At about the time all this happened Gere's personal wealth was estimated to be in the region of £20 million and his high public profile, both on and off the big screen, had cast him as one of Hollywood's most exciting and provocative stars.

It was all in dramatic contrast to his staunchly Methodist upbringing in New York State when he had little serious ambition to become either rich or famous.

# 2

# Make Mine Music?

When Richard Tiffany Gere was born in Philadelphia, Pennsylvania, USA, on Monday 29 August 1949, there was no reason for anyone to suppose that he might one day seek a career in show business, on the stage or as a screen actor. His father, Homer, would soon become an insurance salesman; his grandfather, Albert, had been a life-long Pennsylvania dairy farmer, a way of life he would give up when Richard was about fifteen; and there was nothing in their or his mother's background that suggested a life in front of the bright lights for the infant Richard.

It was the month in which film actress Ingrid Bergman announced her intention to marry film director Roberto Rossellini after their scandalized romance while on location for the film *Stromboli*; a system for broadcasting colour television was announced by RCA (Radio Corporation of America); and noted American author Margaret Mitchell was knocked down by a car and seriously injured; and later tragically died.

But none of these significant events is likely to have impacted heavily on Homer and his home-maker wife, who were much more involved in family matters closer to home. In the end, they would raise four sons, Richard being the second born, and one daughter.

Homer had followed the family tradition to become a farmer, the small farm he grew up on being worked by him and his three brothers. But selling insurance would take over from farming; and Philadelphia would be left behind in favour of a new home some 300 miles further north, close to the Canadian border in a pleasant, middle-class suburb of Syracuse. It was here, a desirable location in rural upstate New York conveniently situated not far from Lake Ontario, that Richard would spend his childhood, growing up in a

comfortable and congenial environment in what has been described as a good and loving home.

His mother and father were both regular churchgoers and sang in the local choir. Music was important to them and their children were encouraged to share their interest, Richard learning the rudiments from the regular lessons he was required to take from a local tutor. Later, to the delight of his parents, he joined a choir, varsity club and boys' glee club; and for good measure was also vice-president of the student council for two years. Music and the arts were also important to his younger brother, David, who would become a concert pianist and critic. His older sister, Susan, would later explain how she and Richard would occasionally entertain the family after dinner with their impressions of relatives, friends and local radio and TV personalities.

There was never any ambition on young Richard's part to follow his grandfather and father into farming. Years later he explained: 'I never worked the farm. I moved on. Traditionally, young guys have always left the farms and gone to the cities to find work.' Then, prophetically relative to his screen image many years later: 'And there are more girls in the city!' Nor indeed did he picture himself selling insurance like his father.

By all accounts Gere enjoyed a normal all-American, suburban upbringing, though his first childhood dream was hardly that: he wanted to represent his country as a gymnast at the Olympic Games. His early years were largely uneventful, however, with no serious illnesses or injuries to speak of and nothing whatsoever in his background to suggest that he was other than a reasonably bright, receptive and eminently normal sort of child. He was by no means a natural academic, but he did not find learning all that difficult either, even if concentrated application was not exactly his strong point.

He was a good athlete and continued to show outstanding promise in gymnastics, becoming a role model and hero among his contemporaries when called upon to represent his school in the county championships and, moreover, winning the top prize. But starring at some future Olympics was a fading dream, which would soon disappear forever. There had always been music in the Gere household and when at about thirteen Richard began to show signs of following his parents' example, they were delighted. His regular lessons had established the basics and his natural ability and developing enthusiasm provided the impetus. He had already acquired good mastery of the trumpet and was soon competent

enough to play in local orchestras. He was only sixteen when he appeared as a trumpet soloist with the Syracuse Symphony Orchestra. By now he was also learning the trombone.

But the young Richard was by no means a musical egghead.

Though generally quiet, an instinctive loner and not the most adventurous of youngsters, he did, however, have his moments of glory. He was about fourteen when he travelled on a school class outing to Washington. It was to endow him with a kind of popular notoriety and added considerably to his standing and status among his peers, which he quite enjoyed.

Radios and musical instruments were banned on the trip, but Richard was not prepared to leave his trombone behind, hiding it away in his luggage. After lights out on the first night in the hotel Richard decided to blast off a few notes. Blowing a trombone at night is not likely to go unnoticed and there was a rumpus. So Richard and his room-mate tied a rope to the trombone and hung it from the outside of the window, completely out of sight. There was no trombone to be seen when the teachers arrived at their room during their investigative round-up. Bolstered by this success, Richard later pulled the trombone up from the window and blasted the trombone again, this time louder and longer. When the teachers arrived a second time, now accompanied by hotel security because so many guests had complained, Richard and friend were comfortably back in bed, the trombone once more suspended from the window, well out of sight. Richard even had the nerve to complain sleepily to the teachers that something really should be done about the noise because it was keeping them awake.

There were other times when Richard was involved in pranks of one sort or another, apparently nothing serious or vindictive, though one classmate from those school days who continued to live in Syracuse would remember Richard ('Dick as we called him then') as a bit of a hell-raiser, but a great guy.

This disposition to let off steam occasionally contrasted with the strict upbringing he experienced at home. His parents were staunchly Methodist and the children were brought up to have respect for authority, their family and friends, their elders and the establishment; and through faith and example were shown right from wrong.

He was a strong, athletic youngster and his gymnastics had helped him develop a good body. Girls at high school were attracted to him, but he was not particularly interested. He would date now and then, but was largely without a steady girlfriend. A schoolmate

remembers him as being 'pretty shy around girls ... in many ways he was an introspective, modest kid and some people took that for surliness or coldness. But he wasn't like that at all.' Another, recalling the high school days they spent together, said he was a 'real gentleman, always bringing my mother a gift whenever he spent the night at our house; and he had perfect manners.'

He was reasonably popular and seemed well-balanced, often fun and exciting to be with. There was the time when he and a friend broke the rules by camping out at night in front of the school flagpole. After talking and joking for most of the night they awoke late in the morning and were almost caught as they hurriedly pulled on their pants as the kids arrived for school.

Alongside such schoolboy pranks and the inevitable studies, which he often found tedious, the evolutionary process, which would carry the youthful Richard forward to a career on the stage and then in movies, was already beginning to take shape as he began writing music for school plays and composing scores for high school end-of-term productions. This led to an interest in taking minor acting roles though years later Richard would confess that even at twenty he was in many ways an extremely tentative and sensitive individual. But his developing talent as an actor and musician was already being acknowledged by pupils and staff alike and he soon became a natural choice for the lead in school plays.

His appearance in his junior high school production of *The Mouse that Roared*, in which he played the role of the president of the United States with the bullishness that could only be mustered by a bustling, inexperienced youngster, became widely thought of as his first stage role, though according to no less an authority than Richard himself it was, in fact, his second. He thought it was hilarious. 'Can you imagine,' he remembered years later, 'this young kid coming out on stage and playing the president?'

In what was actually his first role he played Santa Claus, with similar improbability, wearing a red jacket costume made by his mother onto which she had pasted cotton wool. He was buckled into a big black belt and went on stage with a pillow stuffed up his front to gain the necessary bulk. Richard said he was in the first or third grade at the time, but in response to a question many years later he said, laughing, that he thought that as Santa Claus he was a huge success.

At eighteen, the serious gym work now effectively sidelined – though athletics had one more crucial role to fulfil in Richard's early life – he distinguished himself as the King of Siam in the North

Syracuse High School's production of *The King and I* in the role made famous by Yul Brynner in the Rodgers and Hammerstein musical triumph.

It was his first taste of stardom and, as his mother reflected some years later, started him thinking seriously for the first time about becoming an actor. Yet despite this early success – the local paper compared his performance with that of Brynner's – the way ahead looked far from clear to Richard. There was always the competing pull of music. He had played trumpet and trombone for some time, after which he added piano, guitar, banjo, sitar and bass; and he could sing a bit. At this stage, though, there was no serious thought about the future, though his parents nursed expectations of some sort of professional career.

Richard, meantime, was becoming caught up in the new music and youth culture of the liberated sixties. By the time he was seventeen–eighteen, parading his new-found identity with long hair, leather jacket and dark glasses, sleepy Syracuse was hardly his scene any more; particularly for an adventurous youngster with ideas of becoming a rock musician. His hometown was not exactly New York, or even Philadelphia and fell well short of satisfying his new-found emotional and rebellious needs. Richard was not the only teenager confused and undecided during a time of enormous social change in America – and indeed in many parts of the world. Entrenched values were being challenged, many young women were metaphorically burning their bras as they struck out for their rights as individuals along with men, families at home in America were becoming increasingly restive over sons, brothers, fathers and husbands fighting a war, which seemed increasingly unending and remote, in far-off Vietnam; teenagers discovered the freedom of a new-found emancipation. It was a time of new thoughts and extended frontiers.

But circumstances would step in to dictate the immediate future for the impressionable Richard, for it was time to move on, educationally anyway. Never an exceptional scholar, though he graduated in 1967, his early physical prowess now proved useful, enabling him to win an athletics scholarship, which took him from high school in Syracuse to the University of Massachusetts in Amherst.

The move set him up for a more independent lifestyle, though for many years he would make a point of returning to Syracuse on periodic visits, spending Thanksgiving and Christmas with his family. 'I haven't outgrown it,' he would explain. 'It's where I grew

up ... it's home.' Later, he would hint that life with his parents in those earlier years in New York State might not always have been as close as he would have liked, admitting that there was a lack of talking and getting things across, but that one of the joys of his success was that it enabled him to do things for his parents and his family and friends, and that the relationship remained close.

He said he was never certain that he wanted to go to university, but Amherst none the less would be home for Gere for almost the next two years. He was no more of a natural scholar there than he had been at North Syracuse High, but choosing to major in philosophy, he found the study satisfying and absorbing; enough perhaps to spark an interest that would lead him on to extended beliefs later in life.

With no great relish he joined the prestigious university of Massachusetts drama school, more as a counter-balance to the rigours of formal education than as the next move towards acting professionally, about which he was by no means certain. But his potential was identified by, among others, the University's Professor Vincent Brann, who said he was excited and impressed by Gere's obvious talent and that when he auditioned for *Hamlet* it was clear from the start that there would be no real competition. 'When he got the starring role he showed no emotion and acted like he alone deserved it,' revealed Professor Brann. This point in his life at Amherst would be identified later as the time he began edging towards acting and began to enjoy the experience of playing someone else and, as he would explain, 'getting outside yourself'.

It was about this time also that the independent Richard Gere began to materialize: first the poser wearing sunglasses even at night – the loner and the determined individual; second, the physical body-beautiful.

Free from the influences and disciplines that are invariably part of a teenager's life when living at home, Richard became an individual in control of his own life for the first time. He relished the idea of being young at a time when youth-culture was a new and existing concept; enjoyed its manifestations of exciting status and singular identity and saw himself as a contemporary rebel against adult, conventional society.

He made few friends and would increasingly tuck himself away watching movies in the local cinemas, studying plots, the stars and techniques. But unlike many students, he seemed incapable of benefiting fully from college, either as a life experience or in academic terms. Even at the end of it all he doubted that the

experience had been of much value to him. But the inevitable was not too far away.

With nothing better to do he accompanied a college friend who was going to attend auditions to join the well-respected summer stock theatre company at Cape Cod's Provincetown Playhouse in Massachusetts. Once there he thought he might just as well audition and, despite his disreputable looks with shaggy, shoulder-length hair and somewhat unaccommodating demeanor, he was taken on. Bill Roberts, the director at Provincetown that summer, said he read brilliantly. Roberts and his wife Janet became good friends and were destined to be significant in Gere's unfolding career.

It was summer 1969 and he was not quite twenty. But that summer he would be paid for acting for the first time in his life, just $28.70 a week. He quickly discovered that 'two-week rep' was a gruelling schedule, a realistic baptism of fire for him particularly since his stage experience had been relatively negligible, limited to just a few school and university performances. He would rehearse a part for two weeks and then, while playing that part during the next two weeks, would at the same time rehearse for his next part. It is the kind of schedule to stretch the most experienced actor. For a struggling tyro new to the rigours of the business it was a 24-hour nightmare with hardly time to sleep or learn lines. He felt ill-equipped and unprepared for many of the roles, but the roles kept coming along. Soon he was being cast in lead parts.

His first play was O'Neill's *The Great God Brown* in which the cast spoke their lines normally through plastic masks, then conveyed their innermost feelings after the masks had been taken off. Demanding for the most experienced of actors; doubtless a frightening ordeal for Gere. He also appeared in *Camino Real, The Collection* and *Rosencrantz and Guildenstern are Dead*. 'I played the leads. Why they let me I don't know,' he would comment some time later. But it was a worthy training ground, he enjoyed the atmosphere and the physical and practical nature of being on stage and was soon thinking seriously about an acting career. Local critics praised his performances with words like 'vivid' and 'irresistible'.

At the end of the summer season he was horrified at the prospect of going back to university, but fate stepped forward to deal him an ace he simply could not turn down. Bill Roberts, who had taken him on at Provincetown, was moving to the Seattle Repertory Company for the winter season and asked Gere to join him. It would mean turning his back on university. His parents were upset when he told them, pointing out all the well-known risks that go with the

uncertainty of life on the stage. They had always hoped that he might take up some kind of professional career with its greater stability and security. But he had no interest in banking or politics or academia.

It was a tough decision for Gere to make, and he regretted having to disappoint his parents, but having spent less than two years at university he knew what he wanted; and it was not more university. He gave up a scholarship estimated to be worth almost £10,000 and joined Roberts in Seattle. It was a hard apprenticeship. The pay was meagre at $75 a week and he had to take part-time jobs to pay the rent, including playing background piano at fashion shows. On stage he was not always given the parts he felt would bring the experience and progress he desired, though he did play the lead and composed some incidental music for a production of *Volpone*. After the buzz he had enjoyed at Provincetown, Seattle was a let-down. It was not as friendly. Life was more formal and rigid. The schedules were gruelling. He began to enjoy it less and less. As the situation did not improve, he became disillusioned with the theatre and by summer 1970 he quit, before the season ended. What had his parents said?

For a time acting lost some of its shine. He took to the road in a battered second-hand vehicle and toyed once again with the idea of becoming a rock star. He headed east and made his home camping out on a farm set in 300 acres of land on top of a mountain in Vermont. But he soon came down to earth again. He got together with a few guys he had played with at college with the idea of forming a rock band. It was a nice idea, but hardly profitable; or even practicable. Gere did guitar and vocals but the band, code-name 'The Strangers', were a disparate bunch and the group fell apart without a gig to its name.

He took to the road again. Like many a young man of his age, Richard played out his days as a James Dean–Marlon Brando clone. Motorbikes, leather jackets and tattered jeans stated his contemporary credentials. Years later he admitted that he was pretty wild for some time after that and looked back on those days with intense embarrassment and near disbelief. He explained: 'I lived in a house which had a dope factory upstairs. Some guys gave me a car and a map and told me to contact Felix at the Rio Grande bar in Mexico's Tijuana. I drove all night to the border, but the authorities wouldn't let me across because of my long hair.' So he drove to Arizona and crossed there. Just over the frontier he saw road blocks with Mexican Federales tearing apart cars that were full of bullet holes. He immediately turned around and headed back.

The dream had become a nightmare. He thought about acting

again. He wondered about the security of his parents' home in Syracuse. He even considered trying to get back to university. But he was twenty and it was high time to make his own way in the world. Acting remained his aim, but Hollywood had long since given up creating overnight stars out of soda jerks, bell hops and pump attendants. New York was a better bet. At least some actors found work in the theatres of New York; and there were always the clubs and hotels where a versatile musician might find a berth. If all else failed, there were cafés and corner shops, which would probably pay cash for a few hours of casual work.

There was little real alternative. So Richard Tiffany Gere, his mind made up, headed for New York.

# 3

# New York City ... and Time To Act

You could say that New York went to Richard Gere's head. It was big, brash and provided anonymity, the backdrop for a frenetic and pulsating lifestyle. Gere was twenty when he saw the city for the first time. The tedious disciplines and constraints of university routine had been cast aside and he relished the philosophy set by the 'swinging sixties' with its revolutionary lifestyle and unprecedented freedoms for young people.

New York was his kind of town. But there was a down side too, which struck swift and deep into his psyche. He quickly found that it was also clinically uncharitable, frustrating and at first, for a young actor looking for a job on stage, barren. The tatty fifth-floor 'walk-up' on the undesirable Lower East Side that he had managed to rent was cockroach-infested, despite obtaining an assurance in advance from the landlord that it was not. It had no water or heat and was not exactly what he had hoped for or been used to. But he gritted his teeth and played out the part of the young actor destined for the big-time with admirable flourish. The posturing, he was sure, established his credentials as belonging to the profession. You had to do the New York punk thing or you were not taken seriously, he would later explain with some self-consciousness.

But his ambition, if not always his disposition and temperament, somehow survived. It was all very well for superstars like Frank Sinatra and Liza Minnelli to sing eulogistically about New York, New York being a wonderful town, but for the unknown and inexperienced Richard Gere searching for the merest chink of an opening in the business, well, the melody might have been the same, but the lyrics were different.

He did not blame the place. It was mean and tough, but not too

different from what, deep down, he had expected. After all, even the greatest star had never simply walked off the streets as a stranger and into the dazzling spotlight that was Broadway. So he lived rough. There were many times he came close to submission, but supposing he wanted to give up, turn it all in; where could he go, what would he do? 'I spent a lot of time *not* jumping into the East River,' he would recall some years later. To survive he worked part-time in a café. Robert De Niro called in one day. Richard recognized him. 'I'm going to be as famous as you soon,' he told him. The spirit and the defiance were still there.

The moods came and went and from the upbeat times Gere found consolation in all the big stars who had travelled to New York as hopeful unknowns and struggled through the same bitter and often humiliating experience. It was an inevitable part of the star-making process, even if at the time Gere was not all that concerned about stardom. Any sort of job in a theatre would have done to help pay the rent and buy the food. Much of his time was spent walking the streets looking for work and when his feet got sore or his spirits drained away, he would find a cheap seat in a cinema and lose himself in the fantasy world of film, often spending hours at a time sitting there alone in the dark.

The one contact he had in the whole of that seething mass of a metropolis that was New York, was a scribbled number he had been given by a friend before leaving Seattle for New York. That friend was Bill Roberts, his first theatrical mentor. Bill's wife Janet was a literary agent in New York. Richard got in touch and she occasioned solace, sympathy, encouragement and blandishments as required; but also, more importantly, arranged for him to meet a theatrical agent, Ed Limato, who even then was a big name in entertainment. Limato eyed Gere, the handsome looks and smooth physique and, despite the standard-issue long-haired rebel standing before him, signed him up without even sampling his work. It was the start of a life-long business association and friendship.

Nothing happened immediately, for theatrical agents, even good ones, cannot work miracles, especially in misanthropic New York. But now at least Gere felt less isolated and his essential determination to succeed was undiminished. Coincidentally, music provided the link between the struggle and the breakthrough. Rock operas were all the rage in the early seventies with *Hair* the undisputed genesis. The youthful Gere rode with the fashion. He could sing a bit, played instruments and had long hair and a ragged, downbeat look. *Soon*, a new rock opera, which was already in

preparation, seemed like a good opportunity and Limato sent Gere along to see the show's director, Robert Greenwood. Barry Bostwick, who was destined to re-enter the Gere story more significantly quite soon, had already been taken on in the lead with a talented cast, which included Susan Sarandon, later to move into a significant film career, Peter Allen and Nell Carter, who was in the film version of *Hair*.

Greenwood liked what he saw of Gere and took him on; and impressed on hearing that Gere could also compose music as well as play it, he paid him to write a couple of songs for the show and engaged him to play several instruments on stage. He played more instruments than the entire band and was making less money than anyone else, Gere would explain later. The storyline was about country musicians who move to the city hoping to make it to the big time, when suddenly their acoustic instruments are taken from them and they find themselves playing electric instruments. It was not the most inspiring of plots, but Gere, who would be in the end credited as a co-writer, was thrilled. He enjoyed the companionship of working within the team after his long and lonely treks looking for work, and was encouraged by rehearsals.

*Soon* opened in a theatre close to Broadway on 11 January 1971. The date is significant – surely indelibly implanted in Gere's mind, for the very next day on 12 January 1971 *Soon* closed, to disappear forever. It was a savage blow for cast and crew, though the show would earn a significant entry in Gere's professional dossier as the show in which he made his New York debut.

It was back to the daily grind of searching for work, following up the merest sniff of an opportunity and, most of all, carrying on through the bleakest moments when despair was close at hand. It would take him at least two years to get to know New York, he would explain later. New York was an enormous, complicated unchartered labyrinth, an enigmatic maze for the young Richard but in due course Robert Greenwood again shone the light on Gere's faltering future in another presentation that mixed music with drama. *Richard Farina: A Long Time Coming and a Long Time Gone* was a modest, low-budget production hampered perhaps by its long-winded, off-putting title. But for those in the know, it cleverly encapsulated the absorbing life and tragic early death in a motor-cycle accident of Richard Farina, who had been a cult figure in the early 1960s as a singer and songwriter. He also played the dulcimer and wrote poetry. The venue was a downmarket theatre a world away from the glitzy lights of Broadway, but Gere saw it not

only as a means of helping to pay the bills but also, in the lead role, as a creative challenge, and he absorbed himself thoroughly in researching the part. This kind of exhaustive and intense preparation for a role is something for which Gere would later become widely admired and known during his Hollywood career. The show opened in autumn 1971, but disappointingly closed after just a few weeks. As early as that Greenwood would pick Gere out as a future star commenting on his vast energy and dedication, and the concentration he had in rehearsing for as long as it takes to get the part absolutely right.

The days, weeks and months that followed were largely unproductive as Gere scoured the town for work. It was during this time, however, that he first met photographer Herb Ritts, his fame for wizardry behind the camera still many years into the future and, like Gere, struggling to surface in the massive cauldron that was New York. He would become a life-long friend. It was about this time also that Gere became attracted to the bubbling and vivacious Penelope Milford, an aspiring and talented actress who had been with him in the cast of *Richard Farina*. She was also attracted to him and since both had been thrown out of work at the same time through the collapse of *Richard Farina*, they had plenty of time to spend together as they each tried for other work. The relationship developed and eventually became sufficiently stable for them to be together for almost seven years.

But in New York in the early seventies it was a continuing struggle for both of them. Gere would pick up casual work wherever he could and the money from this, with occasional handouts sent from home and a small, but regular, social benefit payment for being out of work, enabled him to stay in New York to continue the struggle. He spent a couple of weeks dish-washing at 'Hungry Charlie's' in Greenwich Village, preferring to be out of sight doing that rather than being exposed as an out-of-work actor waiting on tables front of house. Penelope's big break was some time away and would come when she won a supporting role in the 1978-released movie, *Coming Home*, starring Jane Fonda and Jon Voight and gaining the additional distinction of being listed in that year's Academy Award nominations. But little of any consequence happened to her career after that.

Gere, however, was off the mark earlier, at the time when Barry Bostwick was rehearsing his lead role in the musical *Grease*. This was four, maybe five years before Paramount and Robert Stigwood, with Allan Carr, would get together to launch the phenomenally

successful movie version as a showcase piece for John Travolta, with the delightful Olivia Newton-John as his co-star, in a follow-on to his triumph in *Saturday Night Fever*.

The upcoming Broadway production of *Grease* was ideal material for Gere, with his acting and musical credentials, and he seized his chance when offered the replacement lead to Bostwick when the show opened on Broadway in late 1972. While understudying Bostwick in New York, Gere heard that London's Duncan Weldon was planning a British production of the show to open in the West End early 1973. He auditioned, won the part and made his acting debut in the UK as the strutting Danny Zuko on stage at the New London Theatre on Tuesday 26 June 1973. Built on the site of the famous old Winter Gardens Theatre, the New London Theatre had been open for less than seven months when *Grease*, with Gere in the lead, opened there to good notices.

J.W. Lambert in the *Sunday Times* reported: 'Highly enjoyable.... In Tom Moore's direction an excellent cast are led by Richard Gere with a real comic gift ...', and from the highly respected critic Clive Hirschorn in the *Sunday Express* – 'A marvellous performance by Richard Gere.' For his more contemporary fans impressed by the later Richard Gere screen persona of handsome hero with heavy sexual overtones, the idea of their superstar being noted for his comic talent would become almost more comical than the reality itself, surely fleetingly blighting their more glamorous image of their idol.

The show was also enthusiastically welcomed by, among many publications, the weekly musical paper *Melody Maker*: 'This is the first valid Rock 'n' Roll musical, it's authentic ... it's brilliantly written and the cast are just neat ... can't really say there is one bad moment in the whole show. The band is red hot ... the music is tongue in cheek ... Great!'

Gere quickly made himself at home in London and although an unknown on arrival was soon the focus of talk and gossip among associates and friends. He relished the regular work and when work was done spent time getting noticed for all the wrong reasons as he roared around London on his powerful British superbike, an image-maker he had bought on arrival in the UK. Gere was the archetypal maverick, by all accounts arrogant and rude at times as he acted out his kind of James Dean prototype. The sixties might have been over, but Gere seemed determined to keep London swinging.

Audiences enjoyed the show, but it was never an outrageous

success. Gere stayed with the London production of *Grease* for six months, and it closed two months later.

By all accounts it was not an altogether happy show to be in. A member of the original cast looked back to that time, remembering the good notices it attracted, and gave me an interesting and fascinating personal perspective on Gere and the show during those early days of his career. 'It wasn't really a very happy experience for me personally,' I was told. 'The management was young and talented, but also relatively inexperienced and a rock musical by definition generates a very chaotic atmosphere anyway.

'Richard was an exciting performer even then, not married and leading anything but a conventional lifestyle. He was a very good actor, but hadn't really matured emotionally. It is ironic that he has the ability to mesmerize an audience, yet at the same time is a very complex man; privately confused, yet he needs to act and when he does he is very focused.'

Someone else who admired Gere's integrity and professionalism as a performer was Duncan Weldon, the man who was responsible for bringing him over to London in the first place. Weldon thought of Gere once again when he began planning a London revival of the 1939 *No Time for Comedy*, and was keen to have Gere for the lead opposite Kathleen Turner. Duncan said: 'I sent the script out to him in America where he was filming. I had paid him £150 a week for *Grease*, but guessed I would have to move the decimal point a bit to clinch the deal, Gere having moved on somewhat since then.'

Duncan added: 'Last time he hardly got a billing; neither did Paul Nicholas or Elaine Paige (who were also in the show). We did two weeks in Coventry before coming into London, but the show wasn't destined for a long run. English audiences didn't take to it like they had done in America. Strange, because the later film version had a major impact on both sides of the Atlantic.'

*No Time for Comedy*, the S.N. Behrman classic, was originally put on at the Haymarket in 1939 with Diana Wynyard, Rex Harrison and Lilli Palmer; and Kathleen Connell and Sir Laurence Olivier did it on Broadway. But sadly, Weldon's revival plan did not work out so the opportunity for Gere to do more stage work in London, for £150 a week – or more – never materialized.

In *Grease*, Gere had around him an experienced cast, which included three performers with 'rock musical' experience. Jacquie-Ann Carr had scored a personal hit in the original cast of *Godspel*, along with Steve Alder and Claire Faulconbridge, both of whom had been in *Hair*. Playing opposite Gere was Stacey Gregg

who shared the principal musical numbers with him: 'All Choked Up' and, of course, the irrepressible 'Summer Nights'. After about three months Stacey left the show, her part of Sandy being taken over by Elaine Paige, then a relatively unknown actress and singer.

While he was in London playing out his twice-nightly role of Danny Zuko in *Grease* a chance event brought him into contact with Frank Dunlop, who was the administrator and associate director of London's National Theatre at the time. The key to it all was the enthusiasm of a secretary in the National Theatre office called Jane Mackintosh. Frank recently talked to me about it: 'Jane, who incidentally would become Mrs Tim Rice, had been to see the show in the West End and was all excited about this marvellous and talented young man she had seen playing the lead and that I really must go and see him for myself. The show was, of course, *Grease* and the young man was, of course, Richard Gere.'

The two men got together, Dunlop gave him a reading, was impressed and recruited Gere for the part of Christopher Sly in his forthcoming London Young Vic production of Shakespeare's *Taming of the Shrew*, which Gere moved into after he left *Grease*. It was a significant and perhaps risky choice; significant because Gere would be the first American actor to join the Young Vic company and risky because Gere's career portfolio was not as yet amply endowed with Shakespeare at that level. But Frank Dunlop clearly remembered the enormous success he achieved in the part.

'Richard was terrified at first,' he said, 'because the concept of the role is that Sly is a member of the audience, a smelly and thoroughly obnoxious character, drunk in the lobby, causing trouble and making himself thoroughly objectionable before the play begins.

'Then, when everyone was seated, Jim Dale, who played Petruchio, made an announcement saying how sorry everyone was, but there had been a disaster and all the sets and costumes had been destroyed in a fire, but that everything was going ahead anyway and everyone would do what they could in the circumstances.'

What happened next was remembered some years later by Richard himself in an interview with *Rolling Stone* magazine: 'I then shouted out from the audience in a drunken voice, "What-are-you-talkin'-about?" so the actors kind of pacified me, brought me up on stage and at that point I became part of the drama – which in fact honours the essence of the play, since it was supposed to be performed for this drunk named Christopher Sly, though that suggestion is normally cut out of most productions.'

Director Frank Dunlop confirmed Richard's view that it was all

great fun, particularly as Richard was actually apprehended on the first night by stewards who did not know that he was supposed to be part of the production. 'Of course, that was the whole point,' said Frank. 'In the programme Richard was credited with playing a part that Christopher Sly actually took on in the play – the Pedant.'

Gere later travelled with the Young Vic touring company to the United States for a highly successful presentation of *The Taming of the Shrew* at the Brooklyn Academy of Music where, on his own territory, he was acclaimed, if for nothing more, as the only American in the cast. 'Gere's performance was so convincing,' said Frank, 'that even Clive Barnes, the enormously experienced and noted hard-man theatre critic of the *New York Times*, was totally taken in by it for a while, thinking it was for real. Not only was he taken in by Richard's "Sly", but was horrified at the creature causing so much trouble sitting in the seat next to him.'

But the Dunlop connection was not yet at an end. Much later, towards the end of 1975, when Gere was back working in New York, he successfully auditioned for Dunlop's Broadway production of the British sex farce *Habeas Corpus* by Alan Bennett. According to Dunlop, Gere's portrayal as Mr Shanks, the salesman 'travelling' in built-up bras, was outstanding in a production that included Donald Sinden, Jean Marsh and the talented Rachel Roberts, then working regularly in America and who would work with Gere again in Britain on the movie *Yanks*.

*Habeas Corpus* was simply too British to make a strong impact with the Americans and closed in February 1976. But Gere had done more than enough to convince Frank Dunlop of his comic talent. Frank told me: 'I felt Richard had enormous promise as a comic and it has always been a disappointment, and indeed mystery, to me that his potential in this direction was never exploited. I am still amazed that his comedy talents have not been used fully in films.' Frank also said that Gere explained to him his reason for going to Hollywood, which was to have success so that he could be more in control of his own career.

Britain's Frank Dunlop obviously played an important part in Gere's early career. 'Of course I would be happy to be working with Richard again. I think he has such a range as an actor that he could play comedy or tragedy, or any variation of the two that presented itself to him,' he said.

It is hardly likely, however, that Gere ever saw himself as a specialist in comic roles. Neither is it likely that a solo music career figured prominently in any vision he might have had for the future;

that is if he looked ahead at all, though even at this stage he was more concerned with getting jobs and being paid now than trying to plot the way ahead.

In the meantime, after his sojourn in Britain, Gere returned to a much more responsive New York. The timing was also right for he took over as Danny Zuko from Barry Bostwick and gave more than 200 performances playing the lead in *Grease*. He followed this with bit parts in the TV series *Kojak*, one of the few shows being taped in New York at that time, and a small part in the television movie *Strike Force*. The latter, a 75-minute pilot made in 1975, was a very important career step for Gere since he was one of three main characters. It was an all-action police thriller set in New York and Gere played the part of a state trooper who joins forces with a Federal Agent and a New York cop to smash a drugs ring. The story was by Sonny Grosso and the film was directed by Barry Shear. It never became a series, but Gere's performance was well received by the critics. He also said the single word 'Hello' in a television special for actress Marlo Thomas, but later became vehemently critical of television, describing it as a disgusting and humiliating experience.

Gere has shunned television since then and certainly, even at that time, it was not really the kind of work he would have preferred. He was much happier when chosen to play Demetrius in *A Midsummer Night's Dream* at the Newhouse Theater at the Lincoln Center. Judith Lamb, a casting agent for Joseph Papp's Public Theatre and who would enter the Gere story at other critical points in his career, chose him for the role after seeing him in the collapsed *Soon*. Again his work was well received. As a film actor later on Gere would be well able to look back with some pride to his roles in the legitimate theatre, for his classical c.v. would also include his earlier work before leaving New York and also the Marowitz version of *Hamlet*.

These later days in New York after his return from Britain were more hopeful and better financially for Gere, who was able to move out of his original squat. He converted a former plumbing-supply store into a comfortable apartment flanked by gay bars near the Hudson River piers, which he shared with Penny Milford. His conduct and attitude were still a complicated mix of the brash and bold action man, bike riding the New York streets in black leather, and the quiet, introspective professional, very much the loner who would in-depth study his stage parts, digging deeper than most of his contemporaries when researching a role.

Of these times a journalist would comment: 'He pursued the attendant rock 'n' roll scene. The seventies would be the decade in

which Gere would fortify his cultivated "bad boy" image, greeting unsuspecting journalists in his underwear.' Milford confirmed this side of his character, saying that he would sometimes get drunk and disappear for hours. But as a professional actor his conduct was always impeccable.

His characteristic determination, psychological strength in the face of setbacks, and increasing ability and experience as an actor, carried him forward strongly with a growing reputation in classical roles.

All told, Gere was not slow in gaining stage experience in the years between ducking out of university and breaking into movies and he strongly enhanced his reputation as a serious actor in a couple of Sam Shepard plays, creating a powerful solo performance as the blindfolded convict in an electric chair in *Killer's Head* at the American Place Theater in New York in 1975, and in *Black Bog Beast Bait*. And at the Academy Festival Theater in Chicago he appeared in the American premiere of David Storey's *The Farm*.

The Place Theater, originally on West 46th Street, had been founded by Wynn Handman and Sidney Lanier, pastor of St Clements, for the production of new and controversial plays, exclusively by American writers. The plays were put on in the church, services being held in the set of the current production. In 1971 the company moved to a theatre in a newly-built Manhattan skyscraper with seating for an audience of about 300.

Sam Shepard was a kindred soul, articulate, anti-establishment and provocative who had begun writing in the early sixties, arriving in New York from his hometown of Fort Sheridan and Duarte, a small town east of Los Angeles, where he had spent his high-school years. Born in 1943, he emerged as a leading American playwright in the late sixties and early seventies with a number of powerful dramas and by the time he was forty had won a Pulitzer Prize with an astonishing body of work, which included forty full-length and one-act plays. His arrival in New York coincided with the beginnings of the 'Off Off' Broadway movement, when the new generation crowd of actors, playwrights, musicians, artists, painters and poets collectively began to make up an exciting new world. Shepard said of those days: 'There was a great make-shift quality then. It only existed for a few years, till Vietnam came along and everything shifted to a very grim perspective. But for a while it was like a carnival, a Mardi Gras – it made you feel you could do anything. Art wasn't a career or anything intellectual, it was a much more active, playful thing, a way to inhabit a life.'

It was the first contact between Shepard and Gere, but their paths would cross again in the theatre and in a film. *Killer's Head* was an intense, strongly focused, extraordinary play that made punishing demands on the actor in terms of nervous energy, concentration, psychological strength and mental tension. Gere claimed much attention for his performance in a seriously demanding role. His success obviously added to his slowly-growing reputation and his name was becoming familiar among New York's regular theatre-goers and others.

It was now the mid-seventies, Gere was twenty-six and at this point came the first tentative hints of a major shift in his career, which would steer him, professionally at least, away from the Big Apple and towards sunny California.

# 4

# Bright Future in Pictures

For a time the way forward seemed unclear. That Richard Gere was building strong credentials as an actor was not in doubt. His track record in both New York and London proved it.

But the theatre alone was unlikely to hold the key to his professional future stretching into the second half of the seventies and beyond. He had shown himself to be versatile, capable of good performances of high professional standard in both classical roles and musical shows; and he had a comic talent. Even so, there were serious limitations in trying to concentrate on live theatre. No matter how successful you were the chances for regular work were limited; and so too, therefore, was your creativity. Hollywood, with its much greater resources and potential, had to be an option and by the mid-seventies 'nudges and winks' in that direction had already become apparent.

Gere did not dislike the movies, despite feelings and rumours that persisted for a time that he had resisted a career move in that direction. On the contrary, had he not enjoyed scores of interesting and contented hours in cinemas while at university and since arriving in New York? In fact, when he had no real friends at university he admitted to submerging himself in movies. 'I remember walking back at two in the morning, night after night, after six hours at the movies,' he would explain. They were a haven of escape from the formal learning he had found so tedious at university and an oasis within a tiring and despairing day when looking for work after arriving in New York.

But it is equally true that, unlike many actors struggling for recognition, Gere had never been dazzled by the so-called glitz of Hollywood. That side of being a 'film star' he would steadfastly

resist throughout his career. He was enough of a realist, however, to consider the movies now as a serious option and when the pickings arrived, tentatively at first, he did not instinctively look the other way. And film offers were now beginning to come in.

Not much has been said about the one that supposedly got away. Few seem to know about it. Gere was still the scene-wise rebel at the time, the radical making his own way against the world, when he was allegedly fired from one of the leading roles in a low-budget, independent film called *The Lords of Flatbush*. Released in 1974 and distributed by Columbia, it won some good reviews and a British release, despite running for only eighty-six minutes, as a well-observed comedy set in New York about the adventures of Brooklyn street-gangs. Sylvester Stallone was featured in the part originally scheduled for Gere.

The one that did bring him to the Hollywood start-line was a far less significant property. It happened soon after his outstanding performance in Shepard's *Killer's Head* at the American Place Theater. His one-man tour de force in this compelling drama, which stretched his mental and physical resources almost to breaking point, not only brought him rave reviews and raised his profile as a serious actor, but eased open the door to Hollywood's enormous possibilities. The picture that started it all was never intended to be a blockbuster, not even a major run-of-the-mill feature, but in United Artists' police melodrama, *Report to the Commissioner* (retitled *Operation Undercover* in the UK), Richard Gere made his big screen debut.

This relatively inconsequential story re-schemed by Abby Mann and Ernest Tidyman from a James Mills novel, is about a policeman's son who follows his father into the force, but finds it hard to come to terms with the tough and seamy life around Times Square. The picture was variously dismissed by critics as being 'a bit too full of sweat and frenzy' (*Illustrated London News*), 'a clear also-ran in the police thriller stakes' (Verina Glaessner) and 'realistic, concerned crime melodrama with nothing very new to say' (*Halliwell's Film Guide*). Michael Moriarty, who was born in Detroit and studied drama in London, took the starring role. He made a number of movies, but gained worldwide acclaim in the television series, *Holocaust*, playing the cold-blooded Nazi, Erik Dorf. Gere's debut was 'successful' or 'inauspicious' depending on whom you read, but at the time it is unlikely that either caused much more than a ripple of interest, for Gere's name was down as far as sixth place in the cast list.

But his performance as the streetwise pimp did not go unnoticed and a number of offers began to creep in. Gere himself was largely reticent, but none the less uncertain. He had taken the role more for the money than for the chance to appear before the camera. About the latter he was by no means convinced. On stage you were required to get things right first time, every time; every new performance brought another challenge. That is what he liked about the theatre. Filming was different. Get it wrong the first time round and you could always do it again. In fact that was what happened most times. Few first takes are what you see when the picture is released.

In a way it offended his sense of being professional. His uncertainty about this was not a problem for the moment. He had retained his flat in New York and after filming *Report to the Commissioner* in Hollywood, he returned and went straight into rehearsals for the aforementioned *Habeas Corpus*, Frank Dunlop's Broadway production.

He followed this declared success with other theatrical engagements, including a revival of the dramatic play by Clifford Odets, *Awake and Sing*, by the prestigious McCarter Theater in Princeton, New Jersey. The play, first produced on Broadway in 1935, is about a Jewish family's fight for survival during the Depression. Odets, who died in 1963, was considered one of America's most gifted of those dramatists who developed a theatre of social protest during the 1930s, his reputation as a radical being well manifested in 1935 with his *Waiting for Lefty*, a one-act battle-cry on behalf of America's working masses. He sustained his criticism of American values in 1937 with *Golden Boy*, the story of a young Italian-American hero forced to choose between becoming a prize-fighter or a violinist. The film version was to become a classic in which William Holden made his Hollywood debut.

In *Awake and Sing* Gere's role of Ralph, an ambitious son who is desperate for better days, had been originated in the thirties by John Garfield, who brought a smouldering intensity to many of his roles. Curiously, Gere's screen persona would be periodically identified with both Garfield and, less so, Holden as his film career developed.

But despite a flurry of theatrical activity, it could only be a matter of time before Hollywood caught up with Gere's mounting reputation and towards the end of 1975 he secured a relatively small part in a new movie called *Baby Blue Marine*, a Second World War drama from Columbia, directed by John Hancock, whose most

assured work would emerge at about this time with *Bang the Drum Slowly* in 1973, a poignant portrait about a dying baseball player, and a neo-beach movie, *California Dreaming*, in 1979. In *Baby Blue Marine* Gere played a shell-shocked, failed, serviceman who returns home psychologically unbalanced and poses as a war hero. The genuine hero, played by Jan-Michael Vincent, is knocked out by Gere who then takes his uniform and whose subsequent adventures become the main part of the picture. Gere played his role with sensitivity and understanding, turning little more than a bit part into a memorable performance about a genuine war-time tragedy. His handling of the part showed much potential and was among the better moments of a moderate film.

A more significant breakthrough came shortly after, and auspiciously, in the most recent work of the highly respected director, producer and screen-writer, Terrence Malick.

And it was Judith Lamb who, for a second time, would create the opening. Gere was still finding it hard to make a serious break into films, but Judith had been impressed by his performance in *Baby Blue Marine*. She was now a casting director at Paramount and in early 1977 recommended Gere to Terrence Malick, who had just signed to do a second movie for the studio, following his largely unexpected success with *Badlands* in 1973.

Malick, born in Illinois in 1943 and educated at Harvard and Oxford University, had moved into films in the early 1970s after a varied background, which included taking odd jobs in the Texas oilfield and on farms before teaching philosophy, working as a journalist and studying at the American Film Institute in Los Angeles. His first work in the movies was re-writing scripts and he made his first feature, *Badlands*, which he also produced and wrote, for a mere $335,000, arranging with many of the players involved to defer their wages until the film was released in 1973. It became a cult film about a young couple on an increasingly compulsive killing spree and was widely acclaimed as a notable contribution within its own sphere. *The Gravy Train*, which he co-wrote, was released a year later.

By 1977 Malick was much in demand in Hollywood, recognized for his skills as an unconventional and uncompromising film-maker. His new project, which he would write and direct, and which emerged as *Days of Heaven*, was a basic story about the love of a woman for two men and set against an enchanted vision of the Texas panhandle region with softly-focused camera lenses and natural light. His already sketched-out screenplay was set in 1916

with migrant workers from the big cities in the east trekking to work as labourers in the vast wheatfields further south.

Even when Malick had moved most of the pieces into place, he was still unsure about the casting and ruminated for weeks about the key roles which remained uncast. Malick was toying with the idea of John Travolta for the central character, but was uncertain about using big names fearing their reputation might divert attention away from the sensitivity of the story he wanted to portray.

You could see his dilemma, for Travolta was not only one of the biggest and most exciting performers around at the time, having recently completed filming the enormously successful *Saturday Night Fever* for Paramount, but was inevitably still strongly linked with his character in that picture, the swaggering extrovert Saturday night disco stud; hardly in harmony with the character Malick had in mind for his new picture. So when Judith Lamb talked to Malick about Gere, he was interested. He knew Gere by reputation and got in touch. They talked a lot about the picture and Gere did some taping, but there was no formal screen test. It took Malick almost three months before making up his mind to offer the part to Gere rather than Travolta.

*Days of Heaven* would turn out to be a typically singular, anti-run-of-the-mill Terrence Malick production. He finished up with a quartet of untried actors in the principal roles, two of whom were inexperienced. When Gere turned up for filming he was delighted to discover that Sam Shepard, author of his earlier stage success, *Killer's Head*, had been surprisingly cast despite having appeared in front of the cameras only once before (in *Renaldo and Clara* the previous year); while for Brooke Adams, a TV and former juvenile stage actress, big-screen filming would be an entirely new and strange experience. She would later star in *Death Corps*, but this picture went into production after *Days of Heaven*, even though it was released ahead of Malick's picture. The fourth casting was that of sophisticated 12-year-old Linda Manz.

Gere played the part of an immigrant, Bill, a hot-headed, impulsive steel-mill worker in Chicago who attacks his boss and escapes police attentions by heading south with his girlfriend Abby (Brooke Adams) and his 11-year-old sister (Linda Manz). They end up in the Texas panhandle working for a wealthy young farmer (Sam Shepard), who is dying. Times are hard and with Bill's background hanging over them, a plan is worked out that should solve their problems. By this time the rich farmer has fallen for Abby so the idea is that she should accept his proposal of marriage.

The farmer will then conveniently die and she, meaning also Bill and his young sister, will inherit a home, land and plenty of money so they can live happily ever after. But the plan begins to fall apart when, after Abby has agreed to marry, first the farmer's health begins to improve and, second and especially, when Abby develops a genuine and unexpected affection for him. Bill can see his carefully contrived scheme being ruined and decides to rescue his plan through violence, but the result is tragedy.

The picture projected one incident after another including the marriage of Brooke Adams to the supposed terminally ill Shepard, a prairie fire, a plague of locusts and a murder, all observed and commented on for the benefit of patrons by the young Linda Manz, with Malick making use of the voice-over technique. All four principals, plus supporting cast, performed impressively for Malick, but his genius was shown most of all in his decision to use Nestor Almendros as cinema-photographer. The latter's creative studies of the American midwest were widely acclaimed as some of the most poignant and rich portrayals ever to be captured on film.

Malick made no compromises in bringing his vision to life and many critics believed he had gone too far in the final cut, the result considered by some critics to be overly aesthetic and too obsessed with atmospheric vistas and self-important, symbolic drama. Such denouncement, however, perhaps fails to take into account the changes and experimentation that film-making was going through in the seventies, with a whole new generation of film-makers, picking up on film history, coming to prominence and replacing Hollywood's traditional old guard who had held sway for more than a decade.

Admittedly, in *Days of Heaven*, neither the actors nor the plot were ever allowed to stand in the way of the atmosphere and sweeping panoramas, along with some extraordinarily beautiful colour photography. In fact Nestor Almendros received an Academy Award for the picture's photography and Ennio Morricone an Academy nomination for the music, while Malick's direction was voted the best of the year by the New York Film Critics Circle.

The making of *Days of Heaven*, however, turned into a nightmare marathon. Most of the picture was shot on location. Malick chose the Canadian prairies around Calgary and Gere and the others were there for three months during the original shooting. The place was remote and nerves became ragged. Gere described the experience as manic.

The big problem was Malick's method of working the picture. He used the script as a start point and would develop an idea or theme spontaneously. Often he would be dissatisfied with what was written down, though he had produced the screenplay himself, and would ask his actors to think of something better. So what was happening in front of the camera moved further and further away from the original script that Gere and the others had first read. Whole chunks were discarded and some scenes required take after take after take; and in the end some were not used. Malick did not always know precisely what he was after. When he did he found it difficult to convey the details of his mind-picture to the cast and crew. It was a tough initiation for Gere in his first major picture and also for the other members of the cast.

If making the picture was shambolic, the editing was only marginally less so. It took Malick more than eighteen months as he laboured over what to leave in and what to take out. In the end it was clear to almost everyone involved with the picture, as well as the critics and perhaps even some of the more discerning cinema-goers, that much of the human drama inherent in the original script had been sacrificed for Almendros's beautiful views of the landscape. As one critic pointed out: 'Some of the scenes were so beautiful that the viewer wanted the moving picture to stop occasionally and just be a picture.' Malick simply became too bewitched by Nestor Almendros's beautifully creative work, though Gere, while acknowledging the fact, would remain staunchly loyal to both the picture and the director. None the less, the way some of his scenes were savaged from the final film would move Gere to comment later: 'I'd like to buy the stuff that was not used and put out my own film.'

It would indeed have been a miracle had the picture, which emerged as *Days of Heaven*, been a financial success. It certainly was not, the Bert and Harold Schneider production reaping a scant box-office harvest. But Malick was never in pictures solely for the money. Making what he was inspired to make, and seeing his vision become reality on the screen, was his reward. And with *Days of Heaven* he had no complaints.

Nor did Gere. More than ten years later he would confirm that *Days of Heaven* was the first real movie he made and, because of his limited knowledge and confidence at that time, it turned out to be one of the most difficult experiences of his life. 'But I'm very proud of that movie,' he said. Gere's performance was competent, if not inspiring, though plenty of potential was on display. Already he was

being likened to De Niro, Montgomery Clift and Gregory Peck – not bad comparisons at all for an actor negotiating his first real movie. In fact it was curious how film critics and others would turn away from recognizing Gere as an individual; they saw him more in the image of others, repeatedly labelling him a modern John Garfield and also another John Travolta, the latter probably because in his early movie career Gere had a tendency to take over roles that Travolta turned down or to win roles against him.

While the general public waited for *Days of Heaven* to be released, there was no such holdup inside the movie business where the word was already being put about that Gere was a new name to watch. And Gere did not have much time to ruminate on Malick's film, for screenwriter, director and producer Richard Brooks (who incidentally like Gere had been born in Philadelphia, though some thirty-seven years earlier) was quickly off the mark. Brooks was then embarked on a project for Paramount and had already started shooting with Diane Keaton cast in the female lead when he was recommended to take a look at Gere. Once more the link was Judith Lamb who, ever diligent in her work as a casting director at the studio, had gone to see Brooks armed with clips from *Baby Blue Marine* and some rushes from *Days of Heaven*.

The project looked promising, for Paramount had secured the film rights to Judith Rossner's best-selling novel about an introverted teacher of deaf-and-dumb children who leads a double life by spending her evenings haunting the singles bars in search of sexual excitement. *Looking for Mr Goodbar*, as the film would emerge, was a chilling tale and Paramount had chosen well in securing Richard Brooks to handle the direction. Brooks had grown up in the business, making his name with a number of taut, male-orientated features leading up to the triumph of *Blackboard Jungle*, the intense school-room drama set in the mid-fifties, which he wrote (from the novel by Evan Hunter) and directed, and for which he received an Oscar nomination. He followed this with Tennessee Williams's *Cat on a Hot Tin Roof*, writing the screenplay for this acknowledged classic in the late fifties.

Recognizing the importance of casting the two critical roles in his new movie, Brooks had finally offered the role of the heroine (Theresa Dunn) to Diane Keaton, even then an actress of some experience and undisputed ability, having just scored an outstanding success in the Woody Allen picture *Annie Hall*, her performance gaining her a personal Oscar in a picture that collected further Academy Awards for best picture, best script and best direction.

Like Gere, who was three years her junior, Keaton had acted in summer stock before moving to New York and making her Broadway debut in 1968 as an understudy in the hippie musical *Hair*, in which she later took a leading role. Her association with Woody Allen, which began in 1969, had a powerful impact on her career. She had made her film debut in a relatively small role of a would-be divorcee in the comedy, *Lovers and Other Strangers*, after which came *The Godfather*, in which she triumphed as the non-Italian girl Al Pacino falls in love with, and then co-starred with Allen in the film version of a show they had already done together on Broadway, *Play It Again, Sam*. She was in Allen's further films, *Sleeper, Love and Death* and, later in 1978, *Interiors*, after co-starring with Allen in *Annie Hall*. *Looking for Mr Goodbar* would be a different kind of movie with her character's dangerous quest for a lover round the singles bars of New York eventually leading to her death.

The other role, rightly adjudged by Brooks to be crucial, was that of the sexual stud Tony Lopanto who, though certainly one of the lesser characters and only in the picture for a limited time, is central to the story and has critical scenes with Diane Keaton. It was an important part with excellent potential for the right person. Brooks had tested a number of young actors but was still looking for someone who could convey the right combination of sexuality and menace.

Time was running out when Judith Lamb talked to him about Gere. Brooks and Gere got together and this one meeting was enough to convince Brooks and Diane Keaton, who had the final say on Brooks's selection of her co-star because of the sexual scenes between the two, which the script called for, that Richard Gere was right for the part.

But Gere was unsure at first. He was still edgy after the difficulties of *Days of Heaven* and Brooks, like Malick but in a different way, was by no means the most conventional of film-makers, though his standing in Hollywood was undisputed. From that point of view Gere had no doubts about working with him. Ed Limato thought Gere should take the part, even though it was by no means a main, if important, casting, and despite the obvious sexual implications within the role. He suggested, rightly, that working with a director of Brooks's reputation would upgrade his own standing, as also would being co-starred with Diane Keaton, a well-established actress of quality and substance. Furthermore, it was almost certainly the kind of picture likely to capture public attention.

In the end that single interview proved enough to convince not just Brooks, but everyone else concerned, that Gere should be in the picture, though Brooks admitted that he did not really have very much to go on and cast him mainly on reputation.

*Looking for Mr Goodbar* is a generally anguished tale that focuses on the difficulties of Theresa Dunn (Diane Keaton), who has a deeply subjective and repressive home-life. Attempting to break out of her straight-jacketed lifestyle she reacts in the extreme by spending her nights in secret and sordid pleasures. Tony Lopanto is what one film commentator would later describe as 'Diane Keaton's animalistic and menacing lover' whom she picks up in a bar and who thrills her in erotic scenes, which, on the whole, are handled well, though the picture would be condemned by some critics for being exploitative and boring.

The one scene to be repeatedly picked out and used as a kind of bench-mark to the picture, and indeed for Gere, comes after Theresa decides to test Tony's promise to be the best lay in her life. It is a remarkable scene in which he virtually terrorizes her with a frighteningly erotic dance around the bedroom wearing only a jock strap and brandishing a wicked-looking knife. It is certainly an advanced and extravagant form of foreplay, the like of which Theresa has not encountered before, and once the tension has built almost to breaking point, Tony switches mood, becoming lustfully carnal and rousing Theresa to the highest pitch of ecstasy.

In fact Gere gives such a depth of understanding and excitement to his character that, despite his relative inexperience in movies, it would be hard to pick out anyone who could have been more convincing. The movement of his body, the tense drumming of his fingers, the evidence of sexuality in his eyes, in the way he stands, gazes and talks, were all clearly set to initiate, along with the sex scenes, the developing public perception of Gere as a smouldering sex symbol rather than the serious actor he wished to be. He also appears in his first nude scene.

Whether he wanted it or not, his early typecasting was already evident for in three out of the four films he had now completed Richard Gere had played a streetwise pimp, a shell-shocked serviceman and a professional stud with sadistic tendencies. Not exactly your most wholesome type of hero.

But *Looking for Mr Goodbar* differed from the others in producing a very healthy profit for the studio and was by far the most successful of Gere's early pictures. Further distinctions were Academy Award nominations for Tuesday Weld, for her supporting

role as Diane Keaton's sister, and for William A. Fraker, for his photography.

The picture was released in late 1977 and brought instant reaction from critics and cinema-goers alike, though the true impact of his performance took longer to feed through. The nature of the picture was itself enough to capture attention, but Gere's swaggering interpretation as the rough-hewn, handsome and erotic lover with considerable sexual presence was the sharp focus of the story. In America, Frank Rich was not the only notable critic who praised Gere's performance but disliked the film and there was a similar reaction to the picture in Britain. The reaction of film-goers in both countries, however, was much more polarized. Gere was the picture and there was little doubt that he had made an enormous impact.

More significantly, *Looking for Mr Goodbar* signalled a major uplift in the public profile of Richard Gere. Life would never be quite the same again. Not only would the picture stimulate female imaginations, becoming the core of many a sexual fantasy around the world, but closer to home, where he was seen to be reasonably accessible and approachable, a desire for more personal contact became an obsession. Gere fans, created overnight in the space of a few minutes of film footage, were suddenly desperate for a large glossy picture of him; wanted to know where and how they could write to him; see him; talk to him. There were phone calls from the most resolute who had somehow managed to get hold of his number; and door-knockers or loiterers who had discovered where he lived. Women would unexpectedly approach him in the street or in shops. Not difficult to understand, perhaps, when you consider that one case-hardened, seen-it-all-before film critic was moved to evaluate Gere's appeal in these evocative words: 'Gere is like a more handsome Robert De Niro; he burns up the screen and embodies the idea of sex as pure energy.'

The problem was that not all reaction was good and wholesome. The explosive sex scenes between Gere and Keaton had also aroused the lewd and the perverted. And the feminist lobby were vocal and active in condemning the sequences. Gere was astonished and rankled by the reaction. For some reason his compelling performance seemed to have generated too close an affinity between the actor and the character, with some women finding it particularly desirable to avoid making the distinction.

Gere preferred to stand well apart from all this arousal, side-stepping interviews and refusing point blank to be drawn about his private life. But the inter-studio gossip was quick to carry the

word that Richard Gere was a hot property and soon he was on the bandwagon, being sent more scripts, outlines and ideas than he could handle. The problem was that almost all were intent on casting him in sexual roles, a kind of recreated Tony Lopanto. A frustrated Gere would later utter ungenerously: 'After *Goodbar* I had enough offers to play Italian crazies for the next fifteen years. The bastards want to put you in a box with a label on and crush it. If you have any hope of growing, of being taken seriously, you have to control the vultures.'

The simple fact was that Gere did not want to be typecast. Never had wanted to be typecast. He was an actor; and an actor should be able to play many parts – even in pictures. In his zeal to avoid being stereotyped with a repeat of sex and *Goodbar*, and insistent that he be allowed to grow and extend as an actor, he would turn down a number of interesting and exciting projects. He even turned his back on the lead role in *Midnight Express*, a best-picture nomination for 1978, because he felt the violence was gratuitous.

Instead he became interested in a couple of projects that would at least neutralize his patent sexuality and give him the chance to do something different. The first was *Bloodbrothers*, in which he was cast once again as an Italian-American in a film based on the novel by Richard Price with screenplay by Walter Newman; the storyline, however, was much less important than the inter-relationships and behaviour of the leading characters. The second was a romantic drama set in the Second World War called *Yanks*, about GIs in Britain preparing for the Second Front.

*Bloodbrothers* was under the direction of Robert Mulligan, a former divinity student who had worked his way up through the ranks of CBS, establishing himself in the 1950s as a leading director of television drama. He made his feature debut with *Fear Strikes Out* (1956), about a leading baseball player with personal problems that lead to a nervous breakdown. More notable was his *To Kill a Mocking Bird* six years later. He received an Academy Award nomination as director and Gregory Peck's leading role in the story, about a lawyer in a small southern town who defends a black man accused of rape, was an Oscar-winning performance.

Mulligan saw Gere as a strong candidate for his new project because of his success as an Italian-American in *Goodbar* and the way he could be convincingly both tough and tender, a quality he needed for his new picture. Gere wanted the part because *Bloodbrothers* was different from his previous roles, even if not dramatically so, and also because it would enable him to take a

full-blooded leading role for the first time in his movie career. But
Mulligan hesitated. There was a problem. Stony De Coco, the main
character, was just eighteen years old. Gere at twenty-eight was
surely too old for the part. In the end Gere at twenty-eight was
better than a younger someone else and contracts were signed.

Gere found himself once again in a movie that did not have the
most uplifting of themes. Indeed, one advance publicity strapline
cautioned the feint-hearted: 'Their father believed in violence –
their mother escaped into it. They only had one way out.' But the
violence and the raw nakedness of the picture's theme does not tell
the whole story. It certainly set noted critic Gordon Gow against the
picture initially, telling readers of *Films and Filming* that for about
half an hour he thought it was going to be too much. 'Then,' Gow
revealed, 'the movie began to grow on me, which I put down chiefly
to some rather good acting, under the exemplary emotional control
of director Robert Mulligan.' Gow sways back a bit in his summing
up, but the picture escapes relatively unscathed, thus: '... that such
boorishness is not at all boring is a measure of Mulligan's skill, and
the film as a whole, while hardly enthralling, has decided merit as a
curious social study.'

It would be surprising indeed if that is what the film was meant to
be. More realistically it tells the story of the Italian-American De
Coco family and in particular their eldest son Stony (Richard Gere)
who, recently out of high school, is at a loss as to what to do with his
life. Family tradition pulls him towards work on a construction site,
like his father; implicit in which is a good deal of heavy drinking and
womanizing. Stony's inner conviction, however, is to work with
needy children and he shows his natural aptitude and skill for this
after becoming recreational assistant in a children's ward at a
hospital. His philosophy is that the remedy for any threatening
danger is to help one another out: to become, in short,
bloodbrothers. As he struggles to find his own identity against
formidable odds, Stony finds love and understanding with Annette
(Marilu Henner).

The background is the Bronx with its unremitting squalor of high
rise flats, bars and discos. An abundance of foul language is
intended to convey conviction and in the old classification it is not
surprising that the film was given an X-certificate. Gere does well as
the sensitive but rebellious 18-year-old, though the film had a
temperate reception and more than one critic mentioned Gere's
difficulty in playing a character so much younger than himself. The
frequent shouting among the family became hard to take and the

picture was weighed down with a surfeit of seemingly endless difficulties and problems experienced by too many grim characters. In fact the picture's redeeming feature is the strong performances by all the cast under Mulligan's direction with Tony Lo Bianco as head of the household, Paul Sorvino as his brother, Lelia Goldoni as his wife and Michael Hershewe as their other son and Gere's brother. As *Films and Filming* pointed out: '... all the performances were superb, including Kenneth McMillan as a crippled bartender and Marilu Henner as a disco waitress.' An effective rhythm-and-blues score was by Elmer Bernstein.

Optioned against *Airport 80: The Concorde* (*The Concorde: Airport 79* in the US), it had only a partial ABC circuit release in the UK in October 1979 and in some cities and towns played no dates at all, though there was a late-night Channel 4 TV showing in July 1987. It had no connection with the stage musical of the same name by Willy Russell, which first appeared in the West End in 1983, with revivals into the nineties.

Much of the film was shot on Gere's own doorstep, in New York, and he found working with Richard Mulligan lacked stress and irritation. Mulligan lived up to his reputation as being the consummate professional who likes to work from a well-organized schedule with each scene carefully planned in advance. For Gere there were no real problems or tensions and he had no complaints in making the picture. Disappointingly though, *Bloodbrothers* would be a financial flop, earning less than $1 million, which was below what the picture cost to make.

# 5

# Another 'Yanks' Invasion

Once shooting was completed on *Bloodbrothers*, Gere packed his bags for England to make *Yanks*. Being chosen for the male lead in a prestigious, big-budget picture being handled by the distinguished British director John Schlesinger was a major coup for Gere, especially since he had won the part against stiff opposition, which included Al Pacino and Dustin Hoffman.

Schlesinger was a director just about everyone wanted to work for; a man capable of drawing the most sensitive performances from his actors. He had started his career on the British stage in the 1950s. He went on to direct TV documentaries, which encouraged a special feel for narrative, and, following further invaluable experience in the theatre, films, radio and television, he moved into picture direction seriously for the first time with the 1962 British feature *A Kind of Loving*, the earthy north-country melodrama written by Keith Waterhouse and Willis Hall from the novel by Stan Barstow, with Alan Bates, June Ritchie and Thora Hird in the cast. Of the film the *London Evening News* commented: 'You will be shocked by this highly moral film only if you are shocked by life.' *Billy Liar, A Kind of Loving, Darling*, a flashy satire of swinging London in the sixties, which shot Julie Christie to stardom, *Midnight Cowboy, Sunday, Bloody Sunday* and *Marathon Man*, all within the space of fifteen years, were enormous testimony to Schlesinger's special magic.

*Yanks* had been in his mind for some time. Nostalgia was in many respects the mode of the seventies and the Second World War was a time of deep human emotions and fleetingly captured relationships. But finding the backing for the story, which set out to capture the once-in-a-lifetime experience and atmosphere of American troops

stationed in England prior to the Normandy landings, was difficult to find. The necessary $7.5 million was raised eventually through various sources and Schlesinger sent British writer Colin Welland and his American co-writer Walter Bernstein away to turn his detailed outline into a successful screenplay.

Gere's name had come up when Schlesinger had talked informally with associates about suitable actors for the picture. A top male star like Hoffman or Pacino would certainly draw the crowds, but he had seen Gere in *Looking for Mr Goodbar* and was impressed by his performance, though he disliked the picture. A number of meetings took place between the two of them before Schlesinger offered the main lead of Matt to Gere. It was an important, pivotal role in Gere's career. His previous pictures had been off-beat affairs dealing with relatively seamy subjects. In contrast, Matt was a regular guy, playing from the top of the pack; serving his country in a time of crisis as a serviceman posted overseas. *Yanks*, in fact, would project Gere unequivocally into mainstream movies, giving him a stronger profile and a more legitimate status.

Once cast in the role Gere did his usual exhaustive research so that he would actually feel to be part of those far-off wartime days. For Gere, *Yanks* was an historical picture about a time and events more than thirty years in the past. He had not even been born then. He worked meticulously on his character, whose home state was supposed to have been Arizona. So he went to Arizona to immerse himself in the kind of life his hero lived before he was war-drafted. He also arranged to spend time in an army camp, working in the mess with the mess sergeant. His character was a serviceman who worked in the company mess. His father had been in the services and Gere studied old photographs of him in his uniform and other pictures from those war-time days. He relished being cast in a 'period' role. 'Playing characters from another time allows you to get outside yourself,' he explained. His perception of the period was sharp and accurate: 'I think of the way my father must have been. It's a whole new point of view that's alien to us, an uncynical view. These guys were pulled out of small towns without knowing anything, and suddenly found themselves playing for high stakes.'

The film also explored how the American army's arrival affected wartime Britain. It was made with American money and British know-how, but according to *The Movie*, experts this side of the Atlantic would say that when Schlesinger's American backer insisted that he tone down the Britishness of the script, it lost a lot of its bite.

None the less, Welland and Bernstein produced a sensitive account

of American GIs stationed in northern England, comparing the
lifestyles and values of the two countries while at the same time
emphasising the underlying kinship between Americans and
Britons.

The picture captured with meritorious sensitivity the spirit and
atmosphere of the time, conveying the sometime tenderness,
sometime crudeness of the close relations that developed between
the visiting Yankee servicemen and the local hometown girls. Music
contributed to the picture's wartime setting with superbly evocative
background themes by Britain's Richard Rodney Bennett
big-band swing and dance sequences, and including snatches from
such classic pieces of the era as 'I'll be seeing you', 'Two o'clock
Jump' and 'String of Pearls'. Annie Ross, an established jazz singer
with a formidable reputation on both sides of the Atlantic during
the war years, is seen, but only in the minor non-singing role of a
Red Cross employee.

*Yanks* marked Schlesinger's return to Britain after spending the
previous seven years in the United States. It also reunited him with
producer Joseph Janni, who had produced his first movie, *A Kind of
Loving*. Of the wartime forties, Schlesinger would say: 'In spite of
the grimness of the time, it was a period of celebration as people
triumphed over the raw conditions of their lives, and of closeness
between people as they came together under stress.' *Yanks* brought
Gere into working contact with an array of classical acting talent
including the tall and commanding Vanessa Redgrave, whose
qualities as an actress are unquestioned, Lisa Eichhorn who, though
American by birth and upbringing, had trained at RADA after
studying literature at St Peter's College, Oxford, and distinguished
Welsh actress Rachel Roberts, who at one time had been married to
Rex Harrison. Redgrave, who was evacuated when little more than
a baby, along with her brother Corin, from their home in north
London to the peace and safety of Herefordshire, was as convincing
as ever, this time as a cultured, rather formal wife with a husband
away in the RAF. She eventually finds the American servicemen's
presence, certainly one particular soldier, irresistible; though her
campaigning off-camera as a trenchant anti-Zionist was said to have
run her close to being fired from the picture.

No such problems for Eichhorn. As a young Northern lass who
falls for the handsome serviceman Matt, played by Richard Gere, in
what was her very first screen role, she collected the *London
Standard*'s Actress of the Year Award and a Golden Globe
nomination. Sadly, *Yanks* would be Rachel Roberts's penultimate

film for in 1980 at the age of fifty-three she committed suicide, her posthumously published journal giving a tragic account of her desertion by Harrison and decline into substance abuse.

Gere spent more than seven months in England shooting the picture and, according to reports enjoyed working with his substantially British crew although, in the style for which he was now becoming known, he kept very much to himself. He did not socialize, was considered stand-offish and even unfriendly, and kept his own counsel about his role and the way the picture was developing; especially to the press. One report said he gave noted American critic Rex Reed the cold-shoulder when he turned up for an interview after travelling from New York. There was talk of friction between himself and Schlesinger after Gere appeared to criticize the way the director was handling the shooting. Gere claimed this was not the case at all and commended Schlesinger, going so far as to say that no other director could have handled the movie as well as Schlesinger.

Gere defended his morose and introverted attitude on the basis that the picture was all-important and he needed to keep within himself and his own space to apply the degree of concentration necessary for his performance. Focus, he would explain, was all-important for an actor and he had to remain focused on those forties wartime days to get the best out of himself in the role. It was like being in a time capsule.

Much of the film was shot in West Yorkshire, where an enormous army base had been constructed close to the wool town of Bradford. Gere rented an apartment just around the corner from Hyde Park and handy for the six weeks of shooting in the Twickenham film studios in London, but for the four weeks of filming on location he was chauffeur-driven up to the north of England every morning and driven back again when work was done in the evening. Days were long and exhausting though his role in *Yanks* was, as he would explain, far more 'normal' than any of his previous roles. A welcome interlude was when his mother and father came over to see him; another when his brother David arrived and they sat through a screening of *Bloodbrothers* together.

The plot of *Yanks* takes up the story of three reasonably typical wartime romances. The aristocratic Vanessa Redgrave has an affair with an American officer (William Devane), while in contrast Chick Vennera, playing an army cook and one-time prize-fighter, enjoys an easy pick-up in the form of the cheery bus conductress played convincingly by another newcomer, Wendy Morgan. The main

focus of the picture, however, is the relationship between Matt, the decent, small-town mess sergeant, played by Gere, and Jean Moreton (Lisa Eichhorn), the innocent daughter of the puritanical local postmaster, played by Tony Melody, and his wife, played by Rachel Roberts. Jean is attracted to Matt, despite having an absent soldier boyfriend, who incidentally (for fans of the British hospital series *Casualty*) is played in a fleeting reunion scene by a youthful-looking Derek Thompson, Charlie Fairhead in the TV success.

Some seventeen years after *Yanks* went on general release, there are still plenty of people in the location areas of West Yorkshire who remember the excitement and the activity that interrupted the routine of their normal community life when film crew and movie stars descended on them.

Hundreds of local folk were taken on as extras for scenes shot in and near Keighley. The youngest recruit, almost certainly, was 6-month-old Claire Louise Lootes. She appeared with her mother, Lynda Lootes of Queensbury, and Clive Crowther of Shelf, who played Lynda's husband.

Cathy Mason, now Cathy Liddle,talked about her 'ten seconds of stardom' as a film extra. She said that Springfield Mills in Keighley was turned into a vast changing room and wardrobe with literally hundreds of uniforms and women's clothing from 1943. 'Authenticity was absolute,' she observed. 'Every item, every style, skirt length, every tilt of the hat, was checked against photographs and newsreels of the period.' A local newspaper advertisement had appealed for youngsters and scores responded.

Cathy Liddle was originally specified as an 'ATS girl', but the uniform did not fit so in a flash she was re-assigned to the 29th US Infantry Division of the American Women's Army Corps. Eventually she was cast as a plain Northern lass in a plain wartime-style brown cardigan and equally dull green beret.

Ah! The tribulations of being a star!

After spending some ten hours on the set, with probably no more than five minutes of actual film in the can, work ended for the day for Cathy and the other extras. But she did sneak a close-up of the picture's main stars, Lisa Eichhorn and Richard Gere. 'They looked every bit the romantic leads they were intended to be,' said Cathy, 'she exceptionally pretty and he the clean-cut all-American hero.'

The area was transported back in time as the build-up to the shooting, along with the process of re-creation, took place. A convoy of US Army vehicles including staff cars and ambulances as

well as US Army trucks, half-tracks, weapons carriers and jeeps, had headed for West Yorkshire from all parts of Europe to be used for filming around the old Steeton Ordnance Camp, which had been unused for years. Newly created parade grounds, barracks and Nissen huts were put up on some fifty acres of ground. Much re-painting was necessary to make it look like an American army camp.

One of a number of challenges for the film-makers was the re-creation of a rail station at Keighley, for the major final scene depicting the US troops leaving the area by train on their way to the embarkation ports prior to landing in Normandy. Steam trains from the period, which had actually carried the American forces destined for Europe prior to the opening of the Second Front, were returned from the Worth Valley to be assembled in working order. The whole area was transformed. Wartime security posters were displayed, modern name-plates blanked out, windows taped as a precaution against shattering glass. It was a splendidly evocative scene, full of emotion as the farewells were lingeringly made; and for those who remembered those times, it was intensely nostalgic.

Gere's portrayal of the likeable GI in *Yanks* brought him many new admirers. Some commentators tipped him to knock John Travolta from his perch in the affections of young female movie-goers, while he himself said towards the end of 1978: 'I doubt I'll have another year that enriching.'

Much of his appeal was his sensitivity, which he displayed to considerable advantage in his tender affair with Eichhorn. His restrained work would, however, prompt a backlash from some critics who felt that his performance had been too restrained and understated, a criticism that he would attract increasingly as his career developed.

Disappointingly *Yanks* was not a financial success, despite the care and patience that had attended its making. Schlesinger had taken his time in bringing his vision to the screen, concentrating on even the smallest of details to ensure they were correct and accurate. His actors had produced some fine portrayals. It had all the ingredients for success with Gere established in a stronger, mainstream position among the top male actors.

But it just did not happen. The picture grossed only $3 million, which was less than half what it cost to make, and Gere's performance as Matt came in for some adverse comment, particularly in America. Too many critics were less than enthusiastic, claiming his interpretation had been too controlled,

too restrained, had not extracted the obvious potential of the role and, while acknowledging that he was a good and talented performer, he had not really brought the picture to life, which was vital for the film to be a major success.

They have a point of course, but a more fundamental reason the picture fared less well than hoped for in America could be the nature and location of the picture. This was basically a picture about Britain, shot in Britain about one remote (to Americans) part of northern Britain, and American servicemen's wartime relationships with British girls on British soil. It was perhaps simply too far removed from the personal experience of new adult Americans with no knowledge of wartime Britain for them to turn out in huge numbers to see it, both in terms of the time it was released, more than thirty years after the period in which it was set, and more than 3,000 miles away from the American homeland.

One consolation was that *Yanks* earned the accolade of a Royal Charity Première at the Odeon Theatre, Leicester Square, London, on Thursday, 1 November, 1979, in the presence of Her Royal Highness The Princess Anne and Captain Mark Phillips.

More closely evocative of the times was the picture's northern première, held at Stockport's Davenport cinema. Army jeeps drew up outside, a cinema organ rose from what remained of the orchestra pit to the strains of 'The White Cliffs of Dover' and John Schlesinger arrived making a Churchillian-type entrance with a huge cigar.

# 6

# The Big Breakthrough

Since he first secured a toe-hold in the business with those early theatre dates and a couple of movies, Richard Gere, the professional actor, had always been single-minded, ever-aware of the way movie-makers and those who invest in pictures can manipulate an actor's career. He now felt that he had already let himself be pulled too much and too far in one direction. He had never set out to be a sex symbol. What had happened to that resolve not to be type-cast?

Never mind, he would be more assertive from now on. He needed to take more control of his own career. He would now decide which parts he would play and which to turn down.

But it is not always easy to divert the course of natural progression, as Gere would discover. And despite an impressive breakthrough into pictures and having six of his movies released between 1974 and 1979, he was still far from being in a sound position to call the odds. The hard fact was that if you put all his pictures together they would not break even financially. Certainly he was in no position to be selective, as events were to prove.

Enter now the highly respected Hollywood director, Paul Schrader. This former Los Angeles film critic had been born in Grand Rapids in 1946. His first-produced screenplay, a cooperative effort with his brother Leonard and Robert Towne, was a Japanese underworld thriller called *The Yakuza*, released in 1975. The story of the movie he now had in prospect, Schrader would later explain, had been written three or four years before while he had been lecturing on film-writing at the University of California, Los Angeles. The group discussion one day had centred on the word 'gigolo' and Schrader developed the theme of the 'paid escort'

definition into someone who finds it hard to receive love and affection. He became absorbed in this area of human relationships, explaining: 'He is unable to receive so has perfected himself into giving.' That then evolved into *American Gigolo* and thus a new film, or rather a new film title, was created.

Schrader had been going through an intense creative spell at the time, producing a number of film scripts, two or three of which he sold to film companies for development. One of the scripts he released he had based on the title *American Gigolo*. It had been bought by Freddie Fields at Paramount, but it was not until late in 1978 that the studio could look at it seriously as a definite picture project. By this time Schrader was much less committed with other projects and found he was able to direct it himself.

Schrader has always said his first choice for the key role of Julian Kay, the fashionably classy male prostitute in *American Gigolo*, was Richard Gere. He sent Gere a copy of the script, they discussed the project together and Schrader reckoned he had found his male lead. The power men at Paramount seemed happy to go along with the director's choice. Gere was enthusiastic, even though the part was still within the broad focus of some of his earlier roles. But he considered the script to be well written and thought the picture, with its sexy theme, had an excellent chance of success. It could provide the break-through he was after. And with nothing else in the offing, he was in no position to turn it down.

Paramount had also been evaluating the potential of *American Gigolo*; and for Gere, that turned into a major problem. The studio bosses had second thoughts. They now felt the picture good enough to warrant a bigger crowd-puller than Richard Gere. John Travolta was the man of the moment after his lavish success as the disco-dancing star turn in *Saturday Night Fever*. He was much the same type as Gere, they asserted, and were willing to dangle big money to secure his name on a contract. With Travolta in the role they not only had an excellent film, but a big box-office success virtually guaranteed. Travolta was delighted. His latest picture, *Moment by Moment*, which Universal had rushed out in the wake of the box-office triumph of *Fever*, was to flop badly. His coltish writhing over the body of his much older co-star Lily Tomlin, estranged from her husband, failed to recapture the innocent magic of his earlier picture. He saw in *American Gigolo* the chance to restore his tarnished image.

Gere was devastated at being dumped and in the vacuum that followed considered playing Shakespeare's *Coriolanus*, before

finding some consolation in a project called *Urban Cowboy*, which was being developed by Paramount from a magazine article, with former Paramount boss Robert Evans producing.

Meantime, on the strength of Travolta's enormous pulling power, *American Gigolo* was being given the full treatment. The studio bosses backed their judgement by hoisting the production budget to $9 million. Schrader flew to Rome to hire set designer Ferdinando Scarfiotti whose brief was to create a series of opulent backgrounds for the smart and sophisticated main location sets. The cost of these sets alone would stretch to $1 million. The picture was required to be photographed creatively and sensitively and John Bailey, a cinema-photographer who had worked with Nestor Almendros on Gere's recent picture, *Days of Heaven*, was brought in. Designer of elegant clothes, the world-famous Giorgio Armani, was commissioned to produce a wardrobe of exceptional quality for Travolta while another haute couture designer, Basile, was engaged to design a special wardrobe for the female lead, now confirmed as Lauren Hutton, formerly one of the highest-paid models in America. After a brief spell as a Playboy bunny, she had worked for Dior and posed for twenty-four covers of *Vogue*, before entering films inauspiciously in 1968.

The screenplay also came in for attention, with new scenes included to give a sharper sexual focus. All the elements were in place. Everything pointed to it being a glossy, smooth, successful picture. Then, with shooting about to start, Travolta pulled out. Studios are used to panics, but this was serious. The official reason for his withdrawal was a family bereavement, but the less charitable, truthful explanation was that he had been finally frightened off by the nature of the film with its somewhat sordid and sexual overtones and the specific character of his role. He saw it as being a major departure from his usual screen persona, a move he doubted his fans would accept. And after the flop of *Moment by Moment* he was not prepared to take the risk.

Gere was now back in the frame. Well, not exactly. According to studio gossip a hurried decision was taken to approach Christopher Reeve, little more than a year after his movie baptism as Superman, but before the superhero acquired his ultimate cult status. He turned it down, almost certainly because it would have brushed uncomfortably against his wholesome beefcake screen image.

With time running out to the start of filming, director Paul Schrader was delighted when Paramount agreed that he approach Gere again. It also gave him the opportunity to re-shape the film,

moving it more in line with his original idea. Gere was given forty-eight hours in which to make up his mind and had just ten days to prepare for the part. He agreed, for a fee of $350,000 plus a percentage of net profits. Reeve's offer was rumoured to have been £1 million. Travolta had been offered the same fee, with extra cash for his personal staff.

Never mind, Gere was back in business and at a bargain price. The curious aftermath was that Travolta misguidedly took over the role that had been offered to Gere in *Urban Cowboy* opposite Debra Winger. It was not a wise decision on Travolta's part since he was generally thought to have been miscast and the picture did not produce the hoped-for success.

On the other hand, *American Gigolo* provided the essential magic for Gere, establishing his credentials as an upwardly-mobile actor and a fully-fledged sex symbol. As the macho male-lover-for-hire caught up in intrigue and murder, he emerged as one of the most exciting actors in Hollywood. He was in his element even if the picture itself stood accused in some quarters of wallowing in perversity and contrived seaminess. Since the days when he collaborated with Martin Scorsese, director Paul Schrader had always been fascinated with the examination of true-life stories and social issues and he would build up a reputation for controversy, which extended into the nineties.

Thus, as the writer of *American Gigolo*, the picture was naturally his kind of picture. The result was a searingly potent treatment of the subject, well in line with his penchant for fundamental themes, as in the earlier *Taxi Driver* (1976), considered a classic study of urban alienation, and *Blue Collar* (1978), a story of carworker exploitation in Detroit. That year he also wrote *Hardcore*, which had him focusing on the world of pornography, while his controversial themes, which extended from the life of Christ on the one hand to terrorism on the other, would follow in the late 1980s.

*American Gigolo* might well have had its critics for its sexual orientation and lack of compassion, but who could deny that with bared chest and oozing sex appeal Gere was precisely right in the part, in retrospect surely above both Travolta and Reeve.

With contract signed, Gere had immediately immersed himself in the character with intensity and thoroughness. A casual dresser in normal life he had to learn to be comfortable, look right and correctly dressed in the stylish wardrobe of a gigolo. Schrader admired the way he went about researching not only the physical side of his character, but also his thoughts, reactions in specific

situations, and the motives behind his actions. His character became real to him. He set out to discover why he would respond in a certain way, what he would have around him in his room, how he would wear his clothes, whether he would be relaxed or taut, how he would walk, talk and sit, and how accomplished he would be in handling his clientele, pimps and the outside world. He needed to know the precise nature of the man before matching his own interpretation. Said Schrader: 'When Richard got involved I got back to making a real movie again.' And there were notable benefits also for the studio. Saving $650,000 in salary costs was enough to get faces smiling again, and with Gere once more in the part they could now impose a cash-saving work schedule of fifty days instead of the sixty-day luxury, which had come as a condition of having Travolta as the star.

Much of the difference was down to the comparative status of the two actors. And that difference at that time was enormous. Their respective box-office pulling power said it all. The combined gross takings of Gere's last three pictures, *Days of Heaven*, *Bloodbrothers* and *Yanks*, was less than the gross receipts of Travolta's single failure with *Moment by Moment*.

*American Gigolo* was not an easy picture to make. It was physically demanding. To achieve the fifty-day deadline meant that Gere's day would often be twelve to fourteen hours long. The picture became his life and he offered himself completely to it. He would wear his character's clothes even off set – the lizard-skin boots, designer jeans and linen jacket. The final cut would show that Gere's presence dominated the picture.

The nature of the movie demanded a tight-rope mentality from Schrader and precisely defined performances from Gere and Hutton particularly, to secure that hairline perfection between realism and crudity. Sensitive scenes needed to be authentic, but not gratuitous.

Paramount trumpeted Gere's role as Julian Kay as '... the highest paid lover in Beverly Hills [who] leaves women feeling more alive than they've ever felt before,' and then, alluding to the film's dramatic climax, 'Except one.' Starring with him, in addition to Lauren Hutton as the bored wife of a Californian State Senator, whom she rarely sees, was Nina Van Pallandt, whose role is to introduce him to wealthy, eager women.

Even with his clothes on Gere looked every inch the part in his Italian handcut suits, handsome and physically impressive, tantalizingly charming and, driving his gleaming Mercedes, displaying all the essential trappings of the smooth man-about-town. His repertoire extends from companion to chauffeur, guide to escort; with a

more personal service added on request. Hutton starts out as a normal client, but a genuine relationship slowly grows into something more.

Schrader saw Gere's character as being outside human emotion and incapable of genuine love, but gradually with Hutton the barriers break down and Julian begins to feel he might really be in love for the first time. But he finds himself caught up in intrigue and murder when his alibi fails to be corroborated, jewels are found in his car and it becomes obvious that someone is out to frame him.

Hutton was ideally cast and produced a polished performance in the role of the senator's wife who becomes involved with Julian Kay and the plot is carried along by the stylish trappings of the set piece which include the Malibu beach-house of Van Pallandt, who makes Julian's appointments and keeps his diary, the Polo Lounge and Julian's own Westwood apartment. Much is seen of Gere's smooth physique and, despite Schrader's intention to have virtually no sex in the picture, preferring to rely on the sumptuous trappings to convey the necessary images and messages, Gere was brave enough to agree to appear in the frontal nude scene. Hutton was nervous about some of the intimate love scenes she had with Gere, but he dispelled her fears by insisting on having all except essential personnel cleared from the set.

The picture had a mixed reception. Some critics found its theme distasteful. Others complained about its contrived plot. *Motion Picture Guide* certainly did not soften the blow with: 'A perverse film devoted to perversity, typical of Schrader's apparently sadistic intent to pillory his audience with every kind of degenerate act he can manufacture.' Some reviewers were only marginally less critical, assessing Gere as, 'a star with a fatal lack of personality'; or 'Gere never really develops the character'; 'Mr Gere is a handsome, able, low-key actor who brings no charm or interest to the role'; and 'This actor lacks a strong sense of his identity'.

But if Gere failed to win over his audience, as these and other reviews implied, then surely the nature of the character he played must take some of the responsibility. Julian Kay was not a sympathetic or charming character and it would have been foolish for Gere to have portrayed him in that fashion. Until the picture draws to a close, when he finally admits his love and need for, Lauren Hutton, he is meant to be shallow and coldly unemotional. Gere played the character as he was meant to be. He did not distort the image of Julian so that he, and perhaps himself, would become more sympathetic and more acceptable to his audiences.

There was a feeling among some critics that he had once again underplayed the part. Perhaps a more balanced assessment came with the clarity that surfaces with the passing of time: and Angela Holden writing in *Sky Magazine* some nine years after the picture was released, echoed much of the sentiment that might well have been felt by then: 'He gave his hustling gigolo a selfish desperation, lifting it way beyond the pretty-boy role the title implied. His sleazy but ultimately moralistic, male prostitute Julian, who is set up on a murder charge then abandoned by the rich and powerful women who were quite happy to sleep with him, captured the increasingly lonely, dog-eat-dog attitudes of the urban early-80s.'

As a vehicle for advancing Gere's reputation as an actor of substance, *Gigolo* was largely incidental. It undoubtedly moved him forward out of the rank-and-file players and into an actor of some consequence, but the far greater development was in his general box-office appeal and especially in his status as a movie personality rather than an actor. After a mere handful of relatively insignificant movies before his widely acknowledged sensitive performance in the more elevated *Yanks*, Gere still failed to emerge from *American Gigolo* as 'the big star'; but he was certainly the screen's most exciting pin-up. His friend, Susan Sarandon, would say of *American Gigolo*: 'It was Richard's coming-out role. I mean coming out as a talent as an actor. His part in *Gigolo* was about power and he is best when he has played characters who express power, not just sex.'

None the less, it was his sexiness that stimulated a brisk trade in large colour posters showing off his handsome features and that smooth, shapely body. Women's magazines climbed over one another to run features on him. It was not exactly the kind of reaction Gere himself had wanted, but he had undoubtedly made sufficient impact during the making of *American Gigolo* for insiders and casting directors to mark him down as a serious candidate for future roles. Gere, however, did not hang about to see what would happen and once shooting on the picture was at an end he took off for Europe and away from it all.

He visited the Cannes Film Festival, where his film, *Days of Heaven*, opened in May 1979. He was cheered by the warm reception he received. He then flew on to Rome to talk to the flamboyant film director Franco Zeffirelli, whose remarkable career had ranged from mounting grand opera at La Scala, Covent Garden and The Met in New York, to directing *The Champ*, a remake of an old Wallace Beery classic, starring John Voight and Faye Dunaway. Zeffirelli was now working on a major new four-hour

production of *Hamlet* for Los Angeles later that year. He and Laurence Olivier were working on making the essential cuts in Shakespeare's original and Zeffirelli had already lined up Jean Simmons, Amy Irving and E.G. Marshall, among others, for the project. Simmons had starred in the film version of *Hamlet* in 1948, which Olivier had produced, directed and starred in, Olivier receiving Oscars for his own performance and Best Picture.

Gere was looking forward to returning to the stage and once back in New York cleared out his diary to allow time for preparation and rehearsal. He still looked on New York as his base, but had not bought a permanent home there. For some reason he seemed reluctant to put down roots in New York, or anywhere else for that matter. He lived in a hotel for the time being. He was enthusiastic about the new project, full of anticipation, but within several weeks of his return to New York, his plans collapsed. Zeffirelli's ambitious project had perhaps been too ambitious. His financial backers had pulled out, concerned that there was insufficient time for all the necessary planning, rehearsals and staging, and alarmed at the size of the proposed budget.

Gere was disappointed. Ed Limato had already turned down a couple of film opportunities, but Gere was keen to do more stage work at this point. Luck changed dramatically when Limato came across a script written by playwright Martin Sherman. The play, called *Bent*, was already running at the Royal Court Theatre in London and gave a dramatic and controversial account about the treatment of homosexuals in Nazi Germany. A Broadway production was in preparation and after meeting Sherman and director Robert Allen Ackerman, Gere agreed to take the starring role.

As a longer-term career move it was seen by many in the business as being about the biggest mis-move it was possible to make. If Gere ever looked ahead, then surely he must see that filming would have to be his future. Whatever the short-comings of *American Gigolo*, it had certainly moved him strongly in the right direction. Putting Hollywood on hold just when he had got the industry interested could not possibly be the way forward. Another more significant point was that taking part in such a play, which although not principally a play about gay men had already aroused considerable outrage among Jewish community leaders in Britain because they felt the play suggested that Jews had been better treated by the Nazis than had been homosexuals, was not likely to endear him to the influential mainstream picture-makers in Hollywood.

But Richard Gere, not for the first or last time, was showing a detached indifference to the outside influences that could affect his career, preferring to make decisions as situations came up and often based on his own gut feeling. And as it turned out, his interpretation of a shaven-headed homosexual prisoner at the infamous Dachau concentration camp, who loses his life rather than deny his identity, won him the *Theatre World* award and some rave notices among a mixed bag of reviews.

Whatever differing views may have been held about the play, *Bent* was certainly an outstanding personal triumph for Richard Gere, professional actor. He gave a brilliant and enormously incisive portrayal. Not surprising because, as usual, he had researched all aspects of the play with the thoroughness for which he was now well known.

Although he had already visited Europe in May 1979 for the opening of *Days of Heaven* at Cannes, he returned in September, visiting Rome to collect the Golden David award for his performance in the Terrence Malick picture. By this time he had secured his role in *Bent* and took the opportunity to carry out some stark, if authentic research. He visited Dachau, which he described as a frightening place. 'The barracks have been burned down, but the foundations are there. You see the administration building, the crematorium, the camp, the wire around the fence, the original signs,' he explained. 'It's overpowering. There are ghosts hanging about.'

He then went on to Munich for more depictive research. Munich had been a focal point of Christopher Isherwood's original story of decadent life in pre-Second World War Berlin. First a stage play and then *Cabaret*, the film that would confirm Liza Minnelli as a major screen star, had been based on Isherwood's writings and, once back in America and in California for some post-production work on *American Gigolo*, Gere took the opportunity to meet the author to obtain more facts on the background to his forthcoming play from someone who had researched the period for his own work.

*Bent* is set in Berlin in the mid-thirties and Max, played by Gere, and his lover Rudy are accused of being homosexuals and sent to the Dachau camp. The story is hardly uplifting as Gere takes part in the killing of his lover, has intercourse with a thirteen year old girl who is dead and falls in love with a fellow prisoner, Horst (played by David Dukes); they 'consummate' their relationship by means of facing each other and talking at close distance. Horst is finally killed by prisoner guards.

*Bent* opened at the New Apollo Theater on New York's 43rd Street

on 2 December 1979. It was a highly emotional and physically draining part. Gere was on stage for most of the play and the mental focus required was considerable. For Gere it was an all-consuming commitment. The play ran for eight months by which time Gere was not only exhausted and mentally depressed by the nature of the play, but had lost a significant amount of bodyweight. Those closest to him had been astonished and impressed by his commitment. Sherman said he was brilliantly alive on stage while director Ackerman observed: 'He's an incredibly hard worker ... he is so focused, so concentrated, so dedicated.' Critics wrote about his courage in taking on such a controversial role and his arresting performances.

Gere was some two months into his run in *Bent* when *American Gigolo* was released in February 1980. The combined impact was considerable and observers began comparing the characters of his role of Max in *Bent* and Julian in *American Gigolo*, isolating similarities. The film instantly clocked up brisk business. It had grossed $9 million in the first week of its release, which was more than the total lifetime receipts of all Gere's previous pictures.

All the more surprising then that his next movie did not appear until 1982. This was not because Hollywood turned its back on Gere after setting him up to become a star, but more because he now considered himself done with snapping up Travolta cast-offs. He wanted to think more about what to do next, not plunge headlong into an insignificant pot-boiler in case his fans forgot about him. He rested and relaxed, showing near contempt for some of the offers that came tumbling in. In the meantime he bought himself a new car and moved out of the New York hotel that had been his home since returning from England after shooting *Yanks*. On the strength of his recent successes he bought himself a luxury penthouse apartment in Greenwich Village, large enough to house his grand piano and his bar-bells and dumb-bells, which he had used to keep in shape almost from his college days.

And he had a new girlfriend. Penny Milford had departed some time before when Gere broke off the relationship. Since then he had dated other girls, but there was nothing on a really continuous basis until Sylvia Martins entered his life. This attractive girl from Brazil had been pestering Gere for some time, making phone calls and trying to meet him on the basis of their shared interest in the arts – his in acting, hers in painting. Gere reckoned there was more to it than that and the last thing he wanted was a doe-eyed fan hanging on to his shirt-tails. But Sylvia was persistent, finally met him, and a

relationship developed, which would last almost as long as he had been with Penny.

At this comparatively early stage in his career Gere was beginning to show signs of the casual, detached attitude to Hollywood's outstretched hand of promise and fame that would extend over the years into what some of his harshest critics would suggest was a full-blown mystifying and singular eccentricity. His antipathy towards the press had already taken root on the basis that his private life was his own business. His only obligation was to his work. He shunned the predictable, kept his own counsel and when being secretly tipped for some blockbuster role or other, following his exciting performance in *American Gigolo*, went instead, and in his own good time, for the lead in a small-budget movie whose ultimate success, as Gere himself would explain, was totally unexpected. Even then, he would bring his agent Ed Limato to the point of apoplexy by repeatedly refusing the part.

When he did finally agree to follow Limato's pleadings and do the film, it was to be the prelude to Gere's full-blown breakthrough in Hollywood. And astonishingly, it was in another of John Travolta's cast-offs.

The new picture, titled *An Officer and a Gentleman*, was to be directed by Taylor Hackford, the script by Douglas Day Stewart, who also wrote the screenplay for *The Blue Lagoon*. It would once more be a Paramount production. It was released in early autumn 1982, at a time when such film characters as ET and Captain Kirk of the Starship Enterprise were bundling many of the standard heroes out of the frame. But after swapping his tailored suit from *Gigolo* for unflattering GI army fatigues and savaging his easy-flowing locks into a utilitarian short-cropped style only fractionally more normal than the shaven head he had sported for *Bent*, Richard Gere emerged as the new Hollywood hero, only established stars Sylvester Stallone and Burt Reynolds perhaps managing in 1982 to hold on to their enormous following.

In North America particularly *An Officer and a Gentleman* was surprisingly a major hit; and it turned in a more than healthy box office in the UK too. Overall it became one of the biggest hits of that year with Gere telling the press later: 'I don't think anybody imagined it would be the blockbuster it was. I certainly never did. I did the film because I liked the script.'

Gere's performance in a challenging, exacting role was convincing and strong enough for more than one critic to pick him out for an almost certain Academy Award nomination. But the

predictions remained unfulfilled, though the picture, which started from nothing, secured distinctions even more emphatic than a nomination. There were Academy Awards for the best supporting actor (Louis Gossett Jnr), for the song 'Up Where We Belong' (Jack Nitzsche), music (Buffy Sainte-Marie) and lyrics (Will Jennings), while Academy Awards nominations went to Gere's co-star Debra Winger, Douglas Day Stewart (original screenplay) and Peter Zinner (music editing). Though Gere himself missed out on the much expected award, the picture – his eighth to be released in as many years – was widely acclaimed to be his best. And it established him in the front line of Hollywood's very best performers.

Superficially, *An Officer and a Gentleman* is a tough unyielding document about a 13-week battle course at the Naval Aviation Officer Candidate School in the USA and at that level it carries the cloying stereotyping you would expect to find in any American movie of its type. But it is much more than that, because all the familiar characterizations of bone-headed drill sergeants and their drained, embattled recruits are not in themselves the essential message. For the film's inner strength, which is simple and straight-forward and conveyed with sincerity, is the changing of a man; and the making of a man. The story is not subtle, but is handled with honesty and conviction.

Gere plays the handsome Naval Aviation Officer recruit Zack Mayo, whose life-hardening background protects, even anaesthetizes, him from the deeper physical and emotional extremes of life. But to the roughneck, brutal training sergeant Emil Foley (Louis Gossett Jnr), he symbolises the best vintage champagne and choicest caviar as he sets out calculatingly and unyieldingly to humiliate and break him physically and psychologically.

The story begins with Zack as a 13-year-old whose mother has just committed suicide because her husband, Chief Petty Officer Byron Mayo (Robert Loggia), is a long-term alcoholic and an obsessional, pathological philanderer. Zack thus spends the next ten years of his life in a run-down Philippine village of shady brothels and sleazy bars. All this is conveyed in intermittent semi-sepia flashback snatches. At twenty-three, the story now up-to-date, Zack decides to ditch his father and put his grim past behind him. He enrols at Port Rainder's Naval Aviation Officer Candidate School with an ambition to fly jet planes. But first he must survive the excruciating challenges of the 13-week intensive battle-training course at physical, psychological and academic levels.

Zack is determined to win through, but the bull-headed Sergeant

Foley, whose purpose in life is to see how much 'stick' his recruits will take before breaking – a yardstick to separate the ones who will make it from the remainder – picks out Zack as a focus for his aggressive, incessant, professional bullying.

Foley is looking for self-discipline, strength of character, courage, bravery, commonsense; and he does his job with an intensity and zeal bordering on the sadistic. Zack must not be allowed the upper hand. Foley will see him physically crippled and mentally tortured first.

You can almost feel the bruising, the physical draining of the recruits as he runs them hard with heavy packs on their backs, torments them through tortuous battle courses, ridicules their efforts and scornfully raises the tempo as they begin to flag.

Foley tightens the screws on Zack, stretching his will to breaking point and thrusting deep into his being. We share Zack's desperation when Foley gives him a brutal nose-bleed during karate training and then, later, in a powerful sequence that grows in intensity as Foley turns the full force of the hosepipe on him when running on the spot, taunting him all the time. Foley makes him run around in circles on the beach and finally makes him repeat an agonizing exercise, keeping him going and going to the point of failure.

Foley wants him off the course. 'You don't mesh, Mayo,' he yells at Zack. 'Because deep down in that bitter little heart of yours, you know that these boys and girls are better than you. You don't give a damn about anybody but yourself, and every single one of your classmates knows it. I'm gonna throw you out of this programme.'

He pushes even harder. 'Tell me what I want to hear,' yells Foley, 'I want your DOR' (date of release; in other words, Zack's submission and request to quit). This leads to a crucial 2-minute sequence in which Foley repeatedly calls for Zack's DOR, finally shouting, 'You're out'. Zack, near to collapse, pleads emotionally: 'Don't you do it ...', and then, more quietly, 'I got nowhere else to go ... I got nowhere else to go....' Finally, submitting and near to collapse, he splutters, almost weeping, his spirit broken and in a faltering whisper, which yearns for even a crumb of compassion, 'I got nothing else, I got nothing ...,' his voice trailing away in utter dejection.

It is a crucial scene, which Gere and Lou Gossett Jnr play superbly. In short, Gere's exceptional performance stops the action in its tracks, creating a moment in time as moving and commanding as the 2-minute silence on Armistice Day. It makes the picture.

Foley respects the man, his courage and his not inconsiderable qualities; and Gere remains on the course.

It appears that this crucial scene was shot over one agonizing long weekend with Gere giving himself completely to the disciplines required. When the shooting was completed and Gere dragged himself off the bunker where the sequence had taken place, his shirt was covered in blood from sores on his back.

Off duty at weekends, with all the hard graft of training and drilling over for a while, Zack finds solace in Paula Pokrifki, a local mill girl played by Debra Winger. She knows from practical experience that recruits like Zack are normally only after a good time with no strings, and at first expects nothing more. But somehow she finds Zack different from her previous liaisons, possessing a rare vulnerability. Their bedroom scene, sexy with plenty of body contact and flesh showing, was tenderly enacted. Winger captured the scene with her sensitive, gentle yet provocative love-play and Gere managed to project a warmth and sensitivity, which had perhaps been lacking in his sex scenes in his previous pictures.

The picture also allows his humanity to come through. At first there are the familiar symbols of the Gere stereotype – this time an upper-arm tattoo, which he tries to hide, the free-spirit innuendo as he roars away astride his motor bike, the quietly operating, smart-arsed wide-boy doing sly deals on the side and the macho lover who views girls cynically if not with contempt.

But all that changes as Zack, when confronted with extreme situations, shows that he really does care by helping out a colleague in trouble, a friend confronted with a girlfriend's suspected pregnancy (which ends in tragedy), and by his compassion and genuine affection for Paula, who is not just someone to have sex with.

A Zack-Foley reconciliation is eventually forged through a rugged kind of mutual respect and the picture, helped along considerably by a memorable theme tune (sung by Joe Cocker and Jennifer Warnes), which became a big international hit to add to the Oscar, advances through a mixture of strained emotions, character tests, violent eruptions and love-struggles likely to raise a tear or bring a lump to the throat.

Debra Winger is equally believable as Gere's lover, with her delicate nuances, and as the gum-chewing machine-minder in a noisy factory. The love scenes come across with such sincerity that it is hard to believe that they did not get along too well together.

When pressed into it, Winger said that at first she found Gere friendly and helpful, but later in the three-month shoot he began shouting a lot and she did not particularly want to know him. Gere agreed that tension developed between them but claimed that was not unusual when making a picture and was not always a bad thing if the best results were to be achieved.

The picture won unexpected critical acclaim on its release in America with the *New York Times* assessing it as one of the most unpretentious and thoroughly enjoyable films of the year. Leading critic Rex Reed said it was one of the most gripping, suspenseful and thoroughly moving films he had seen that year, while the *Los Angeles Times* declared: 'One of the season's happiest surprises. Remarkable. Tropically sexy, unabashed, uninhibited and unashamed of calling forth big emotional responses in several flavours.' *Newsweek*'s critic would go further: 'Zack Mayo is Richard Gere's breakthrough role, the lowlife who wants to be a respectable officer. It's a perfect merger of movie iconographies – on the one side the clear gaze and all-American good looks of Robert Redford, on the other the tortured narcissistic intensity of Montgomery Clift, Brando and James Dean, always the outsider.' An accolade indeed!

In the picture Zack Mayo eventually wins through against all the odds, earning the right to wear his graduation officer whites, to be a professional flyer and commander, and taking his girl Paula with him on the back of his bike and into a new life.

David Keith, as Gere's buddy who finally hangs himself, and Lisa Blount as Winger's girlfriend, give excellent portrayals, but the picture owes much to the outstanding performance of Louis Gossett Jnr as the drill sergeant. Richard Gere certainly won his spurs as an actor to be taken seriously in what was undoubtedly his most dynamic role to date. He developed a considerable cult following after *American Gigolo* and especially after *An Officer and a Gentleman* and was described by one journal as the male fertility totem of his generation.

And if in some isolated pockets he still was not taken all that seriously as an actor on this one performance, then there appeared always to be plenty of fans who did not care; nor did it seem to worry Gere. For then, in the early eighties, he was certainly an extremely bankable performer. *An Officer and a Gentleman* was released in the late summer of 1982 and by the end of the year was second to *ET* in gross receipts. Cinema receipts would quickly exceed $100 million and the picture would eventually make more than $250 million worldwide.

You could say that Richard Gere was now a star. A very big star.

# 7

# Richard Gere – Super-stud

The so-called glory days of Hollywood some forty or fifty years ago have little to do with film-making in the 1980s and 90s. The major studios like MGM, Paramount, Twentieth Century Fox and Warner Bros not only created all those legendary big-name stars like Judy Garland, Clark Gable, Ginger Rogers and Robert Taylor, but literally ran their lives for them, almost twenty-four hours a day. It was a monopolistic-type situation and if you wanted to be a star, and remain a star, you signed a contract and toed the studio line.

In those days Richard Gere would have been an outcast, the roundest peg in the squarest hole you could find. He would have been too individual; too intent on making his own decisions as he went along; too concerned with running his own life in the way he wanted to run it. Film-making these days is different. The all-powerful monolithic studios have gone and actors and actresses have been freed from the strait-jacket of those life-encompassing studio contracts. Today they are able to pick and choose the parts they play, negotiate individual deals and have much more control of their own lives, both off and on the screen. It is the kind of liberalization that is the very essence of the free-wheeling life enjoyed by an instinctive individualist like Gere.

When his next picture, *Breathless*, was released in America in May 1983 he was not yet thirty-four years old. It was only eight years since his tentative and modest movie debut and less than half that time since he emerged as 'a new boy to take note of ' in *American Gigolo*. Yet he was already one of Hollywood's biggest stars. And one of the most incomprehensible.

From the beginning Richard Gere has been a one-off, full of unfathomable contradictions and ambiguities. He shunned the

limelight, but as time went on he began to lead a high-profile private life, which had the paparazzi camping out almost permanently on his doorstep. He can be inexcusably foul-mouthed and insulting; and just as easily charming, understanding and polite. His easy, relaxed style somehow manages to combine intelligence and experience with artlessness. He rapidly became Hollywood's greatest sex symbol, and the most reluctant. Hollywood turned out to be good for Gere, yet he often conveyed an unworthy contempt for its institutions and what it stands for. In fact there is more than a touch of the Jekyll and Hyde about our Richard. The persona itself is so fascinatingly confusing that who would be surprised if the whole thing was a sham, a facade? Or it could be quite as easily a case of what you see is what you get – the genuine Richard Gere. The latter is almost certainly the more likely.

Richard Gere has classically handsome features and a smoothly muscular, athletic body, even though by Hollywood tradition a trifle short in height for what used to be known as a romantic lead, though cinema history has thrown up notable and extremely stunted exceptions like Alan Ladd and John Garfield. He looks every bit the film hero and it is no surprise that because of his smouldering physical presence on the big screen he was increasingly cast in sexy roles. He never had any inhibitions about taking off his clothes on a film set – seemed to relish the opportunity in fact – and in several of his early hits appeared nude, establishing something of a reputation for it. His stock answer to probing questions on baring himself for the camera was simply that if the character would do it, then he would do it. 'But I'm not going to do anything if I think I'm being exploited,' he added. 'I don't want to be an object.' Later on he would explain that he takes his clothes off in pictures because that is what people do when they make love or take a shower. It is curious that in the majority of those early pictures he seemed to be called upon to do both quite a lot.

Almost from the start of his movie-making career Gere found press intrusion hard to handle. When he did agree to be interviewed, which was not all that often, journalists would be prone to comment about his late arrival, or a general lack of interest and co-operation; or an uncalled-for boorishness when confronted with a question that he felt was out of line or perhaps had not anticipated. In some respects, however, his prickly relations with the press were hardly surprising and somewhat justified perhaps when, after starring in those earlier sexy pictures, he quickly acquired the put-down tag line among the tabloids of 'Get-em-off-Gere'. Interviews with him acquired a rarity value akin to gold dust, even when he was still a burgeoning actor and

might well have found the publicity useful. Nor for a time it seemed did he become significantly more accessible as his reputation soared. Yet he had a style and charisma that allowed him to dominate the showbiz headlines like no other actor.

Even as early as the mid-eighties Richard Gere had provided ample proof that he was not your ordinary Hollywood heart-throb. Never star-struck and always resolutely his own man, he was quietly determined to live his life the way he wanted, a film phenomenon or not. He never really planned his career, preferring to take or reject opportunities as they came along and casually allowing his life to develop organically. He refused to manufacture a showbiz personality for media consumption. Richard Gere was Richard Gere, whether making a picture, enjoying solitary trips overseas, giving time to worthy causes or frolicking with a new-found lady friend on some distant sun-drenched beach. If he was seriously ambitious he gave little indication of it and, according to the commentators, displayed scant wisdom in the seemingly abstract way he said yes to films that he fancied and unceremoniously thumbed down the rest.

Often he would have to be hard-talked into taking on a role. Reliable sources close to the studios agree that he turned down the lead in *An Officer and a Gentleman* five times before finally agreeing to do the picture. In this way alone he must have been a nightmare to his agents trying to nurture a clearer and more accommodating public profile. It was also strongly rumoured that he rejected the coveted lead of Avigdor (subsequently played by Mandy Patinkin) opposite the legendary superstar Barbra Streisand in the 1983 box office success, *Yentl*. But according to reports he might well have found a crumb or two of consolation in the off-screen fling he was rumoured to have had with Streisand at about this time. In any case, he seems not to indulge in regrets, being uncommonly philosophical for a movie actor. The successes, which he also appears to take so consummately in his stride, seemed to be more than enough to make up for the knock-downs he might face in life.

And it is not exactly standard practice for a top movie actor to be a practising Buddhist. Journalists were cynical when this little gem first came to light. Hollywood widened its suspecting eyes as he put his career on hold and took time off to study with the Dalai Lama. Now, more than fifteen years later, he considers his faith to be stronger than ever, though like his movie career, he never makes a fuss about it.

Even some of his closest friends and associates are likely to agree

that he is a complex and complicated individual, at times conventionally sensible, at other times infuriatingly irrational. Facing him during the early years of his star status, interviewers would mention his tardiness, his occasional quiet but angry outbursts, his casual dropping of expletives into his conversation. Yet at the same time he exudes an inner strength and confidence, which is undiminished by success or failure, attracting the unbridled admiration and loyalty of those who appear to know him best.

Above all else his sexual appeal has continued to grow over the years and after the success of *An Officer and a Gentleman*, he seriously accelerated the pulse rate of his army of female fans with the release of the explosive *Breathless*, in which their hero was said to have pushed back the frontiers of conventional cinema nudity to the threshold of outer-space with another glimpse of a 'full frontal' while taking a shower. And as if that were not enough Gere, who was said to have helped with the writing and casting of the film, grabbed more shock headlines when the gossip press reported how, in selecting his co-star, he had screen tested as many as sixty naked women in a French hotel bedroom, posing them in front of the video camera. Valerie Kaprisky, a 20-year-old French actress and former model, was finally cast, but reportedly not before she was required to take further tests in the nude with Gere. His involvement did not stipulate he should be naked during the tests, but he said later that he stripped off anyway to make her feel more comfortable.

In this, as in much of the press gossip and tittle-tattle, which seemed habitually to accompany the release of a Richard Gere film, it would remain difficult to separate fabrication from fact, for the star himself has never been one to help the media sort out the truth, always assuming that was what they wanted to hear. But in terms of publicity for the film, it was all sound and enterprising marketing for the picture. It was also claimed that Gere himself picked up $200,000 on top of his fee for baring all in front of the cameras.

*Breathless* certainly monopolized the film headlines at the time. One described it as Gere's sexiest yet. 'Getting Breathless over Gere', proclaimed another. A third: 'Richard Gere goes further with nudity than any other popular young actor has ever dared.' The 'scandalous' shower sequence – in reality no more than a passing, though admittedly intimately revealing, moment, if you were alert for it or were quick to flip the video on pause – was unquestionably a breakthrough for popular adult cinema. But Gere did not admit to it being anything special. That particular scene in the shower, which

he admitted many people found sexy, had been included purely as a comic interlude, he claimed – though it is hard to take him seriously. In any case, there is a sexier sequence later on with Gere and Kaprisky together in the shower, their enthusiasm, seen hazily through the frosted and steamy glass, bringing about the partial collapse of a section of the cubicle, amid happy laughter from within. However, in running the video of *Breathless* more than ten years after its initial release it is perhaps surprising how the nude and semi-nude sequences involving Gere and Kaprisky have lost something of their ability to shock; perhaps because of the authenticity of the situations.

In 1983 though, it is not surprising that *Breathless*, a mainstream movie directed by Jim McBride and produced by Martin Erlichman, who for a long time handled the affairs of Barbra Streisand, was seen as a potential box-office hit and well within the market to attract a cult following. True, the picture grabbed the headlines because of its unusually frank sex scenes, but it also ran the gauntlet with a cold-blooded if accidental killing and a popular hero who took from life what he wanted, was loutish and brutal when it suited him and who rejected if not despised most accepted forms of authority and common decency.

Like many films, *Breathless* had a painful and protracted birth. As early as 1978 film-maker Jim McBride and writer Kit Carson had taken their pet project to Marty Erlichman, who was contracted to supply scripts to Paramount.

At this point Gere had already been brought into the project and had examined the script. He was enthusiastic, though it was evident that the picture would take advantage of his pronounced sexual image. Outweighing that consideration, however, was the fact that he found the story intriguing, his character tantalizingly complex and fascinating, and he was impressed by the way McBride and Carson visualized its presentation.

Paramount hesitated about a picture that had as its 'hero' the composite petty gangster, professional car thief and cop killer. The project then stumbled through an unreceptive no-man's-land of rejection and indifference as Paramount turned it down; Universal expressed interest, then lost interest; new writers were drafted in and then sent away; Robert De Niro, Al Pacino and John Travolta were all in turn labelled as saviours, before fading from the scene. It looked as though the project had irrevocably run aground. Salvation came when Gere's initiative secured renewed involvement from McBride and Carson, with independent financial backing and Gere once more in the main role.

Based on the 1959 French classic, *A Bout de Souffle*, which starred Jean-Paul Belmondo and Jean Seberg, this Americanized update never quite carried the conviction of the original though at an international level it had a much higher profile and set up a far bigger and stronger wave of excitement and expectancy.

*Breathless* would certainly go down as a success for Richard, but for many critics it fell short of *An Officer and a Gentleman, American Gigolo* and perhaps even *Yanks* as a picture to remember. The French original was set in Paris. The new version had Los Angeles as its location. Gere is Jesse Lujack, a narcissistic, streetwise hustler and car thief obsessed with his hip image, who races the Porsche he has just stolen past a car full of waving, admiring girls and on into the Mojave Desert. Chased by a traffic cop for speeding he crashes the car into a detour barrier, ending up stuck in a sand-dune. The cop gets out of his patrol car and, with his automatic covering the now immobilized Porsche, orders Jesse out of the car. Jesse is cornered and in his panic to evade arrest sees the gun, which he had previously found in the glove compartment of the car, going off in his hand, killing the policeman.

He is now on the run and, once back in Los Angeles, seeks refuge with Monica, a French girl with whom he had a one night stand not so long before and who is now at UCLA (University of California at Los Angeles) as an architectural student. But Monica, who by now has put her experience with Jesse behind her, is concentrating on her studies and in any event is currently dating one of her tutors. She turns down Jesse's obviously impractical invitation to escape to Mexico with him. But Jesse, handsome and appealing, forces himself back into her life and Monica's resolve melts away.

Much of the film is about Jesse's obsessive love for Monica and the erotic charge that develops between them, but even before the end there is little real chance that Jesse will make his successful escape to Mexico with Monica. The police pick up Jesse's trail and he and Monica hide away in a cinema. But in the end Monica is unable to reconcile her basic decency, compassion and need for some kind of planned and calm future, with the arrogance, aggression, selfishness and paranoia of Jesse, who is incapable of showing remorse for the savage way he takes what he wants from life, whatever the consequences. In the end she betrays him to the police.

It is fair to say that *Breathless* was not the best picture that has ever been made, but Gere's performance as the strutting, posturing and contemptible Jesse is infuriatingly convincing, his interpretation, especially in the early scenes, stopping marginally short of parody,

while Kaprisky is young, pretty and sensually vulnerable as the coerced Monica.

Gere carries the picture almost single-handedly and is in sole charge for the first fifteen minutes or so with no-one else of significance on screen. Muttering, talking almost incoherently to himself and hyped-up by the incessant pulsating beat of his favourite Jerry Lee Lewis rock 'n' roll tape, which he has fed into the stolen Porsche's music deck, his character is driven by his own self-willed, marauding, almost manic, yet vulnerable, arrogance. His inspiration comes from his comic book hero, Silver Surfer, the sky rider of the space waves, freely adopting his philosophy of 'power supreme'. At first his perpetual energy and grotesque behaviour is almost too much to bear, but in the end – and certainly after a second viewing of the picture – the sadness and vulnerability of Jesse shows through, for in spite of everything, and in other circumstances, he could perhaps have become quite a likeable guy.

The picture carries a simple, one-dimensional story about the physical love between an aggressive, impulsive man and a more gentle, caring, sympathetic young woman. In the end their basic incompatibility destroys whatever permanent relationship there might have been. The film ends dramatically with the picture frozen as Jesse reaches for his gun that will bring retaliation from the police and Monica shouting, 'I love you'. Some of the critics, predictably, called it a cop-out. More surprising, so did a few picture-goers. But it was different and deserved a more understanding general response.

The picture, once in its stride, moves at a hectic pace with sundry items of male and female clothing frequently discarded – in the shower, where Gere drops everything for his much heralded full disrobe (the shower door just happens to be open for all of us to see); in the movie house (she virtually topless); in the girl's room (she and he topless, then she naked); by the swimming pool (a legitimate disrobing for her, since she is in the water wearing a one-piece swimsuit); in her apartment once (or is it twice?) again; and on the bed (both naked with Gere running close once more to total exposure), before moving into the second shower sequence already described.

Gere spends most of the picture bare-chested anyway and it is not altogether surprising that he drops in the four-letter word from time to time, which Monica seems to do her best to ignore.

You could argue that a film of this kind is merely an excuse to focus on sex, but having once accepted the story for what it is, then

the nudity follows naturally. And considering the intimate nature of many of the love scenes, Gere and Kaprisky were able to make them convincingly natural and relaxed. Within the context of *Breathless* it would have been ludicrous to substitute the nude scenes with conventional fade-outs. For one thing these sequences are too central to the basis of the picture for them to be devalued in this way; such artificial coyness would have been an unconvincing contradiction to the remainder of the picture with its tough, uncompromising, basic approach to this flawed, ultimately doomed human relationship. For certainly, this was not the Walter Pidgeon–Greer Garson, Mrs Miniver-type love story.

But in the end it is difficult to isolate the picture from the hype that surrounded its making and release. It was difficult for *Breathless*, distinctly meritorious in terms of its realistic photography and the way the dialogue was loosened to give the players scope for individual conviction and spontaneity, to climb out from under the restricting 'love story with clothes off' popular tag. And objectivity was perhaps hard to isolate from the competing mass of behind-the-scenes stories and rumours, which prevailed at the time of the film's release.

There was the way director and co-writer Jim McBride, whose debut film, the unconventional *David Holzman's Diaries*, had been widely acclaimed in 1967, was said to have trawled through America, Canada and Europe in his search for Gere's co-star, a young girl whose looks and physical presence would combine a beguiling innocence with a powerful capacity for love. Both Gere and producer Martin Erlichman helped with the selection and the final choice of French newcomer Valerie Kaprisky was made only after thousands of auditions had taken place and Kaprisky herself had almost been passed over because her first reading was unconvincing. Given a second chance she made sure of her lines. 'This time it was wonderful,' she declared at the time. 'I didn't want to leave. I just can't act without feelings and I felt something very special for Richard during that scene.'

It was a remark that would only add to the almost inevitable rumours of an off set affair between the co-stars, but it was left to Kaprisky to scotch the gossip, pointing out (which was more than Richard had done) that Richard already had a girlfriend, Brazilian painter Sylvia Martins. 'They love each other very much,' she explained.

Gere was probably more involved in different aspects of *Breathless* than he had been in any of his previous films. His positive

desire to do the picture in the first place was a major influence in making the film happen and he helped write much of his own dialogue as the picture progressed.

After the sensitivity and introspection of his performance in the previous *An Officer and a Gentleman*, Gere was equally convincing as the broad-shouldered, hyper-physical, impulsive, highly-charged Jesse in *Breathless*. 'I know I'm crazy, I can't help it,' he explains at one point, as if to justify his extreme behaviour to the audience as well as to Monica. And when he kills the cop early in the film there is a fleeting moment when he seems shocked and upset by what he has done. You can well understand how Monica enjoys the danger and excitement of the man. For all its steamy sex, one of the most vivid and compelling scenes takes place in and around an autowreckers yard when Gere fights a couple of guys who know he is on the run from the cops and try to beat him down on the cash value of the car he has taken in.

In the end the movie achieved only moderate ratings, perhaps bitten by the hand of sexuality that was meant to feed it. But equally, it enhanced Gere's personal status as Hollywood's most potent sex symbol. Critics who largely condemned the picture rated Gere's own performance as 'convincing', 'spirited' or even 'electrifying'. Gere *was* the picture. There is very little time when he is not on screen. The general feeling was that the role, not unlike that of Brando in *On the Waterfront* or Travolta in *Saturday Night Fever*, gave Richard the chance to be touching, more open, more vulnerable than any other he had taken until that time. And there was little argument when Ivor Davis in *The Times* declared that Richard Gere was 'the hottest, most desirable commodity in the movies today'.

Certainly looking back, *Breathless* did no harm at all to his personal reputation. It is perhaps surprising therefore that even before the picture went out on general release Gere was trying to down-play, even ditch, his sexy image. He told a reporter: 'It's madness. I certainly could have played characters that focus on sex for the next 10 years and make an enormous amount of money. But I've consciously not done that.' The $1 million Gere was reported to have made from *Breathless* was some consolation. The picture remained in the top ten for much longer than most commentators anticipated.

Yet on the sex theme, Gere had already contracted himself to a role with Britain's Michael Caine, which, if not sexual to the extent of *Breathless*, would have Gere in various stages of undress.

Perhaps the image was proving more difficult to shed than the clothes.

Just three days after completing work on *Breathless*, Gere flew out to Mexico to work on the new picture, called *The Honorary Consul* and based on the famous Graham Greene political thriller written in 1973, with Bob Hoskins as well as Caine in the cast. Much of the film was shot in Mexico, though the location of the picture is Argentina, and by all accounts it was not the happiest of experiences for any of those taking part. Dysentery took its toll almost before shooting started and Gere was extremely unwell after eating in what Caine would later describe as a rat-infested café. It also meant being tucked away in relatively remote parts of Mexico for quite some weeks, but these constraints apart, the picture was seen as a promising vehicle for Greene's exciting tale of terrorism and a clash of loyalties in South America.

Michael Caine starred as Charley Fortnum, a drunken and pathetic small-time official with little self-respect and not much inclination or time for anything or anybody other than his beautiful, much younger Mexican-Indian bride, Clara, played by 21-year-old Mexican actress Elpidia Carrillo, who had made her film debut two years earlier in the Jack Nicholson movie, *The Border*.

Richard Gere played an English-Paraguayan doctor with a very passable English accent, and, despite his second billing, had by far the biggest part in the film. Bob Hoskins played the Argentinian Chief of Police, Colonel Perez. The Greene story, typically complicated, was tailored for the camera by Christopher Hampton and the picture was directed by John Mackenzie, his first international big-budget film after his acclaimed success in television drama.

Gere became intrigued by the character of Dr Eduardo Plarr soon after Norma Heyman (ex-wife of film producer John Heyman and herself now a film executive) sent him a copy of the script after they had met by chance at a dinner in New York. Ms Heyman had first read the book much earlier, since when she had struggled to interest a major studio in the project, but without success. She visualized Gere in the role of the doctor after seeing him on Broadway in *Bent*. He was a big enough name to count in Hollywood and with him included in the package Ms Heyman's ambitious plan to turn the story into a motion picture seemed much more hopeful.

The last segment of the jig-saw, and the most influential in financing the movie, was in place once Michael Caine, already the star of more than forty major feature films with enormous box-office

influence, agreed to take the title role. The picture finally went out through World Film Services with Norma Heyman as producer and was distributed by 20th Century Fox.

At the very beginning of the picture Gere's character, Plarr, is seen driving through the night-darkened streets of a city in North Argentina when he is flagged down by an Englishman urging assistance. The British Honorary Consul, Charles Fortnum (Michael Caine), has drunk himself legless in a local bar and needs transporting home. But instead of going home, Fortnum orders Plarr to take him to a nearby brothel, where the young doctor sees the dark and beautiful Clara and is immediately obsessed. When Plarr later returns to the brothel to see Clara he is told that she has left.

A main thrust of the story, however, is that Plarr is seeking the whereabouts of his father, whom he has not seen for two years. His quest brings him into contact with Chief of Police, Colonel Perez (Bob Hoskins), sporting a thick South American-style moustache and close-cropped hair. The two strike up a friendship.

The story edges forward when Dr Plarr is called in by Fortnum to attend his sick wife and is astonished to find that the wife is none other than the beautiful young prostitute Clara. Some time later Fortnum encourages Plarr to accompany his wife on a shopping trip and it is no surprise that they make love in Plarr's apartment.

The picture allowed Gere to display his versatility as an actor and he gave a sensitive portrayal as a man having an affair with the consul's wife. There was no need for the histrionics of *Breathless* and he underplayed his role of the largely unsympathetic Dr Plarr with conviction.

In trying to find his father, Plarr innocently becomes involved in a plot to kidnap the visiting American Ambassador in order to negotiate the release of political prisoners. The scheme goes wrong and the kidnappers end up with Charles Fortnum as hostage. In trying to escape Fortnum is shot in the leg and Plarr is called in to attend to the wound. Each is dumb-founded to see the other. Plarr then realizes he has been used by the revolutionaries and that all his efforts have been in vain, for his father has been dead for more than a year.

But the main interest of the picture is not essentially the plot, but the characterizations of the principal players and their developing mistrust of one another. Fortnum is seen to be more than the despicable, drink-sodden waster we assess him to be in the early scenes, while the cool, confident Plarr is shown to be flawed when

the pressure becomes intense. And whatever he might have said at the time of the release of *Breathless*, Gere manages once again to star in a picture that occasionally drops in the four-letter word, and in which he himself features in more of those steamy love scenes.

It had been an outstanding achievement for Norma Heyman to fulfil her 5-year dream and bring the famous Graham Greene story to the big screen and it is to be hoped that she was pleased with the result. But Michael Caine's verdict on the picture was not in doubt. Speaking of the experience some years later his mind seemed filled with the difficulties of shooting a picture in Mexico, the illnesses the crew experienced there and the day-to-day problems of getting the film made on a tight schedule and a limited budget.

The three main characters had all been working hard on previous assignments (Gere on *Breathless* in the US, Caine on *Educating Rita* in Dublin and Hoskins on the London stage as Nathan Detroit in the National Theatre production of *Guys and Dolls*), before flying out to Veracruz on Mexico's Gulf Coast where they found director Mackenzie and his British-American-Mexican crew had already been hard at work for three weeks battling away with the usual difficulties of a location far from home. One problem they had not anticipated was the tail-end of a hurricane, which battered the unit and blew down carefully-constructed exterior sets.

Others as well as Gere almost immediately went down with dysentery and other stomach problems while Caine was given aspirin by mistake. The pain-killer, to which he has always been allergic, promptly put him out of action. There was unexpected drama when Caine and Gere decided to get away from the location when a free weekend came up. They hired a small plane and headed for Mexico City, where they were to meet Caine's wife, Shakira, who was flying in from Los Angeles, and Gere's current girlfriend, Sylvia Martins, who had gone on ahead. On landing at Veracruz on their return, they stepped out of the plane into a menacing close circle of soldiers with rifles cocked at the ready. Where they had landed was an airfield known to be used by drug-smugglers and the pilot had some hard explaining to do before Caine and Gere were allowed to go.

The incident is recorded in Caine's autobiography, *What's It All About?*, in which he continues: 'That was the last of anything remotely interesting on this film and after an eternity we flew quickly back to our loved ones.' He went on: 'The picture was not well received anywhere, but when it was finally released in America they hammered the last nail in its coffin by changing the title to

*Beyond the Limit* which not only effectively got rid of anybody who had read the book or was a Graham Greene fan, but also made it sound like a science fiction film.'

Whether the picture was quite such a disappointment artistically for producer Norma Heyman, whose original vision and courage had contributed so much to bringing her project to the screen, was hard to say. Of Gere's contribution, however, she was not reticent. 'Richard has that extraordinary vulnerability that all the best actors have,' she said. 'Under his surface toughness he's terribly sensitive.'

As usual, Gere had little comment to make about *The Honorary Consul* and was soon to be found working on his next assignment.

# 8

# Tough at the Top

International events taking place in the 1950s were destined to have a profound effect on both the personal life and Hollywood career of Richard Gere.

On Monday 22 May 1950, Mao Tse-tung, head of communist China, offered neighbouring Tibet regional autonomy if it joined China. Tibet, independent of Chinese rule since 1911, refused. Less than six months later, on Monday 30 October, Chinese troops were advancing towards Lhasa. On Sunday 9 September 1951, they occupied the Tibetan capital. Subsequent uprisings against the Chinese forces and a continuing guerrilla campaign were estimated by mid-1958 to be costing 300 Tibetan lives a day.

A further uprising in early 1959 was brutally suppressed and on Tuesday 31 March that year the Dalai Lama, spiritual leader of Tibet, disguised as a servant and together with thousands of refugees, fled the country to find sanctuary in the new republic of neighbouring India.

It all seemed far distant from the United States and even more remote from young Richard Tiffany Gere, not quite ten years old at the time the Dalai Lama sought refuge in the mountain retreat of Dharamsala. But the plight of the Tibetan people and their continued oppression under Chinese rule would, many years later, become increasingly central to Richard Gere's life, leading him into the wider issues of human rights worldwide and an honest, religious conversion to Buddhism.

Gere's spiritual quest is said to have taken root when he was in his early to mid-twenties. It is difficult to pitch it more accurately since Gere has steadfastly side-stepped questions about the origins of his religious conversion. Years later in press interviews he would so

often say that he would rather not dwell on the past, that one was left to wonder if giving up the past was part of his newly adopted creed. What is a matter of record, however, is that his feelings intensified in 1981 when he met the Dalai Lama for the first time and, one might say, the conversion was confirmed.

When he started making pictures and became a public figure the doubts and cynicism hinted at by the press and others were not unexpected. After all, he would not have been the first media personality to peddle an unusual hobby or way of life to build and sustain an easily identifiable public image. Except that from the start Gere never promoted his new-found faith; indeed, he almost deliberately tried to keep it private and entirely separate from his professional life. It was impossible of course and he became increasingly irritated and angry to have his motives examined and analysed in public.

But his basic personality was such that he never really bothered too much about what people might think on this, or indeed any other subject. The real issue was that he had become a Buddhist for his own good reasons and was not interested in spreading them around.

As he would explain some years later: 'Okay, I'm a Buddhist. But I don't go around thinking, "I'm a Buddhist", as a way of defining myself, that's not what it's all about.' He went on to say that Buddhism was about learning to see things clearly, learning to be generous in difficult situations, learning where your destructive emotional behaviour comes from and what motivates it. He said in 1993 that a Buddhist gets up in the morning and sets his motivation for the day and that motivation, or meditation, is to be altruistic, to open your heart, to find a generosity of spirit. 'Every day you learn how to do that a little bit better,' he explained.

It was a vague-enough notion for even the average, conventional person to take in his stride. For Hollywood, beset for more than a generation with its own pugnacious, street-cred philosophy, Gere's approach to life was as distant as the Dalai Lama himself. It all sounded a bit freakish at best; certainly not exactly calculated to grip the chattering inner circle of Hollywood's elitist, party-going crowd.

Not that such a denial would cause Gere sleepless nights because, first as a burgeoning Hollywood actor and then later, even when he had become a major star, he shunned the established order of Tinseltown, much preferring to ignore the establishment and live a much more independent, private life. But for the cynics all this new

mumbo-jumbo was a far cry from his earlier, wilder days in New York when, among other perverse activities, he once admitted to urinating in the street.

But his devotion to the Tibetan persuasion increased as time went on, leading to his support for AIDS research and to fringe activities like homosexual and lesbian support groups. He founded Tibet House, the cultural centre based in New York and continued to campaign for an independent, free Tibet. Later he would set up the Gere Foundation for Aid to the Tibetan People.

It became not unusual for him to disappear periodically to the solitude of the Himalayas or to take off unexpectedly for an audience with the Dalai Lama, causing concern about his whereabouts back home. Probably the most notable occasion was in 1993 when his spiritual mission took him to the Tibetan capital of Lhasa itself, where he reportedly travelled around on a rented bicycle while acting as the official representative of the Dalai Lama. It is more than likely that the inner harmony and more balanced perspective he undoubtedly found through Buddhism helped him to accept with a degree of equanimity the ups and downs of his career.

It was a career which, because of the impact of *American Gigolo, An Officer and a Gentleman* especially, and *Breathless*, had been remarkably transformed within just three years. The financial bonanza, which came with the change of fortune, brought increased security and a greater sense of independence. More freely able to move his career in line with his own instincts, he felt no immediate desire to return to the theatre. He did not pretend that pictures could match the special buzz that comes from the response of a live audience. On the other hand, he was enough of a realist to be impressed by the enormous and much wider spread of influence of film. So his conversion to Hollywood as a means of expressing himself as an actor, was virtually complete.

He could now, with greater comfort, be more choosy when picking through the scripts on offer. Film-makers were keen to tempt him into pet projects. More importantly for Gere, his box-office credibility gave him a greater say in the way his movies should be presented on screen. Disappointingly, this did not mean that his choice of material was more commercial. How much he could make from a film was not a real concern when being tempted by a project. Frederick Zollo, who went on to produce *Miles from Home*, in which Gere starred in 1988, defended his choice of parts. 'Richard is a trained actor with a conscience,' he observed. 'He tries through the parts he chooses, to make people think.' It was

certainly not a recipe for making money as *Miles from Home*, with Gere taking a cut in salary to get the picture made, would prove.

Trying to make people think, if that was what Gere was anxious to do in the mid-1980s, led him into a rag-bag selection of films that not only disappointed, even disturbed his fans, but took him on an uncomfortable roller-coaster ride that did little to enhance his reputation as an actor either. To be fair, almost all started out with high hopes of being more than just successful. In the end Gere was fortunate to come through this period with his celebrity persona intact. For women particularly, and in spite of a dismal and disappointing run of largely moderate movies, he was still a star.

Some professional Richard Gere watchers would disparagingly call this period his 'wilderness years', yet no fewer than five of his pictures were released in the five years 1984–8, with Gere seldom far from the studio lot or location site. In 1984 he played the part of a jazz musician at the Cotton Club in New York during the years of the Depression who becomes a Hollywood star. In 1985 he played a shepherd-boy-cum-poet-warrier interpreting the word of God for the Kingdom of Israel in the biblical disaster *King David*. That same year he played a political PR man in *Power* and then in 1986 he converted to a tough Chicago cop in *No Mercy*. The unconventional *Miles from Home*, in which he was one of two brothers who burn down their farm and take to the road, was released in 1988.

They were a mixed bunch, certainly; and even collectively hardly enhanced Gere's reputation as a superstar able to choose the blockbusting material his fans felt he deserved. Of the five pictures, perhaps *The Cotton Club* would become the most memorable. At least the plot was novel in the way it blended fact with fantasy. It was also the first time since moving into pictures that Gere was not the only star turn. But for anyone who enjoys musical movies, there was plenty on offer to be enjoyed in *The Cotton Club*.

Billed as a true tale of Hollywood, the film tells the story of Harlem's famous night club during the notorious era of gangsters, gangsters' molls, show-stopping music and floor-shows in the heady and hectic days of the stock-market crash.

The project had a troubled and anxious birth. Producer Robert Evans stayed at New York's Astoria Studios while preparing to put the film into production and his intention was to direct it himself. He had ambitious plans for the movie, which looked at this point as if it could not fail. After all, Evans had a powerful pedigree of success. After becoming vice-president in charge of production at Paramount Pictures in 1966, and later as an independent producer,

he supervised triumphs like *Barefoot in the Park* with Robert Redford and Jane Fonda, *Love Story* (with Ali MacGraw and Ryan O'Neal), the two *Godfather* films and *Marathon Man* (with Dustin Hoffman). But after running into early problems with *The Cotton Club*, he brought in the vastly experienced Francis Coppola (already a big name for writing *Patton* and *The Great Gatsby*, directing *Finian's Rainbow* and directing and writing *The Godfather* and *Apocalypse Now*) as director and co-writer to master-mind a critical salvage operation. Britain's John Barry was to provide the music. Gere, with sleeked short hair and a black slimline moustache, headed the fictitious characters as Dixie Dwyer, a cornet player who becomes involved with mobster Dutch Schultz, played by James Remar, after saving him from a rival gangster's bullet.

In preparing for the role Gere studied with trumpet master Warren Bache so he could record his own cornet performances, though there was no need for him to do so. The music could quite easily have been dubbed. One unconfirmed report even suggested that Gere's cornet playing was not used in the final cut. Gregory Hines took the part of Sandman Williams; Lonette McKee, who won a Tony for her part in the Broadway revival of *Showboat*, played Lila Rose Oliver; and Bob Hoskins, who was working with Gere for the second time although at that time he was not the well-known actor he is today, played Owney Madden, owner of the Cotton Club.

Schultz was a character who really existed in the twenties and frequently visited the Cotton Club. Dwyer is drawn into the underworld of gangsters and crime, but places himself in the danger zone when he becomes attracted to Schultz's girlfriend Vera Cicero, played by Diane Lane. The script thereafter stumbles along a twisty and messy route mixing parallel romances with tap dancing, jazz music and gangland shootings, giving some substance to the report that circulated at the time that it went through more than thirty drafts even while the cameras were rolling.

In fact, behind the scenes lurked a story every bit as stormy and compelling as *The Cotton Club* itself. Three people on the picture were said to have suffered heart attacks, while dozens more claimed that working on the film was an experience they were never likely to forget or would wish to suffer again. The overall atmosphere was described as continuing confusion and unrelenting tension. Gere is said to have refused to work for a whole week and Coppola simply walked off the set one day and flew to England. Production

designer Dick Sylbert was sufficiently exasperated by the whole experience that he claimed at the end of it all that the movie was like a vampire. 'You'd think, this is it, it's finally got a stake through its heart. But every day it would come out of its coffin.'

Not surprisingly the picture surged uncontrollably over budget. Originally presented as a $20 million 'certainty', it climbed into a hideous $47 million monster gamble, needing to gross $150 million just to break even. It did not have a hope.

Gere had not been first or even second choice for the lead. The part was originally offered to Al Pacino, who turned it down because he said the project was too much like *The Godfather* and *The Godfather, Part 2*, in which he had appeared. Next in the frame was Sylvester Stallone, who made a tentative commitment to do the film for a fee of $2 million. But when one of Stallone's associates came back later suggesting that a more realistic fee would be $4 million, the deal was quickly aborted.

Producer Robert Evans then targeted Richard Gere, who was unhappy at first with the script. Evans was pressed to satisfy and secure the star without delay while he had the chance, for Gere was already contracted to do *King David* for Paramount within the year. But the situation looked bleak once more when Gere, after looking at some early re-writes, said he was still not happy and, more to the point, was no longer sure he wanted the role anyway. He then threatened to leave the project unless some changes were made to his character. He wanted Dixie Dwyer to be a trumpet player and for him to run out at the end of the picture as a good guy. A tense and pressured Evans quickly agreed and was happy to cross Gere off as perhaps the most major of his many problems solved.

But Gere, who always likes to work from an orderly, well planned base and to have enough time to be in full control of all his scenes, found it difficult to work with Coppola, who was furiously writing the script and incorporating changes as the picture went along. There were angry scenes amid the general confusion and when Gere stormed off the set the situation was sufficiently serious for urgent top-level thought to be given to a replacement, Matt Dillon being identified as a possible target. But the storm blew over and Richard went back to work after his lawyer negotiated new terms, which assured the star of at least $3 million from the picture as a basic contract deal; and there was to be, reportedly, an additional $2 million if the picture ran much past its deadline.

It did to such an extent that when Gere was called back for his final scenes he had grown long hair and a beard for his role in *King*

*David*, his next picture. His final close-ups for *The Cotton Club* had to be filmed later. Hoskins ran into similar problems. His head had been shaved ready for his next film in which he would play Mussolini, the Italian dictator. He wore a wig for his final scenes for *The Cotton Club*.

The project ran perilously short of cash a number of times and the miracle is that the picture was ever completed. Yet despite all the chaos and confusion *The Cotton Club*, with over forty songs and musical numbers in the final credits, the colourful floor shows, which were a vital part of the entertainment of this once famous nighterie, and the characters based on such jazz luminaries of the time as Duke Ellington, Lena Horne and Cab Calloway, was, musically at least, a vibrant and an interesting and entertaining movie. Among the classic jazz numbers featured were 'Running Wild', 'Am I Blue?', 'Blowing Me No Good' and 'Crazy Rhythm', while dance enthusiasts would be enthralled by the expertise of members of the 'huffer's club'.

It is a pity that Gere so often appears to be disappointed with the outcome of his films. Of *The Cotton Club* he said that he went into it wanting to do a story about a white man who wants to be black, a cornet player who wants to play with a black group. This, he claimed, would have given the script energy and a reason to have a white man in the story. But it never happened. 'It's a shame that idea got lost in all the rewrites,' he lamented. *The Cotton Club* fell well short of being a hit. It had a patchy response, though Gere gave a competent performance in a generally undistinguished offering.

*King David* followed hard on the heels of *The Cotton Club*, having been delayed by some four months due to the over-run of *The Cotton Club*. Gere was probably tempted into the part because he received the original script, which was written by the Englishman Andrew Birkin, from Marty Elfand, who had done a good job producing Gere's successful *An Officer and a Gentleman*. But the original version was a huge tome, which was perhaps fortunate to survive at least ten further drafts during its painful conversion into something manageable as a picture.

Gere was also biased in its favour because Bruce Beresford, the Australian-born director and writer whose movies he much admired, was already pencilled in to direct the movie. The project presented Gere with probably his biggest challenge to date and there was no shortage of ambition when work began on the picture, to be distributed by Paramount. A considerable budget of $20 million had been set aside for the project, which had been in

discussion for years as a follow-up to the biblical epics of yesteryear. Initial shooting had been scheduled for Pinewood Studios in England with location work planned in Italy and North Africa.

Richard had his own definite views on how the story should be presented – 'we tried to avoid over-poeticized spiritual digressions and the kind of style typified by the Biblical engravings of Gustave Dore,' he explained, citing just one example of the approach being made to a story that at best would not be all that easy to make convincing in popular terms.

But in spite of all the good intentions and earnest desire to produce a sensitive and coherent documentation, the result was widely condemned by critics for being inept, confused and, in one case, 'astonishingly tedious'. There might also have been something in the idea put forward at the time that it was a film that was trying to recapture something of the Biblical epic, a hallowed movie genre made famous by Cecil B. DeMille too many years before, that was not ready for a resurrection. On this basis it was certainly expensive and misguided. In *King David*, Gere ages from twenty-three to seventy and looks disgustingly handsome at both extremes though is hardly convincing in later scenes, simply because of his age. The ramifications of the film, in which Gere is seen as a shepherd boy, outlaw, king and traitor, lover and spiritual seeker, along with the fundamental nature of the story, were insufficient to save it from an early demise.

British actors Edward Woodward and Denis Quilley, along with actress-model Cherie Lunghi, well-known later for her Kenco coffee commercials on British television, were included in a formidable cast. To prepare for the part Gere had taken himself off to the Atlas mountains on the end of the Sahara and somehow managed, with the aid of his guide, to negotiate safe entry into a Bedouin tent, not always an altogether sensible move to make. Not being Jewish, Gere did his best to absorb what being Jewish might mean at that time. He reckoned his portrayal of King David was the most challenging of his career up to that point. While on location in Italy he was visited by a group of British stage actors. Niall Buggy, a National Theatre player who was working on the picture, told a reporter: 'Richard is the most generous actor I've ever worked with. We were naturally in awe of him, but he didn't want to be treated like a star. In a scene where his son Absalom is killed he broke into tears and I found myself standing on the side in floods of tears too.' Gina Bellman, a 17-year-old Londoner who played Gere's daughter in the picture, loved working with him. She said they joked a lot,

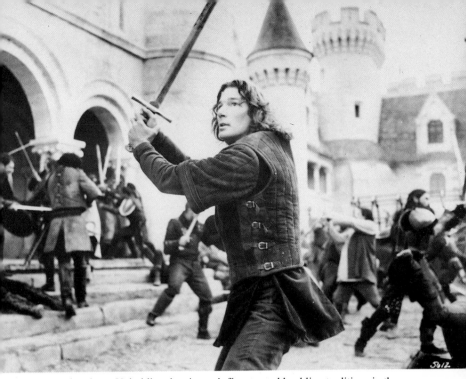

The modern hero. Upholding the cinema's finest swashbuckling traditions in the 1995-released *First Knight*

A fifteen-minute appearance with Diane Keaton in *Looking for Mr Goodbar* in 1977 made an enormous impact and defined Richard Gere's future star status in only his third film

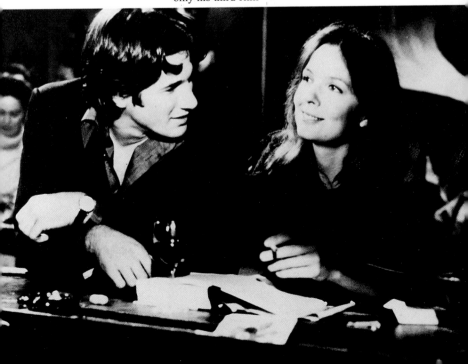

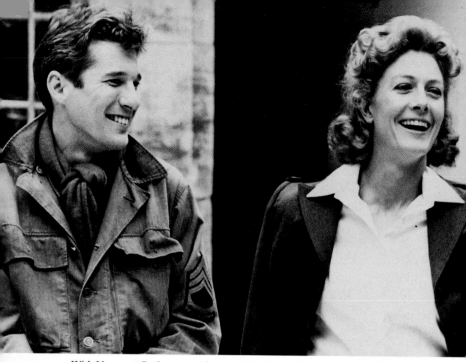

With Vanessaa Redgrave on the set of the World War Two drama, *Yanks* (1979).
The picture projected Gere unequivocally into mainstream movies

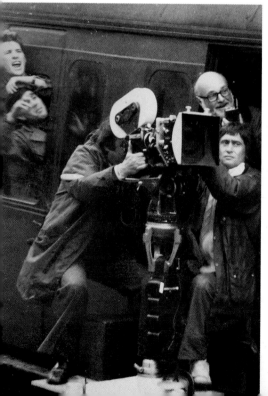

Much of *Yanks* was shot on
location in the north of England.
One of the many local people
involved as 'extras' shot this
picture

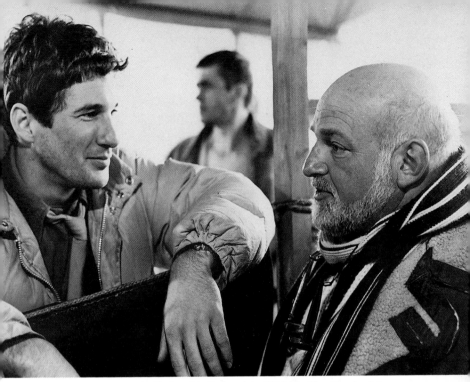

Talking over a scene in *Yanks* with distinguished British film director John Schlesinger. Gere won the part against Pacino and Hoffman

*American Gigolo* (1980) established Gere's credentials as a fully-fledged sex symbol. He emerged from the picture as one of the most exciting actors in Hollywood

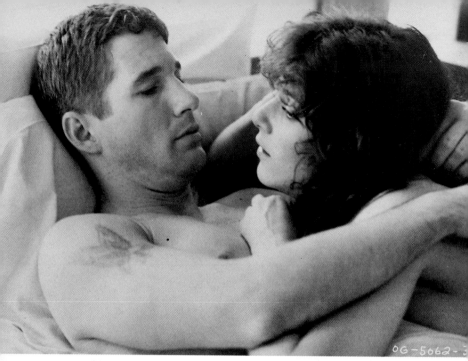

With Debra Winger in *An Officer and a Gentleman* (1982). Their intimate love-scenes were tender and sexy, but off-screen their relationship was reportedly tense

Giving one of his best-ever performances as the embattled officer recruit Zack Mayo in *An Officer and a Gentleman.* He missed out on the Oscar many felt he deserved. The picture became an unexpected blockbuster and confirmed his status as one of Hollywood's top actors

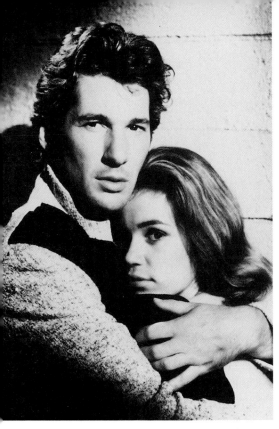

In 1983 *Breathless* consolidated Gere's sexy image in an American-based version of the original French classic, *A Bout de Souffle.* His co-star was the beguiling, 19-year-old French newcomer Valerie Kaprisky

The steamy sex scenes and Gere's much publicized full-frontal shower sequence in *Breathless* made the headlines

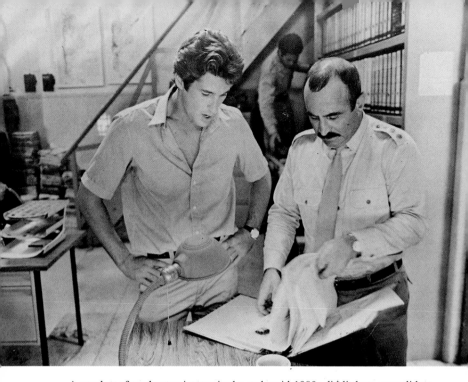

A number of moderate pictures in the early mid-1980s did little to consolidate
Gere's reputation. In the British-made *The Honorary Consul* (1983) he
appeared with Michael Caine and (pictured) Bob Hoskins. *Below* a scene from
*Power* (1985), in which Gere, complete with dark moustache, co-starred
with Julie Christie and Gene Hackman

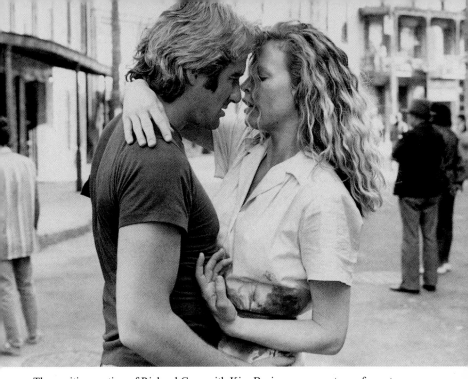

The exciting casting of Richard Gere with Kim Basinger gave a strong focus to *No Mercy* in 1986

Handcuffed together in the Louisiana bayou. Gere and Basinger in the detective thriller *No Mercy*. He rode with Chicago's undercover cops in researching the role

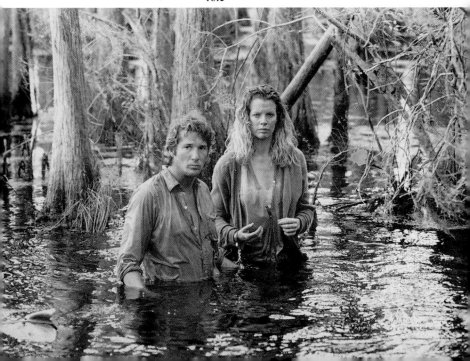

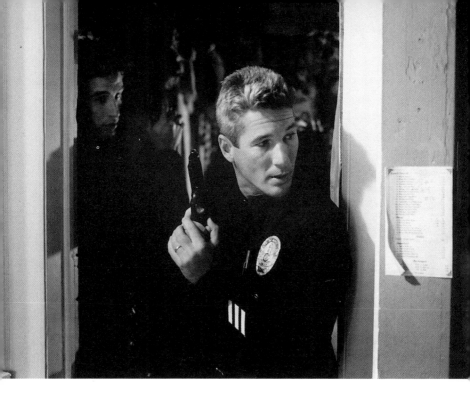

Two major movies released in 1990 re-established Gere's superstar status. In *Internal Affairs* he played a tough psychopathic cop in a tense thriller which also starred Andy Garcia

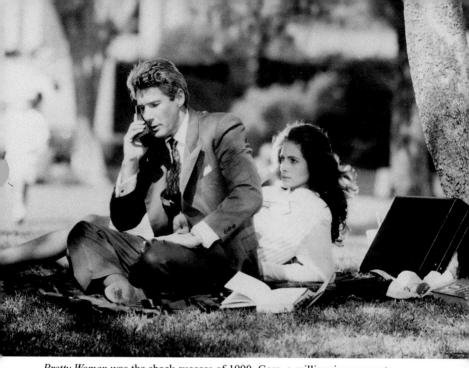

*Pretty Woman* was the shock success of 1990. Gere, a millionaire corporate business mogul, co-starred with mini-skirted hooker Julia Roberts

The cool chemistry between Gere and Roberts had much to do with the enormous success of *Pretty Woman*. It eventually grossed more than $450 million worldwide

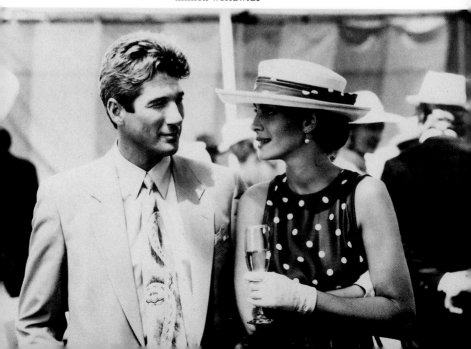

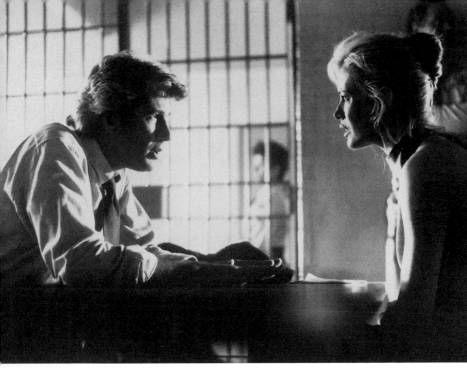

*Final Analysis* (1992) brought Richard Gere and Kim Basinger together again in a taut psychological thriller. The plot was full of tense intrigue with Gere caught in a sisterly conspiracy

With Jodie Foster in the 1992 film *Sommersby,* he produced a sensitive performance in a challenging role as the plantation owner who returns from the Civil War a changed man

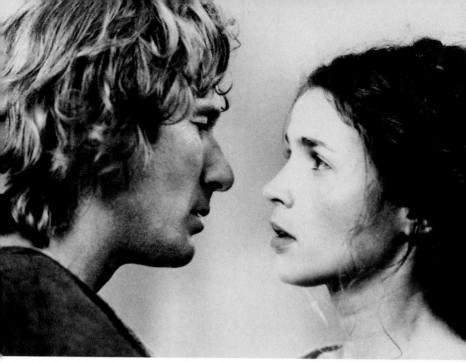

The latest in a long line of captivating co-stars. Britain's Julie Ormond was beautiful Guinevere to Gere's Lancelot in *First Knight,* the latest King Arthur story, released in 1995

Talking about Survival (a worldwide organization supporting tribal peoples) in London at the celebrity opening of Harrod's famous sale in 1995

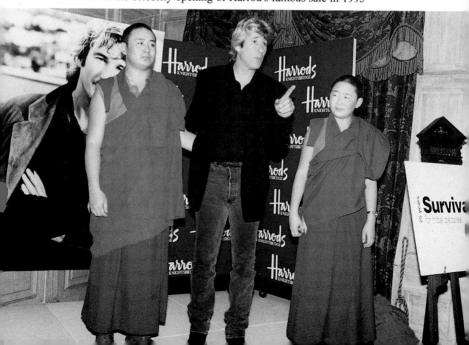

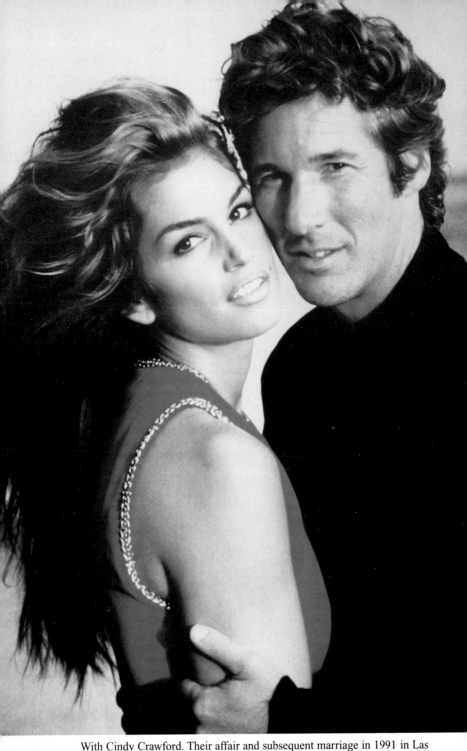

With Cindy Crawford. Their affair and subsequent marriage in 1991 in Las Vegas made headlines round the world

kidded around and he was very protective of her too. *King David* was released in the summer of 1985 and was summarily put aside as one of Gere's most conspicuous failures. It represented the third dud film on the trot for Gere, yet he was now in the middle of one of his busiest, if not altogether his most creative or successful, periods with two further pictures released in the following two years.

*Power* saw him co-starred with Julie Christie; *No Mercy* with Kim Basinger. Of the two, perhaps *No Mercy* made the bigger impact, though neither would significantly enhance Gere's career in the opinion of the critics. Nor were they exactly a sensation at the box office. *No Mercy* struggled to reach a tepid eighth place in the charts and rapidly fell from even that undistinguished position. Certainly, it was nothing to write home about for the superstar.

In *No Mercy*, Richard played Eddie Jillette in what was billed as 'an exotic romantic thriller about a tough Chicago policeman trying to track down the man who killed his partner'. As the blurb said: 'His travels take him to the Louisiana Bayou, to a vicious criminal named Losado and a beautiful Cajun woman named Michel (played by Basinger), who is Losado's mistress. Torn between the two, the mysterious, sultry Michel can follow Cajun custom and protect Losado, or help Eddie with whom she has fallen in love. But whatever she decides, there is ... No Mercy.'

Director Richard Pearce offered a reason for Gere's interest in the project, perhaps initiating a view that others would later share: 'Richard is a major John Garfield fan and Eddie in *No Mercy* is in many ways a contemporary version of the kind of character Garfield often played in the 40s,' he suggested. Gere's own explanation was more psychological and involved: 'I'm drawn to characters whose façades break down to reveal their essential selves and Eddie is one of those characters,' he said. 'He's a tough guy living in a rough world with rough rules, but a damaged tough guy for all that – and because of a bad marriage in the past, he is sceptical of women. I think that the title, *No Mercy*, is very indicative of the way life has treated both Eddie and Michel.' He went on: 'As the film shows, when he and Michel, the most unlikely people in the world, are thrown together and their defences relax, Eddie begins to lean towards love and to learn how to express it.'

Much of the picture was shot on location in Chicago, the crew spending three weeks there, and Gere maintained his reputation for 'heart and soul' involvement in any project he takes on. He thought and read about the role and his practical research included spending many hours riding with Chicago undercover cops, sometimes

visiting the city's seamiest and most violent neighbourhoods.

The other location was New Orleans, the city's vibrant French quarter becoming the scene of Eddie Jillette's search for Michel. It was Gere's first time in the city, where part of a tourist information building was converted into a police station. What is seen in the picture as the elaborate Blue Parrot Club, was constructed in the grounds of an empty warehouse in mythical Algiers, across the river from New Orleans. It was Basinger's performance in the dance scene in the Blue Parrot Club that, more than any other sequence, secured the part of Michel for her. Producer Constantine Conte explained: 'For this scene particularly I felt we needed a totally modern equivalent of a great 40s star in her most famous role – namely Rita Hayworth in Gilda. I felt Kim Basinger was an actress who could generate the kind of excitement that Hayworth did and who could also meet the other demands of the part.'

Basinger, incidentally, served a serious, full apprenticeship in the business and is not the superficial bimbo her ravishing looks might suggest. She apparently sings well, plays piano and guitar and also, following fifteen years of ballet training, is an expert dancer, though her ambition was always to become an actress.

Director Richard Pearce, who became committed to the swiftly moving story with its layered characters, worked closely with producer Constantine Conte, writer Jim Carabatsos and Richard Gere in the development of the shooting script and scouted numerous locations before settling mainly on Louisiana and North Carolina. But the picture, disappointingly for all concerned, never advanced much beyond first base, though Gere and Basinger fans would not be slow to claim that, no matter what the critics might say, *No Mercy* deserved to fare better than it did at the box office.

The same could be said of *Power*, which had Sidney Lumet, with an enormously impressive list of pictures to his credit stretching from the late 1950s, as director. The equally talented Cy Coleman was in charge of the music. Gere sported a slightly thicker moustache this time in a tale that intertwines politics and sex, with Gere starring as Pete St John, a consultant and specialist in shaping public profiles. He is the perfect manipulator, but discovers that the tables are being turned on him. Julie Christie is Gere's ex-wife and an investigative journalist on *The Washington Post*; Gene Hackman plays his former partner and mentor; Kate Capshaw is cast as St John's assistant and casual bed partner; and E.G. Marshall and Denzel Washington are also in the cast. *Power* had started life as *Special Elections* with Burt Reynolds tipped as the star, before Gere was cast.

Watching both *Power* and *No Mercy* a decade after their initial release, it is hard to say just why they did not pull in bigger audiences. Gere increasingly showed that he was a commendable actor well capable of holding down roles other than those highly physical parts that had rocketed him to stardom a decade before.

Gere's ninth and last film to be released in the 1980s, *Miles from Home*, a more prosaic tale put out in 1988, surprisingly did better with both the critics and the public.

Gere anyway, set his own criteria and worked to his own high standards, always being attracted more by characters and the interplay between them, than by action or even plot. What caught his attention with *Miles from Home* was simply that it was, what he called, a 'brothers movie'. He said he liked a close relationship feel to things and, perhaps above all else, it struck a personal chord with him, taking him back to the time as a kid he would go down to his grandfather's farm to help out.

The picture is about a couple of brothers, the other played by Kevin Anderson who three years later would star in the Julia Roberts blockbuster, *Sleeping with the Enemy*, who inherit a farm, which their father has spent his life building up, but developers want to take over. Rather than let that happen they burn the farm down and go on the run; the picture then focuses on the changing attitudes of the brothers to each other. It was mainly the storyline that fascinated Gere and he quickly agreed to join the project after reading the early treatment of the story.

On a wider issue, it is interesting to speculate on how Gere's attitude to film selection might have affected his movie career. He gives the impression of being perfectly content to go along planning a movie at a time, responding to themes and situations that attract his interest. He seldom seems to have the will, discipline or inclination to choose his work on the basis of either cash or a career move. It is doubtful if Gere himself could recall just how many projects, and which, he turned his back on because they simply did not excite or interest him. Nor is there any real evidence to suggest that making the enormously financially successful *Pretty Woman*, which was still to come, made him any happier than *The Cotton Club*, for example, or *Power*.

In these ways the man is probably unique among the superstar élite, an outcast in Hollywood where your social rating is so often influenced by the success of your latest movie; and the more blockbusters you can contrive to make, the better. But then in Gere's scheme of things, Hollywood is not much of an issue either.

He had never felt a part of all that.

He explained at the time of *Miles from Home* that the picture gave him the chance to explore how he felt about things. He said he had been looking for a country story about farms and farming and he was attracted as soon as he started reading the script. He told *Film Review*: 'It struck a chord in me. Not just because my father was a farmer, but also because my mother was a smalltown girl too. There were just 200 people where we lived.' He went on: 'It seemed really important to make an adult connection with my mythic memories of my background – the farm and the animals. To re-examine them with adult emotions and through adult eyes.'

What also appealed to him was the distinct similarity of backgrounds between his character's and his own. He said that the picture gave him the chance to explore how he felt about things, although he did not share his character's aggressive instincts.

During the eighties especially, Gere's interest in Buddhism and the support of certain causes would develop into a commitment and dedication of real strength. This obviously had some bearing on his attitude to life and was probably responsible for the way he felt about making the sort of movies he wanted to make, without too much thought on how much money he could make out of them.

But for all that, an alignment of the two has become more evident with the passing years. Buddhism, for instance, which was founded as a non-theistic religion and philosophical system in north east India in the sixth century BC, teaches that greed, hatred and delusion separate the individual from the true perception of the nature of things and that the apparent substantiality of all objects, including self, is illusion, and that everything mundane is impermanent and ultimately unsatisfying; though Buddhism today manifests itself in many different forms.

But there was perhaps a revelation of sorts in comments made by Gere at the time *Miles from Home* was released when he talked about the kind of pictures he wanted to make in the future. He said that as many as half of the future projects he had in mind were to do with human rights situations. He would not argue if they happened to turn out to be commercial successes, he said smiling, then added: 'But it's breaking barriers, expanding mind and heart that I'm really committed to now.'

Explaining his then current film-making philosophy he said that he would ask himself before deciding on a film whether he really wanted to live with knowing he had made it. 'I ask whether it's worthy of the sort of legacy I want to leave behind me,' he said,

adding that if he can impress himself, then there is a good chance that he can impress someone else.

But other forces had gradually begun to infiltrate the business of movie-making that could possibly influence Gere's uncompromising attitude when deciding which pictures to make. The costs of putting a picture into production were spiralling and backers were becoming increasingly sceptical about adding unnecessarily to the financial burdens, preferring to go along with the safer options. Gere had acknowledged this situation some years before when he said that if he did *American Gigolo 2* or *An Officer and a Gentleman 3* he would have no problem. 'But step outside your niche, your successful niche, and there's trouble,' he added. 'And that applies no matter how big a star or director you are.'

Gere had developed an effective escape-hatch to counter such irritations. The foothills of Nepal were an astonishing leveller for the human spirit. When it first became known that Richard Gere was a practising Buddhist dedicated to supporting the cause of oppressed people, the jokey reaction almost stretched to the point of ridicule. After all he was the screen's major sex symbol and more than happy, it seemed, to take his clothes off for steamy scenes with glamorous co-stars. Yet events have shown just how far ahead of his time he was in taking the road to Tibet.

For as Buddhism lost ground in its traditional homelands, support for the Dalai Lama and his oppressed peoples has been little short of phenomenal in the Western world. And when in 1995 the Dalai Lama celebrated his sixtieth birthday, there was ample evidence of an astonishing 'celebrity surge' of support from both America and Britain. People like John Cleese, Harrison Ford, Sharon Stone, Koo Stark, Jonathon Porritt and Glenys Kinnock were among an exclusive army happy to be openly associated with the cause, with Gere still solidly in the vanguard of the advance.

He and Koo Stark organized an exclusive fund-raising dinner for just a hundred selected guests at London's Grosvenor House, each guest paying £150, and again in London, Gere later officially opened Harrod's famous sale by writing a cheque for £250,000 made out to the Gere Foundation for Aid to the Tibetan People. And it was Gere, so the story goes, who persuaded an apron-dressed Sharon Stone to feature in a 'Cook for Peace' event by preparing something called *dyesee*, a sweet pudding that is eaten in Tibetan monasteries.

Never before had the Dalai Lama garnered such high-powered, public profile support. Koo Stark revealed how her involvement

with Tibetan Buddhism and the Tibetan community in exile had become an active part of her life. Harrison Ford, reputed to be in the $10 million fee bracket, was said to be willing to do voice-overs for free on films that exposed the cruelty of the Chinese in Tibet. Photographs of the exiled Dalai Lama with celebrities like Gere, Cindy Crawford, Joanna Lumley and even John Major, became relatively commonplace.

The boom in Tibetan Buddhism since the Dalai Lama fled to the foothills of the Himalayas in India in 1959 has been little short of explosive. But there are those who caution against this continuing tidal wave of celebrity support, fearing a backlash. Tim Bell, administrator of a Tibet Support Group warned in 1995: 'If a cause becomes a fashion thing, the balloon can burst and supporters may move on.' There is also the danger that some celebrities could use their connection with the charity events to gain publicity for themselves.

Meantime, Gere continues his one-man crusade with a subtle zeal and 'resistance-fighter' intensity, giving the impression perhaps that he would willingly eliminate the popularity the movement has acquired with celebrities and the increasing publicity it receives, if there was a more subtle way of promoting the cause as effectively.

He, perhaps more than anyone, knows the extent of the oppression suffered in Tibet. Disinclined to make public statements about himself and his private life, he will eagerly tell you about the million-plus Tibetans who have died of starvation since the invasion by China in 1950; how their religion has been outlawed, their children taken from them; and the abortions and sterilizations enforced by the authorities. He campaigns fearlessly, his courage never in doubt. Remember the Oscar presentation ceremonies in 1993? His candid and impassioned speech supporting Tibet, which he has never publicly regretted, resulted in his summary expulsion from the Academy of Motion Picture Arts and Sciences.

For Gere, the story of Tibet is the story of stark, depressing and inhuman reality, which is as vivid to him today as it was twenty years ago. To him it is not a fad or a fashion and he willingly takes the crusade into his own homeland, most recently with more than twenty of his own evocative photographs taken on his travels to Tibet between 1983 and 1993, which he placed on public exhibition in Los Angeles, the very heart of Hollywood.

# 9

# Nineties' Box-office Star

Richard Gere was forty in August 1989. If there had been little to excite his loyal supporters in recent times, they could at least take some comfort from having seen their hero on screen more often than at any time in the past. And significant shifts in his career were none the less quietly taking place.

His latest pictures, though hardly inspirational, had done little to damage his long-term reputation. From *The Cotton Club* to *Miles from Home*, his competent and sometimes sensitive performances in a variety of roles had shown, if nothing else, that he could at least do more than take his shirt off and unzip his flies; even if as some sort of sex icon he could still do both better than most.

Much more significant was his signature on a couple of films, which would bring him back into the big-time in spectacular fashion. Both pictures would be released in the UK within a week of each other, in May 1990.

After *Power* and *No Mercy*, Gere had lost himself in self-imposed exile. His professional decline had taken hold after *An Officer and a Gentleman*, only gently at first with *Breathless*. *The Honorary Consul* deepened and accelerated the process, which was only marginally and temporarily stemmed with the release of *The Cotton Club*, before plunging close to self-destruct free-fall with *King David*.

Not that Hollywood had given up on him. Limato continued to put scripts before him, but they were not what he wanted. It was hard to see exactly what he was after. The legacy of sex-symbol, linked to deviant or sleazy roles stretching back to *Goodbar*, persisted. He certainly did not want that any more. In fact he had been trying to shake himself free of it for some time. The making of

*Power* and *No Mercy* seemed to be little more than interludes in a life-pattern that began to focus more strongly on the emotional issues of life. His growing concern for the fate of the oppressed people of Tibet led to wider issues of human rights in South America and elsewhere. Against this deepening emotional involvement, the process of film-making was stripped of much of its magic. He did not seem all that interested anymore.

His two-year opt-out was only temporarily and timorously halted with the release of *Miles from Home*. Neither Gere nor anyone else saw it as a major come-back. The picture had been mounted as a low-budget, fairly inconsequential affair and while Gere played up the fact that he had done it because he was interested in the part and the story touched a chord from his own childhood, he was said to have been talked into doing it by his director and friend, Gary Sinise. On that basis it was a remarkably good movie, though not one to excite a mass audience.

Another problem was the kind of movies that were now gaining a big following. Pictures that could have sparked Gere's interest had suddenly fallen prey to the new blockbuster phenomenon. While Gere's *King David* was being released on an unresponsive world, Stallone and Schwarzenegger were amassing fortunes and smashing box-office records with *Rambo, The Terminator* and *Conan the Destroyer*. These comic-book fantasies were a universe away from Gere's established genre or the sort of pictures he might have wanted to make. But even some of the more traditional names were making the effort to cope with the change; and doing rather well. Swayze was already into *Dirty Dancing*; Mel Gibson into *Lethal Weapon*. So there was plenty going on in Hollywood. Richard Gere just was not part of it. The new pictures with their paper-thin storylines, over-blown imagery and galvanizing action left him unimpressed. It was not that Gere had been forgotten. He just was not interested.

In the year that *Miles from Home* was released, *Die Hard* was set to become an enormous hit for Bruce Willis. The success of this powerful action movie, full of suspense and special effects, spawned a first highly lucrative follow-up just two years later.

Yet Gere had flatly refused to do *Die Hard*.

Only when they found it impossible to persuade him to change his mind did producers Joel Silver and Lawrence Gordon turn to Willis. In 1987, only two years after the release of *Power* and one year after *No Mercy*, *Wall Street* was the big, big movie. This top-profile story of financial chicanery at the highest level became an enormous hit

worldwide and brought Michael Douglas an Oscar as best actor of the year.

Gere had also turned down Douglas' part in *Wall Street*.

He seemed unperturbed by his own kamikaze attitude. He simply dropped out, directing most of his concentration, effort and energy into his involvement with the Dalai Lama and a widening concern for the impoverished, persecuted and disadvantaged people of the world. Gere's withdrawal, in film terms if in no other way, had enabled the adrenalin to drain from his naked, sexy image. The stark reality of those earlier roles with which he became so strongly identified did not seem quite so vivid any more. And moving into his fortieth year he was perhaps, in image terms, not quite the adventurous, virile, earnest, instinctive, cavaliering lover of *Goodbar, Gigolo*, and even *Breathless*. But maybe he would soon prove to the most ardent cynics that he could actually act a bit as well.

When all seemed lost there materialized an astonishing turn of events, which would thrust Gere back on the scene with remarkable impact. Paramount had a tempting thriller waiting to go into production called *Internal Affairs*, to be directed by British-born Mike Figgis, a one-time member of a rock band who later toured with an experimental theatre group. Figgis then made his mark with a British-made television movie called *The House* before moving into moody thrillers on the big screen with *Stormy Monday*, featuring Melanie Griffith, Tommy Lee Jones, Sting and Sean Bean, which was released in 1987.

The studio considered *Internal Affairs* a highly promising vehicle with the potential to be a money-spinner. They intended to give it full backing. Figgis needed a big name for the starring role of a tough cop who is also a psychopath. Early reports tipped Mel Gibson as a front-runner; then Kurt Russell. Gere was not even aware of the picture at this stage and was taken aback when his agent asked him if he was interested. Typically, he was uncertain. He wondered if such a hard-nosed character who, although an accredited American cop but who is not beyond bending the rules for his own ends, would be right for him at this stage of his career. Frankly, almost any role would have been right for him. His career was desperate for better exposure and this was a high-profile role in a major picture at a time when he was by no means big box-office. He had already turned down too many opportunities. Rumour had it that he rejected *Internal Affairs* several times, unsure about his ability to fit the character. Pressed once more, he agreed.

Eighteen months later he would chronicle the background to his change of heart and how he interpreted this lean period. 'Last year I looked around and asked myself why I wasn't being offered certain movies anymore,' he said. 'There was a point where I thought the courageous thing to do would be to get out of the business, but then I thought: no, the courageous choice is to stay in the business.'

*Internal Affairs* started shooting during 1989. It signalled the beginning of one of the most remarkable transformations in Gere's entire career, for it was while he was still working on that important movie that he was first approached about a further project, which at that stage had the working title of *Three Thousand*. Julia Roberts, meantime, had been approached about the female lead in *Three Thousand*.

At the time Roberts was almost as much in need of the impact a really successful movie could provide as Gere and, remarkably for a while, both teetered on the edge of missing out on a move that would probably turn out to be the smartest of their respective careers.

Roberts, born in 1967 and 18 years younger than Gere, had been introduced to the performing arts as a child by her parents, who ran theatre workshops in Atlantic City. Just three years after her graduation the tall teenager headed for New York looking for a career in showbiz. Then, in the best traditions of Hollywood, a talent scout is said to have spotted her walking along the street and recommended her to actor's agent Bob McGowan. To him her acting experience was zero and her professional c.v. non-existent, but the sight of her flowing good looks and 5ft 9in presence was all the potential he needed to take her on.

But she did not quite become a star overnight. It took the influence of her then more famous elder brother, Eric, already an actor, to kick-start her career. He roped her in to play his sister in an insignificant, low-budget Western called *Blood Red*. It did not even achieve a picture-house release, but managed a salvation of sorts when put out as a video some time later.

She did better in 1988 when she appeared in *Satisfaction*, a movie originally made for cable TV. But the really important break came that same year when she appeared in *Mystic Pizza*, about three young women experiencing love and affairs for the first time. She showed strong potential as a raunchy and rebellious working-class girl employed in a pizza parlour, winning good notices and the attention of casting directors.

She then seized her big chance alongside an array of established

talent including Shirley MacLaine, Sally Field, Daryl Hannah and Dolly Parton in *Steel Magnolias*, released in 1989. Her lucky break had come when producer Ray Stark was looking for a replacement for Meg Ryan, who had opted for *When Harry Met Sally*, in preference to *Steel Magnolias*. Roberts read for the part three times and, with surprisingly little opposition, was an obvious choice.

This picture, which according to Halliwell 'was a slickly made, sentimental account of marriage and motherhood that provided some meaty roles for the assembled actresses', proved to be a strategic move for Roberts who, despite some formidable acting competition in a highly talented cast, secured a Golden Globe award and an Oscar nomination for the best supporting actress.

There were differing views about Roberts' next move. One story says she decided to take time off until the right project came along. Another says she committed herself just as soon as *Steel Magnolias* finished shooting, to a project called *Beyond Reasonable Doubt*. What is beyond reasonable doubt is that a competing forthcoming movie from Disney subsidiary, Tombstone Pictures, which then carried the working title of *Three Thousand*, captured her interest; and the interest developed into a near obsession, for she stuck with this later project even when faced with a lawsuit for pulling out of *Beyond Reasonable Doubt*.

But if Julia Roberts was right for *Three Thousand*, as so conclusively would prove to be the case, Tombstone were not convinced. It took them all of three weeks to exercise their option on her, and only took the decision to cast her as streetwise Hollywood hooker, Vivian Ward, on the very last day.

*Three Thousand* would, of course, become *Pretty Woman*, the relevance of the working title being that $3,000 is the price, in the movie, that Roberts would charge Gere for a week's entertainment.

But meantime, Gere had been even closer than Roberts had been to slipping through the net. His roles so far did not qualify him as a natural choice for the part of the millionaire corporate mogul Edward Lewis in a romantic comedy not unreminiscent of an updated *My Fair Lady*. Even so, he was, apparently, director Garry Marshall's first choice for the male lead, but he showed little interest. 'It was not the kind of movie I do,' he commented after Disney's Jeffrey Katzenberg sent over the script for him to see. He had earlier mentioned to Gere that it was a kind of cross between *My Fair Lady* and *Wall Street*, so Richard had expected songs. 'But there were none,' he said.

Meantime, Roberts was left waiting while the search for her

co-star went on. Al Pacino and Sean Connery, some said Sting too, were considered before the focus turned back to Gere. This time Roberts and Marshall pleaded their case by flying over to New York to see Gere personally. Marshall then admitted that Gere had not really been his natural choice, being unable to see him convincingly in light comedy, it not being his image. 'But I was surprised by his love of comedy. He's very witty and likes to tell jokes, have a good time and fool around,' he said. Marshall and Gere were no strangers to each other, having first met when Marshall's actress-director sister, Penny, had introduced them in New York at about the time of *Bent*.

Once the deal had been done Marshall, Gere and Roberts worked together improving the script, Gere claiming that his part was initially underwritten. He said that in the original interpretation Edward was a user. He could not communicate. He had no sense of irony. What helped to clinch the deal, reputedly worth a basic £1 million to Gere, was that Gere and Marshall seemed to get along well together and that Gere had seen a tape of Julia in *Mystic Pizza*. 'I hadn't seen her work before and she was terrific,' he said, adding: 'I was never interested in this type of movie before,' going on to say that he made no pretence of being a comedian in the role. 'It's the situations in the script that are funny.'

Gere explained when the picture was released. 'My character is a corporate pirate. He buys companies, breaks them up and sells off the pieces for huge profits. I think the beauty of the story is watching my character and Vivian escape and expand in their respective worlds.'

Gere added: 'It's really about two people who are very similar.' As Edward says to Vivian in the picture, 'We both screw people for money.' Gere continued: 'They're both business people; they both make deals. That's how they contend with the world. It's about finding love in unexpected places.'

*Pretty Woman* would ultimately benefit from a lively, well constructed, sometimes sensitive and often funny script, and was remarkable, as a 40s-style romantic comedy, in being able to embody widespread up-to-date appeal and outstanding success at a time when Hollywood had been almost engulfed by an outpouring of heavy, all-action movies.

The simple, easily-assimilated plot has Richard Gere as Edward Lewis, a successful businessman visiting Los Angeles. His girlfriend has just broken off their relationship and the millionaire mogul has driven off in anger in his lawyer friend's Porsche. He loses his way

not far from Hollywood Boulevard and asks directions to his Beverly Hills hotel from Vivian Ward (Julia Roberts), suitably hooker-attired in thigh-high boots and mini-skirt. She shows him the way, for a fee, and at Edward's further invitation, spends the next hour with him, also for a fee, though to her astonishment no sex is required. He is in town to finish a deal and needs a female companion to help him pass the time and be his social escort. An arrangement is struck whereby Edward hires Vivian for a week for $3000.

He has so much money that the extensive use of his credit cards seems to be a reasonable part of the deal for both of them. Insufficiently sophisticated and certainly anything but the sophisticated wife or fashionable girl-about-town in her skimpy 'come-on' outfits, Vivian goes shopping for clothes in fashionable Rodeo Drive. It is amusing to see how the attitude of a boutique manageress and her staff, one of disdain and near-horror as they outlaw her when automatically assuming she is not the type of person to be shopping there, contrasts with the pampered servility and subservience at another boutique when they realize that she has resources and standing sufficient to buy the establishment.

Another choice incident is Vivian's *faux pas* at the opera. When asked whether she enjoyed the performance, she replies brightly: 'I nearly peed my pants!' An immediate and successful cover-up has Edward explaining: 'She said she liked it better than *The Pirates of Penzance.*'

The picture portrays Edward's almost sinister ruthlessness. He shows no mercy when setting up his next takeover victim, or with Vivian's further ineptitudes and her threatened walkout during a tiff. He is similarly ruthless when he sees her talking to David Morse (Alex Hyde-White) at a polo match and, feeling jealous, tells David of her background; and he immediately fires his business associate, Philip Stuckey (Jason Alexander), on discovering him attempting to rape Vivian.

During their week together the inevitable happens. Edward and Vivian make love and fall in love. In a picture that has been described as *Cinderella* and *Pygmalion* rolled into one, with something of *Breakfast at Tiffany's* thrown in for good measure, Edward does a good 'My Fair Lady' job in smoothing away many of Vivian's rough and ragged social edges, while the beguiling honesty and inherent goodness of Vivian has a softening influence on Edward, who becomes more tender and considerate and less of a workaholic and committed corporate predator.

As one review put it: 'The whole thing is highly improbable, of course, and the huge success of Roberts in the role of a hooker is terribly non-1990, but the sheer charm of *Pretty Woman* never fails to shine through.'

In some respects Gere's is a supporting role; and he underplays the part to perfection. It was strange to see him dressed in a city suit and, in the beginning at least, more of a businessman than the avowed lover. But one reviewer probably said what many of his fans were thinking and, at the same time, succinctly said it all about the picture: 'Gere is still the raunchiest practising Buddhist in the movies while Roberts, all minis and thigh boots, does a breathless impression of a 90s Eliza Doolittle in this lightweight designer morality tale packed with just enough style and sex to suggest that its massive Stateside success is likely to be repeated throughout the UK.'

But more than all of that, Gere said he enjoyed working on *Pretty Woman*, not least because he found the frothy romance to be the perfect antidote to the dark, destructive character he played in the tense thriller, *Internal Affairs*. 'It was fun,' he said. The finished picture is also likely to have pleased him because of the eminently suitable and effective music orchestrated by James Newton Howard and under the musical direction of Marty Paich. It included extracts from Vivaldi's *The Four Seasons*; Verdi's *La Traviata*; 'Fame' performed by David Bowie; 'Kiss' by Prince; 'Wild Women Do' by Matthew Wilder, Greg Prestopino and Sam Lorber and performed by Natalie Cole; 'Oh Pretty Woman' by Roy Orbison and William Dees, and performed by Orbison; 'One Sweet Letter from You' by Harry Warren, Sidney Clare and Lew Brown, and performed by the Grand Dominion Jazz Band; and 'Songbird' by and performed by Kenny G. Of special note was *Piano Solo*, by and performed by, as the credits made clear, Richard Gere.

Meantime, there was *Internal Affairs*, which Gere had completed just before starting work on *Pretty Woman*. The contrast could not have been more extreme or stark. This convincing thriller has Gere in the role of Dennis Peck, an extremely complex and charismatic cop who is respected by everyone but who, despite his reputation, does not always obey the law. 'His ability to read the problems in others is the key to his success in manipulating the actions of those around him,' explained Gere at the time.

Director Mike Figgis, who was making his American feature debut with the picture, said that in a large city like Los Angeles, policemen are exposed to large-scale corruption and in order to

function they might have to start bending the rules. '*Internal Affairs* is about the effects that this could have,' he added. Featured with Gere were Andy Garcia of *The Godfather Part 3*, *The Untouchables* and *Black Rain*, and Nancy Travis of *Three Men and a Baby* and *Three Men and a Lady*. Garcia plays Sergeant Raymond Avila, the investigator determined to bring Peck to justice; Travis plays his wife. She becomes a target for Peck when he retaliates against Avila.

It was the sort of part that particularly interested Gere because Peck is not the traditional villain. Gere explained at the time of shooting: 'A theme of the first movie I was in, *Days of Heaven*, is that people are part-angel and part-devil. Some of us are predominantly one or the other; or both of them at the same time ... which I think is the case with Dennis Peck.'

*Internal Affairs* is a tough story about tough people and set in a tough environment. Peck knows how to launder money, run a scam, fix a bad rap and can even, for the right price, arrange a murder. His line is 'Trust me, I'm a cop'. He is also a bully, thief and seducer; a brutalizer of women. It is dark and powerful, a supercharged police thriller in which Peck, in the face of Raymond Avila's determination to bring him to justice, is not going down without a fight, for the slick, cold-blooded manipulator intends to take Avila's career, his marriage, even his sanity, with him.

Gere's expressed doubts about making *Internal Affairs* had been very real and were probably valid at the time. He claimed it was a very dark exploration of a personality and a more violent film than he wanted to be involved in. But even he could see that after the nadir of the mid-eighties, his career was desperately in need of resuscitation. 'I hadn't had successful films for a while and,' typically unable to pass over a role that he found fascinating and intriguing, 'it was a character that I was really interested in exploring.' His sense of adventure finally won the day and he gave one of the most gripping performances of his career.

Suddenly Richard Gere was making headlines again – and for all the right reasons. In *Internal Affairs* he had played a corrupt and violent policeman under investigation, using a veneer of charm to hide his psychotic malevolence. He had done it with conviction and authority. In *Pretty Woman* he had portrayed a millionaire mogul who plays Pygmalion to a hooker in his first venture into romantic fiction. His performances in both roles were to the manner born and he perhaps even surprised his most resolute fans with his versatility and, in particular, his fine comic timing and deft characterization in the latter movie.

After five years in the wilderness – some less charitable observers claimed it was seven – Gere had powered himself back into the spotlight in two fiercely contrasting roles, which signalled not only one of the most spectacular personal revivals in Hollywood history, but would extend his reputation, proving he could act every bit as well as he could take off his clothes in front of the camera. All the more remarkable was that both *Internal Affairs* and *Pretty Woman* were by no means obvious Richard Gere movies.

Too often infuriatingly passive in terms of the materialistic aspects of his life, it was now obvious that Gere himself was pleased and content with what he had achieved. Realizing that he must do something extraordinary to get his career moving again, he had planned to do three pictures in a row after *The Cotton Club, King David, Power, No Mercy* and *Miles from Home.* But the enormous success of *Internal Affairs* and *Pretty Woman* now made that third film unnecessary.

For two to three weeks in May 1990, Richard Gere was once more just about the hottest talking point in Hollywood. *Internal Affairs*, which had been released in New York in January 1990, opened in the UK on 18 May that year and immediately hit the jackpot. It grossed over £1.4 million in the first nine weeks of its release in the UK and went straight to the top of the rental charts when released on video. It proceeded to become an enormous hit in both the USA and UK.

Just seven days before, *Pretty Woman* had received its British release and had become an instant success. Within weeks it was being tipped as the picture of the year. Within months it had achieved blockbuster status and a phenomenal box-office worldwide. By the time the video came out shortly after, *Pretty Woman* had already become the highest grosser of the year at more than $315 million, and rising. It became one of the biggest money-spinners in years and eventually only *Ghost*, starring Patrick Swayze, Demi Moore and Whoopi Goldberg, would outstrip it as the phenomenon of 1990.

It is reasonable to assume that after the success of *Pretty Woman* and *Internal Affairs* Gere could have taken his pick of almost any movie on offer. Picture-makers, writers, directors, producers and studios would see him as one of the hottest properties in the business. But having once re-established his commercial savvy and box office credibility in the most positive way, he instead went moon-walking again, signing up for a cameo role in a Japanese offering called *Hachigatsu No Kyohshikyoku* (*Rhapsody in August*).

The publicity blurb described this Japanese picture as a beautiful film about the unusual experiences of four generations of a family who spend their summer vacation with their grandmother. The story takes place in the countryside near Nagasaki against the background of the anniversary of her husband's death. The film deals with the family coming to terms with the differences between the generations and the relationship with their Japanese-American relative.

For most of his adult life Gere has been drawn to the mystics of the east, later to be extended through a growing fascination with the culture of, and way of life in, Japan. He made visits to the country from time to time so it was not altogether surprising that he took notice of a new picture on which the veteran, legendary Japanese film director, Akira Kurosawa, was embarking.

Kurosawa made films before the war, but with the return to peacetime conditions he quickly gained a reputation for portraying the ethical and metaphysical dilemmas of post-war culture, often focusing on people with moral and ethical choices. His film-making career spanning forty years had brought him worldwide critical and popular acclaim. In *Rhapsody in August* his idea was to create what he felt would be a more accurate and balanced perception of Japan's involvement in the war. The story was told by a Japanese grandmother who, prompted by her four grandchildren and a visit from her Japanese-American nephew, recalls the death of her husband when the atomic bomb was dropped on Nagasaki.

Kurosawa wanted an American input to help the picture's distribution chances in the United States; ideally a known American actor in the role of the nephew. Just the sort of off-beat project Gere might go for – he did. But, whatever the original motives, the film turned out to be a veiled attack on America's national conscience, with Gere's character being manoeuvred into situations where he felt uncomfortable, embarrassed, regretful, apologetic and even ashamed of what his country had done to the Japanese.

The picture was a tedious affair, not helped for English-speaking audiences by the sub-titling. Nor did it mean much for Richard Gere fans, who saw their hero on screen for barely a half-hour of the film's total running time of 97 minutes.

The picture was well received in Japan and was premièred in the UK as part of a Japan Festival at London's Barbican Centre. Here it was billed as 'a touching and beautiful film' that deals with a family coming to terms with the differences between the generations and the relationship with their cousin. But certainly that is not how the

majority of Americans saw it, particularly since its release in the United States was unfortunately, not to say, provocatively timed close to the fiftieth anniversary of the attack on Pearl Harbor.

Such was the feeling among service and veteran organizations that Kurosawa felt obliged to explain that his motives were honourable and inspired by the need for wider understanding of the situation.

It is unlikely that Gere gained many friends from being in the film and, caught in the middle of the fallout, he fell silent. Whether he was paid for his pains is not on record. Nor has he ever fully explained his reasons for involving himself in the project. It was probably for no better reason than Japan and its culture were a growing fascination to him and it fitted comfortably into his schedule. In any event, he would soon clear his mind of the experience as he began work later in 1991 on his next picture.

One or two projects were being lined up but *Final Analysis*, in which he co-starred with Kim Basinger for the second time in eight years, was the first to see the light of day. Much was expected of him after the triumphs of *Internal Affairs* and *Pretty Woman*, and early publicity on the following lines raised expectations: a man of confidence and professional expertise, fully in control of himself and his world (Richard Gere); a woman of intelligence and stunning beauty who enters his life and inexorably alters his destiny (Kim Basinger); a troubled girl whose disturbed dreams lead to a dangerous mystery (Uma Thurman); a great city on the edge of a continent, hiding a thousand secrets; a lighthouse on the edge of a great city, where secrets are revealed; all in addition to love, desire, deception and – murder.

What film could possibly live up to the blurb? Of course, there is more to it than that. Isaac Barr (Gere) is an established psychiatrist and an expert in the insanity plea; he falls for the beautiful Heather Evans (Basinger), the sister of his deeply disturbed patient Diana Baylor (Thurman). Although Heather is married, her marriage is an unhappy one, and Isaac and Heather quickly fall into an affair. As Heather and Isaac become more involved, it also becomes clear that Heather is almost as troubled as her sister. When Heather kills her abusive husband in an alcohol-induced rage, Isaac uses his expertise to plead temporary insanity due to Heather's supposed sensitivity to alcohol. Isaac becomes suspicious, however, when he learns that Heather is the beneficiary of her husband's hefty life insurance policy. Following a bizarre trail of psychological clues, Isaac learns the truth about Heather and Diana.

After the triumphs of *Internal Affairs* and *Pretty Woman*, another success would have consolidated Gere's position among

Hollywood's top stars. All the basics appeared to be in place. Gere's reputation could not have been higher. Basinger was one of America's most prominent screen actresses and was back in the studio after featuring in the new-style big-screen version of *Batman* with Michael Keaton and Jack Nicholson. Uma Thurman had been seen in *Dangerous Liaisons* and had won critical praise for her powerful performance as June Mansfield, author Henry Miller's besieged wife, in Philip Kaufman's controversial *Henry and June*.

So there were no problems with the casting. The screenplay came from Wesley Strick who, along with Robert Berger, had written the original story. In fact the script was said to have made such a strong impression on Gere that he not only wanted to star in the movie, but took on the additional role of executive producer, his first such venture, along with Maggie Wilde.

Billed as a taut psychological thriller in the style of Hitchcock, the picture was a disappointment for those expecting a *Pretty Woman* or *Internal Affairs* level of success, despite the obviously potent combination of two such sex symbols as Gere and Basinger. And in spite of earlier optimism the script, like so much scripting for the cinema, ran into difficulties from which it never totally recovered. Most cinema-goers, however, would rate it a good picture, tense and unexpected in story development, with plenty of intrigue.

Gere had other things on his mind in the early 1990s beside his movie career to which he was never passionately dedicated, at least not to the exclusion of life itself. In June 1990 he had travelled to Tokyo to attend an Asian peace conference and was particularly committed during the year, designated the Year of Tibet, with meetings and special events staged at Tibet House in New York. The following year a Tibetan exhibition at the Asian Art Museum in San Francisco was something of a coup, for Gere brought the Dalai Lama over officially to open the event.

And then, of course, there was Cindy. By this time he and Crawford were very much an item and, their professional engagements apart, almost inseparable. They had proved that their relationship was not just a quick infatuation and there was gossip about them even going so far as to get married; and having children! Certainly events appeared to be heading that way when he was said to have paid approaching $4 million for a lavish home by the beach at fashionable Malibu; particularly since they each had apartments in New York and a shared place in Connecticut.

Marriage? A family? The best of Hollywood beefcake becoming domesticated? Well it could happen, perhaps ...

# 10

# Bring on the Girls

In his professional and so-called private life, women have been important to Richard Gere. The steady live-in girlfriend when he first moved to New York as a 20-year-old; his early co-stars like Lauren Hutton, Debra Winger and Julie Christie; the headline-making Cindy Crawford affair, then marriage followed by separation – all these and many other contacts and liaisons have contributed almost as much to his status as a media celebrity as his highly-charged roles in films.

His sizzling on-screen image became a legend. So did the glamour and excitement of his love life. Yet his beautiful co-stars on screen and off, were just as likely to talk about his understanding, helpfulness, vulnerability, support, sincerity and charm as much as his role as a heavy romantic.

His most famous relationship is the extended time he spent with supermodel Cindy Crawford. It obviously meant so much to both of them that any account of Gere's life has to give more than a passing reference to the one girl in more than twenty years of steady relationships and exotic affairs who, against all the popular odds, became his wife.

Cindy Crawford was born on Sunday 20 February 1966 in the small, working-class town of De Kalb, Illinois, population 15,000. She was the middle one of three daughters and during the summers worked in the cornfields near her home. Her father, an electrician, walked out on her mother when Cindy was in her teens. Cindy had a common-sense nature as a child and with one eye on a secure future in a skilled occupation studied chemical engineering at university in Chicago. She was such a dedicated student that at seventeen she was found to be suffering from a stomach ulcer. After a year she ditched

her studies to become a model.

A glimpse of the future materialized while she was still in high school when she modelled for a bra ad for a retail store. But for the girl who would later be able to command $50,000 for half an hour on the catwalk, success was not easy or automatic. Yet her determination and natural instincts worked to her advantage. Against advice she resolutely handed off the pressures to have her distinctive facial mole removed and to become even thinner, though at 5ft 9in she was only a size eight. Crawford also shattered the well-held belief that you had to be blue-eyed and blonde-haired to be a model. When she was twenty she moved to New York to be more in the centre of fashion and her first important break came soon after, in August 1986, when she was on the cover of the American *Vogue*.

Her impact was remarkable. She went on to create a record by being on the cover of *Vogue* eleven times. Soon her open face and well-modelled figure seemed to be everywhere, but particularly in glossy magazines and sophisticated adverts. She captured more widespread attention when pictured in a wet T-shirt for a L'Oréal campaign and caused an international flutter in the industry when photographed nude for the cover of *Playboy*. It was the sort of thing which legitimate fashion models just did not do.

But like Gere, stripping off for her art did not bother her. She posed naked in a bath in a video for George Michael's song, *Freedom*, but in the end the shot was never used. She matched Gere also in her profound dedication to her career. Seldom temperamental when on an assignment, she rapidly built a reputation for being prompt, organized, articulate and co-operative. Her self-discipline was exceptional – a legend in the business. 'Cindy's professional to a fault,' said Monique Pillard, president of her New York model agency.

Her success continued to climb. She became the first supermodel to advertise Pepsi, following rock stars Michael Jackson, Madonna, David Bowie and Tina Turner, and in 1989 signed an exclusive contract with Revlon. She became the highest-earning model in the world. Later all the other extensions and exploitations of the so-called 'Cindy Machine' would move into overdrive bringing, among numerous accolades, her media success on television as host on MTV's regular fashion show. She was a self-confessed workaholic, shunned drugs, did not smoke and admitted to a childhood ambition to be the first female president of the United States.

'Cindymania' soared to new heights in Europe in 1992, when she was twenty-six and visited London. Now dubbed the world's most beautiful woman, as well as the most bankable model, she brought the capital's congested traffic to a halt in a mini-skirt, high heels and black top. Inside Harrods a crowd of 2,000 were kept in check on the ground floor by security guards linking arms while hundreds more people waited outside in Knightsbridge hoping for a glance at the year's 'wonder woman'. Similar scenes greeted her appearance at Selfridges in Oxford Street, where a planned one-hour visit had to be cut short amid safety worries as 1,000 fans surged forward.

It had been four years earlier, in 1988, that Cindy Crawford had met Richard Gere for the first time on that memorable occasion at Herb Ritts's Californian home. She had been dedicating much of her time to the development of her modelling career and harboured no complicated pedigree of relationships with men. Gere's love-life, on the other hand, went back a long way, not unnaturally perhaps since he was that much older than Cindy; and surprisingly, when set against his scorching screen image, his early associations had been a model of stability when judged on how they had lasted. His affairs with Penelope Milford, and later with Sylvia Martins, were significant examples of affairs that quickly developed into sustained relationships.

Penny Milford was a young actress of twenty when they first started going together. Gere was still the long-haired drop-out foraging for that crucial break on the stage during those early days in New York. It was a time of intense struggle for both of them as they attempted to establish their theatrical credentials; and their relationship was sufficiently strong and durable to survive through the hardest times. Later when Gere, still in New York, was doing better and moved into a much nicer flat in a more congenial area, he invited Penny to move in with him. The split came later when Gere returned to the US after making *Yanks* in England. Penny had just made the 1978-released Jane Fonda movie, *Coming Home*, for which she received an Academy Award nomination for best supporting actress, Fonda's co-star Jon Voight receiving an Oscar for his role as an embittered veteran of Vietnam who falls for the wife of a serving soldier.

Then at the end of 1978, with little if any warning, Gere simply told Penny it was all over. Surprised or not, she was certainly distraught, but held back from publicly condemning him. She explained rather sadly about the good she found in him, like the way he always made you feel wanted and of his need for you to love him.

Penny declared that Richard off-screen was what he was on it – a very complicated, strong, silent type, who enjoys attracting women and sets out to do it. 'But part of that appeal is that you don't see it,' she said, though in 1981 she was still happy to describe him as irresistible. Sometime later she would claim dispassionately; 'He loved his German Shepherd dog more than me. I can compete with another woman, but I can't compete with a dog.'

It was Milford who, before Crawford, said that Gere hated being normal. She claimed he was basically shy and that many people mistook that for arrogance. She had shared many of his toughest times in a hostile New York, which for too long had snubbed his emerging talent. She had been there when he returned from his first successful trip to England for *Grease*, had seen him make that significant breakthrough into pictures with *Report to the Commissioner, Baby Blue Marine, Days of Heaven, Goodbar* and *Bloodbrothers*. She had even been by his side when Herb Ritts had taken those first pin-up shots of Gere and when, with Ritts and Gere, a tyre had blown on her Buick and Ritts spent the waiting time taking more 'explosive' pictures, which would convert Gere into one of the screen's most glamorous and sexy players.

But the relationship faltered during Gere's prolonged absence in England making *Yanks*. When he returned it was all over and Milford moved out. But another woman soon hove into view, stepping into his life in a serious way.

Sylvia Martins, a raven-haired Brazilian beauty, painter and former model who was several years younger than Gere, had become obsessive about him from afar and was determined to get closer to him, though she insisted it was not because she was the usual sort of female fan-worshipper, but as a fellow artist. In a most extraordinary display of persistence, leading almost to desperation, she wrote to him endless times, left messages, telephoned, and made numerous whimsical, though abortive attempts to see him. She pursued him relentlessly and became such a nuisance that an exasperated and increasingly angry Gere finally closed down all possible avenues of contact and simply ignored all her approaches.

But Sylvia was not to be put off and eventually caught up with him when he was eating alone in a New York restaurant. He lost his temper and there was a bust-up. Having now successfully made contact, Sylvia was determined not to let him go; and in such freakish circumstances did another long-term partnership begin. It prospered for more than six years. The end came when he refused to marry her.

Sylvia was a beautiful girl, talented as an artist with a growing reputation among those who matter for her animated abstracts, and a sophisticated lady from a well-to-do family; and according to those close to them both at the time, she was good for him. He became more relaxed; seemed more contented. He enjoyed being with her and they spent a lot of time together. Whenever possible he made a point of arranging for her to be around when he was working on the set. She often accompanied him on location, or flew out to him when he had a day or two away from the cameras.

'He was noticeably less tense, more open, warmer, less challenging,' concluded a studio insider at the time he was making *An Officer and a Gentleman*, which was put down to a security and steadiness in his private life with Sylvia. Yet Martins' explanation after the split that they did not have a committed relationship perhaps surprised many who were outside the couple's 'inner circle'. 'He had things on the side,' she said. 'I was not always there.'

Mind you, all this is not to say that life for the two of them was dull. They were both young, life was meant to be lived, New York was one of the most vibrant places on earth, and perhaps the quirky circumstances of their coming together with Martins in hot and persistent pursuit, made their relationship that much more exciting, certainly at the beginning. For these were also the days of the eccentric artist Andy Warhol and the notorious Studio 54, the 'in' rendezvous for the cool crowd and power people of the times. It became a way of life to act impulsively. 'You just did things without thinking – you'd see someone and go for it,' Martins reflected many years later.

But as time went on the relationship became strained and eventually, frustrated and annoyed (almost certainly by then because of his refusal to start a family), Sylvia walked out of his life. One committed Gere watcher would later explain that the best way to handle Gere was to stand up to him. 'It's one reason Sylvia Martins lasted so long – she gave as good as she got.'

Years later she would end a well-documented romance with the billionaire Constantine Niarchos, at thirty-three some five years younger than Martins. News of her split with Niarchos leaked out when Sylvia returned to New York in September 1995 and was reportedly back in the Manhattan social whirl and, significant to our story, visiting an exhibition of Tibetan photographs organized by Gere. But despite this tenuous contact they did not get together again. There was also his reported dating of Diana Ross for a brief spell in 1982 and there would be a further flutter of press excitement

when he was said to be attracted to Barbra Streisand after she had ended her long-term relationship with Jon Peters.

But alongside these mainstream romances there ran a secondary tale about Gere and his co-stars. Such stories in the film world are not uncommon and it is difficult to sort fantasy from fact, since leaked titbits about a possible romance between the stars of a forthcoming movie is bound to build up useful column inches of publicity in the press and perhaps secure a few more 'bums on seats' in cinemas countrywide. Gere was a natural target anyway, especially with a film like *Breathless* in 1983 with all those sizzling love scenes. Comments from his youthful co-star Valerie Kaprisky, experiencing her first on-screen romance, only added to the titillation. 'Richard's character makes me, in my role, so much more sensual,' she explained with some naivety. 'The problem for me, the difficulty if you like, was that Richard was not far from the character and so it became a confusing situation. Richard was wonderful to work with. He gives you everything to react to.' Then later, before an eager press: 'Richard's not far from Jesse. We are not acting the love scenes. They were half real. People told me (beforehand) that friendships made when making a movie end when it is completed. I am afraid I opened my heart too much and when I tried to close it, it wouldn't. I truly fell in love with Richard, but then it was all over.'

Earlier he was said to have been attracted to Brooke Adams in *Days of Heaven* (1978). Lauren Hutton, his co-star in *American Gigolo*, would praise his sensitivity and care for her feelings when playing their nude scenes in that picture, though Debra Winger, his co-star in *An Officer and a Gentleman* claimed he was arrogant and said live on American television that she would 'never work with Richard Gere again', though Winger, who years later was said to have the sexiest laugh in Hollywood, was at the time reckoned to have more or less written the rule book on how best to handle a sex scene with Richard Gere.

However, Lisa Blount, who also starred in *An Officer and a Gentleman*, had a different interpretation of Gere's attitude on set. She and Gere were preparing to shoot one of the most emotional scenes in the picture when he leaned over, patted her on the knee, stared deep into her eyes and asked softly if there was anything he could do for her. Lisa said all her instincts were to tell him to carry on rubbing her knee, but she was so keyed up that she took the offer for what it was, simply to do whatever he could to make the scene go right. 'I said: "Treat me as an outcast ... don't be kind",' Lisa explained. She said Gere took her literally and for the next four

days had her convinced he hated her. The story goes that he was exceptionally rude and finally, when shooting was over, he kissed her and said that was the hardest thing he had ever done. 'Richard is really a very kind man. I'm a big fan of his,' said Lisa.

Diane Lane spoke rather guardedly about her co-star in *The Cotton Club*, saying it was not difficult working up a relationship with Richard – it just took time and care. 'We arrived at a really good rapport,' she added. His attraction to many of the women who starred with him in pictures was undiminished as the years moved on and his hair began to grow greyish streaks. For later, Kate Capshaw (*Power*), Kim Basinger (*No Mercy*), Julia Roberts (*Pretty Woman*) and Swedish actress Lena Olin (*Mr Jones*) were all said to have fallen temporarily under Gere's magic spell. Basinger said after working with him on *No Mercy*, which was their first picture together: 'I love him dearly. He's a very sensitive guy and a bit misunderstood. In fact, he's very, very funny. Working with him was a dream.' It is said that it was Basinger's attraction for Gere that persuaded her to make *Final Analysis* with him six years later.

Roberts reputedly fell in love with Gere when they were filming *Pretty Woman* and when Richard complained that she was not reacting the way he wanted her to, she felt he was blaming her for his shortcomings, but added: 'I wasn't capable of protesting against such a sacred idol.' Even four years after the release of *Pretty Woman*, after Roberts had separated from her husband, Lyle Lovett, reporters in Los Angeles wrote about her being seen around with Gere. It was about that time that Roberts was moving closer to Gere in her 'good cause' campaigning, visiting a healthcare centre in Port-au-Prince, Haiti, on a six-day tour as Unicef's goodwill ambassador.

A co-star who was said to mean a lot to Gere at the time was Julie Christie, who starred with him in the 1985 picture, *Power*, though there was no suggestion of a romance. Christie had been a major sex symbol back in the swinging sixties, an iconic actress of quality and the personification of every 'teen and twenty' girl during those exciting, permissive times. She was a sexually liberated contemporary woman almost before the phrase had been invented and as recently as 1995, when she was fifty-four, a men's magazine rated her in the top ten of the 'hundred sexiest women ever'.

Like Gere, Christie found herself in roles that had sexual overtones, or were perceived as such. Her love scene with Donald Sutherland in *Don't Look Now* in 1973 was so convincing that even now there are those who say there was little 'acting' involved. In

*Doctor Zhivago* (1965) her sexual intensity as an object of desire as the passionate, tender Lara contributed enormously to the success of this lavish, complex epic.

Like Gere, she often appeared to have a chip on her shoulder, out of tune with modern values and not afraid to express her personal opinions however deviant they may be against more conformist views.

Like Gere again, she championed deserving causes with a steadfast intensity. Hers included ecological awareness, human and animal rights, anti-consumerism; and once more like Gere, she was seemingly too often ready to commit her life and career to apparent oblivion.

Little wonder then that when I asked her to talk to me about Richard Gere as a co-star and as someone who has worked closely with him, she enquired through her agent if the biography had Gere's official blessing. When she learned it had not, she declined to comment. Loyalty is another attribute that Gere seems to attract. People are often drawn to him instinctively.

It was the Duchess of Habsburg who was to become important to him after his affair with Sylvia Martins had ended. Sophia, Duchess of Habsburg, was more than just a pretty face with a charming personality and look-again figure. She was linked through her title to the most prominent European royal dynasty, which stretched from the fifteenth to the twentieth centuries. The family originated in Switzerland in the tenth century and consolidated their influence, through marriage and conquest to Austria and other parts of the continent, with Spain, with its European and American possessions being added later to the Habsburg domains. The Spanish branch died out in 1700, but the Austrian Habsburgs continued to rule, becoming emperors of Austria in 1804 and of Austria – Hungary in 1848, which they continued to rule until the end of the the First World War.

Not that this is likely to have been of deep concern to Gere, or to have influenced his developing relationship with Sophia. He would have taken note of her charming personality and blonde beauty of course, along with her enticing blue eyes and elegantly long legs. But equally influential in bringing them closer together was the charity work she was doing, since by this time, around 1987, Gere was increasingly neglectful of Hollywood in favour of his preoccupation with Buddhism, world peace and justice for the oppressed peoples.

Sophia was working tirelessly for needy children all over the

world through an organization called SOS International. They first met when she went to interview him and the batteries on her tape recorder faded. 'So while we took a break to sort that out, we got the chance to get to know one another better,' explained Sophia at the time. She had not long before seen Gere in *American Gigolo* and was expecting him to resemble the character he played in the picture. 'It wasn't a movie megastar who turned up, however, but a man with great personality and charm, one whom I liked a whole lot better,' she added.

Their charity work was a natural bond between them and they planned to work together on ventures that combined Richard's Buddhist faith and Sophia's love of children. Gere had visited a couple of the children's villages SOS had set up even before meeting Sophia and found it hard to believe that a real duchess could be so involved. This discovery was what first attracted him to her. Later Richard introduced Sophia to the Dalai Lama and there was talk of a future together, with plans for her to take Gere to her home in Spain and to show him around Barcelona and other cities.

They organised jointly a charity dinner in Madrid after fund-raising in New York and with picture-making consigned to the back-burner, Gere took every opportunity to promote the cause of the Dalai Lama and the alleviation of world suffering. He explained: 'The Dalai Lama is the spiritual and political head of Tibet. His principles of life are completely based on thinking of others first. That's something we don't know too much about in America; we tend to be so selfish.'

But for all that, his relationship with Sophia did not appear to have the personal intensity of those he shared with Penny Milford or Sylvia Martins. Nor did it last as long, though it did signal a change of sorts. In future he would be attracted more to models than actresses or the aristocracy, though his love life would appear to be none the less complicated. To Gere himself, however, there was a straightforward explanation. 'I'm very monogamous,' he explained. 'When I'm with someone, I'm really with them. I've had long relationships. I never felt particularly right being single. I was always looking to find one person I wanted to focus on.'

Some of the focusing had been fleeting. At various times he is said to have romanced designer Diane von Furstenburg, movie executive Dawn Steel, jewellery designer and model Tina Chow, who was his girlfriend for just four months in 1988, Canadian-born model Gabrielle Lazure who, only months after their first meeting was claiming that he had already proposed to her and wanted

babies, and Katherine Moore. 'Gere certainly isn't someone that women want to mother – that's not the chemistry at all,' said one commentator. Another critic speculated: 'To either sex Gere represents a threat, a compulsively attractive menace, a sexual grenade.'

Of course, to be fair, it is not hard to imagine that his screen roles have added a subjective dimension to his persona as an ordinary person. When you are saying lines like: 'You know what I can do. I can make you relax like you've never relaxed before. I know how to touch you, where to touch you, how to kiss you, where to kiss you,' as he did in *American Gigolo*, it is perhaps not all that surprising that he can so easily become the object of some women's sexual fantasies.

His relationship with Cindy Crawford was set to become one of the most serious of them all, with strong hints of domesticity before the unhappy break-up. But at first there were few hints to suggest that their relationship would last as long as it did. In fact, the word was at the time, that his *Pretty Woman* co-star Julia Roberts was furious when she realised that she had been dumped by Gere in favour of his then girlfriend Cindy Crawford.

Materialistically the relationship had all the ingredients for survival. Gere was famous and wealthy even by Hollywood standards. Crawford was a high-profile celebrity successfully rushing to the top of the modelling tree and in almost constant demand. At one point they would have five separate homes, luxury spreads in Malibu and Bel-Air, another house in expensive Westchester in New York, and a couple of apartments in Manhattan. And despite the insistent pressures on their time exerted by film and photographic deadlines, long workdays and almost constant travel, Cindy was eager to get involved in Richard's charity work and support him in his Buddhist faith, while Richard seemed pleased to be so closely associated with Cindy's continuing popularity.

They made a wonderfully glamorous couple, both incredibly handsome and attractive. But even with so much going for them, could it possibly last? After all, showbiz marriages have a notoriously high mortality rate. Then, after being seriously together for more than three years, their secret fairy-tale Las Vegas marriage seemed to silence the doubters and seal their relationship. There was even talk of them having a family. But in the end, even the formal commitment of marriage was unable to prevent the inevitable; or maybe even accelerated it. The media had focused

heavily on their wedding, which did little to curtail the gossip and speculation about their sexuality and their own relationship, about which there were persistent rumours.

Speculation was also growing that, in spite of their marriage, all was not well between them. Hardly of help to a sensitive situation was the news that self-styled uninhibited actress, Marilu Henner, who had appeared with Gere in *Bloodbrothers* in 1978, was on the verge of publishing a tell-all autobiography, which recounted her love escapades with a series of men including Richard Gere.

When Gere moved to London to film his new picture, *First Knight*, the British model Laura Bailey was already on the scene. According to Bailey they first met at a party at London's Grosvenor House to raise money for Tibet in July 1994 and, again according to Laura, became very close. For a time they were able to keep their relationship to themselves, but the news was rapidly common knowledge once the turret-lens cameras, which were focused on the Chelsea home where Gere was staying, caught Laura scrambling on to the premises from the house next door. Although the joint statement from Cindy and Richard announcing their separation was still some months away, Laura insists that her affair with Richard did not split them up – they were already separated at the time, she claimed.

Reading between the lines it appears that neither Gere nor Bailey was looking for a long-term relationship and after a short but concentrated time together in London, after which, in Laura's own words, they had a few crazy trips, the romance seemed to fade out of the news. But the beautiful blonde Laura, daughter of a professor of law at Oxford and intelligent enough while at Southampton University to gain one of the highest firsts in English literature, was also strongly ambitious and when, some months later, she packed her bags and left London to base herself in New York, mainly because of the intrusion of the capital's unyielding media spotlight, the move brought Gere once more obliquely into the news. By this time Richard was back working in Los Angeles and although Laura admitted that she had talked with him about New York, and he had been encouraging her to work there, she insisted that the decision to go was hers alone and that Richard was as surprised as her other friends when she started looking for somewhere to live there.

Although by this time their romance seemed to be well and truly over, Laura later remembered it as a happy time, an important part of her life and a great learning and growing up time. 'I have amazing special memories and I am not denying anything, but I want to keep

the relationship very private. It's a very special thing,' she said. She also said that she considered Richard to be a wonderful and special friend forever.

Meantime, Gere had moved on to further conquests, squiring actress-model Vanessa Angel and then making sensational news in the very best traditions of his media past. In a full-colour picture exclusive the *News of the World* showed him nude bathing with an equally nude 25-year-old Swedish student, Stina Norbye. Reports suggested that he was besotted with her and the two had been inseparable since he arrived for a short holiday. Later they were said to have flown off to Denmark and were reportedly seen eating together in a Copenhagen fish restaurant.

Coincidentally, only a week before, Cindy Crawford was reported to be battling to win back her estranged husband. It was hard not to sympathise with her after she had gone public explaining just how difficult it is to keep a relationship going when two people are so busy that they just do not get time to see much of each other. 'I think our biggest mistake was that we weren't together enough. Every other week is not enough, and, you know, having five homes sounds glamorous, but it's not if you never feel settled anywhere.'

Although in the very same month the same British tabloid had shown pictures of a topless Cindy happily swimming and sunning herself with an un-named male companion.

Ah well ...

# 11

# New Role for Sex Star

*Internal Affairs* and *Pretty Woman* especially had set up the 1990s as Gere's time of rebirth as a movie actor and his public had every right to be optimistic. *Rhapsody in August* had already been consigned to the metaphorical 'sin-bin', a monumental rush of blood to the head even for Gere, who had already shown just how foolhardy and eccentric he could be when choosing projects that should have either advanced his career or been commercially sensible. And while the potentially explosive re-matching of Gere with Kim Basinger in *Final Analysis* had been somewhat disappointing, two other projects of major potential were already in view.

By now Richard was not simply content to take or reject options that were put before him. He wanted a greater say in how a picture was angled, who his co-stars would be, how the script was treated. That meant being an executive producer. His first, not altogether auspicious, experience of this new and extended role had been *Final Analysis*, when he and Maggie Wilde shared responsibilities as executive producers under the banner of Gere Productions.

He and Wilde were not strangers. Indeed they went back as far as 1979 when Wilde was a production executive at Paramount and Gere was brought to Los Angeles from New York to star in that studio's *American Gigolo*. Born in New York City and raised in Andover, Massachusetts, Maggie Wilde had graduated from Barnard College with a degree in French Literature. Following her cultural inclinations, she moved to Paris for a time, studying at the Sorbonne. Her move into entertainment came when distinguished film-makers Ismail Merchant and James Ivory put her to work as a production assistant on the 1956-released United Artists', *The Wild*

*Party*, a largely unsavoury melodrama about an ex-football star who
plots a kidnapping with the help of some Los Angeles layabouts.
None the less, it starred the redoubtable Anthony Quinn.

Gere had noted that Maggie's progress in the film industry had
been steady and sure, first as a production assistant, then as
production assistant and co-ordinator, eventually being recruited by
British-born director Robert Stigwood to his RSO films as a
production executive, where she worked on both Travolta
successes, *Saturday Night Fever* and *Grease*. She was later employed
as a production executive for both Paramount and Time-Life Films,
following which Gere was happy to have her join him on *Final
Analysis*.

Notwithstanding the mediocre response to this movie, Gere and
Wilde continued as executive producers on one of Gere's next two
pictures. *Sommersby* was about as big a departure from the sexual
image of Gere as you could get, for here he was to feature in a
American period drama about a young plantation owner who fights
in the Civil War and returns unexpectedly and mysteriously to bring
dramatic changes to his isolated hometown and everyone in it.

In fact the original plan would have had Gere working first on a
Tristar Pictures' presentation of the Rastar Production, *Mr Jones*,
with Gere sharing the executive producer role, this time with Jerry
A. Baerwitz. This, as it would turn out, ill-chosen piece is the story
of the power of love that is unusual on two fronts: it illuminates the
extraordinary complexities of the manic-depressive condition (also
known as bipolar effective disorder) and examines the fragile doctor
– patient relationship in the difficult world of mental health.

However, getting the picture made would turn out to be an even
more debilitating and traumatic experience than the dispiriting
nature of the plot itself, taking more than two years from beginning
to release. In fact the picture had been on the starting grid even
before shooting began on *Final Analysis*. Script, production,
personnel – the problems mounted and ranged crazily along the
length and breadth of the project – but we will come back to the
chaos of *Mr Jones* a little later.

Meantime, *Sommersby* had successfully negotiated its pre-
production stage, its status enormously enhanced with the signing of
Jodie Foster to play Gere's (Jack Sommersby's) wife, Laurel, hot
from her success in what would become the legendary *The Silence of
the Lambs*.

Foster was the consummate professional; a gifted youngster at
school she graduated with honours from Yale University, earning a

BA in literature. She won widespread critical praise and attracted
international attention in 1976 through her powerful portrayal of a
drug-addicted 12-year-old prostitute immune to affection who
inspires Robert De Niro's violent 'rescue mission' in Martin Scorsese's
*Taxi Driver*, for which she received her first Oscar nomination. By
now an accomplished director as well as actress, her stunning
performances as a rape survivor in *The Accused* in 1988 and
particularly as the cool, persistent Special Agent Clarice Starling in
the 1991 hit thriller, *The Silence of the Lambs*, earned her two
Academy Awards for Best Actress, placing her almost in a class of
her own in dramatic and powerful roles.

But if *Sommersby* offered Foster a different type of role, it was also
a challenging experience for her co-star. The risks for Gere were that
his public would not accept their *American Gigolo* and *Breathless*
sex-star as the responsible husband and father in a period drama with
hardly a nipple in sight; and that, as one of the picture's executive
producers, his judgement could be dealt a severe blow if it failed.

The film tells the story of young plantation owner Jack Som-
mersby, a difficult man, often crude, violent and ineffectual in
overseeing his lands. When he departed Vine Hill in Tennessee to
fight in the Civil War, he left behind a wife and infant son, and friends
and acquaintances, who saw him leave with mixed emotions. His wife
Laurel was left to run the plantation on her own, raising a child and
surviving a devastating war, but she also felt the relief in being free
from Sommersby's coldness and occasional brutality.

When Sommersby failed to return from the battlefield, family
friend Orin Meecham, played by Bill Pullman, saw the opportunity
to court Laurel, working her land and helping to raise her son,
looking forward to the day when the principled Laurel would
consider her husband officially dead and he could marry her.

But unexpectedly, Jack Sommersby returns, more than two years
after the end of the war, and with no real explanation for his absence.
He is also a very different man. He rekindles the love that once drew
Laurel to him, showing himself to be at once gentler and more
passionate than she ever remembered. He turns the tide of poverty in
Vine Hill, bringing the entire town back to prosperity by pioneering
the cultivation of tobacco. (Incidentally, one of the more unusual
set-dressing requirements for the picture was thirty acres of tobacco
to accommodate this important story point. The production planted,
cultivated and harvested its own crop, developing a real 'feel' for the
quality of the farming life in the Southeast).

The transformation in Jack Sommersby is so complete that people

seriously begin to wonder if he could possibly be the same man who left the town seven years before. Only his adoring wife, Laurel, eventually knows the secrets that Sommersby carries with him.

There were good reasons for Gere to be attracted to *Sommersby* when producers Arnon Milchan and Steven Reuther first showed him the script, for the three of them had not too long before worked together on the enormously successful *Pretty Woman*; a repeat success from the team would certainly not be unwelcome.

Milchan, in fact, had been sitting on the idea for some time, assessing it as a 'truly extraordinary love story, a great and timeless saga incorporating elements of all the great love stories'; presumably his intention was to do something about it one day, though circumstances showed that it was an initiative from Gere that first set the ball rolling.

He and Maggie Wilde had come across the *Sommersby* screenplay, which had been written by Nicholas Meyer, when casually going through a pile of scripts, which no one had taken up and had been put on one side. They quickly recognized its potential and then discovered, remarkably, that his co-producers from *Pretty Woman* controlled the rights. Gere contacted Milchan, who confirmed that the script was still available. Let's do something about it, they agreed, making immediate plans to turn it into a successful motion picture.

Gere felt that Meyer's work, which was based on the French film *The Return of Martin Guerre*, written by Daniel Vigne and Jean-Claude Carrière, needed some attention. Meyer had done an impressive job in reshaping the original, sixteenth century-based French legend, into an American Civil War drama. Gere, however, felt the need to bring in another writer and he also worked on the script himself. But was it possible to create another blockbuster so soon after *Pretty Woman*?

Typically, Gere was more interested, and Milchan also to a degree, in discovering if the screenplay had the potential to become a worthy and significant film than its possibilities for making huge amounts of money. He was particularly fascinated by the thin line between desire and reality, which the main character crosses. He would explain later: 'Jack Sommersby saw himself as loathsome, but in the confusion and upheaval following the Civil War, he miraculously becomes the person he always dreamed of being.' Gere went on: 'In just one turbulent year this man touches the lives of everyone around him. People entrust their lives to him and they are enriched. Sommersby reaches the best part of himself, an

identity so profound it leads him through an ironic and tragic twist of events.'

It soon became evident how crucial to the picture's success would be the casting of Sommersby's wife, Laurel. She needed to be sympathetic, sensual in more private moments, but also physically and psychologically convincing in the role of the work-hardened wife who had absorbed the responsibility of mother and bread-winner in her husband's long, and it seemed unending, absence.

A stroke of luck helped the process along. Jodie Foster, who had not long finished working on *The Silence of the Lambs*, was interested and decided to take the part. It turned out to be a piece of astute casting, for she met all the required criteria. Foster, whose second Academy Award as Best Actress for *The Silence of the Lambs* was announced while she was preparing for *Sommersby*, said she was attracted to the project because her role of Laurel Sommersby was a true ancestor of her contemporary roles of strong and independent characters.

'Laurel is tough, stubborn, proud and rebellious, the kind who won't settle for less than dignity and respect,' she explained. 'She is an unconventional woman in an era guided by convention. *Sommersby* is about so much more than love. It touches on truths about family, honour and faith in humanity.'

Foster said later that she had been particularly fascinated by the sharply-defined focus of her character who, it seems, might have allowed a stranger into her bed. 'But is a woman's love necessarily exclusive?' she posed, adding, 'In Victorian times women could hope for very little personal fulfilment. That's why Laurel is so captivated by her returning husband. He is both the dangerous and unpredictable stranger of her fantasies as well as a devoted husband and father, loving her, as she says in the picture, like he has never loved her before.'

There is no doubt that Gere's role in a period drama was light years away from anything he had done before, but he set about it with his usual dedication, determination and sensitivity, working himself well into his character and the atmosphere of those hard and difficult times.

Everything was falling into place as London-born Jon Amiel was brought in by Gere himself to direct the movie. He was probably best known for directing British television's *The Singing Detective*, which gained numerous awards including the Golden Globe Award for Best TV series, three British Academy of Film and Television

Awards, England's Drama Critics Award and the Golden Gate Award at the San Francisco Film Festival. His first American movie was *Tune in Tomorrow*, released in 1990, which starred Barbara Hershey, Keanu Reeves and Peter Falk.

Amiel knew just how important his choice of location would be to the authority and realism of the picture and considered locations in fifteen states. The picture would eventually be authentically filmed entirely on location in Virginia and, as an interesting aside, became the first motion picture allowed to shoot in the George Washington National Forest, though not one hole was allowed to be dug by the construction crew without an accredited archaeologist being present to look for remains of habitation that might have dated back over 9,000 years. Its rugged and remote hills looking down on the pristine Jackson River presented an unspoiled, stark but picturesque setting for the post-war saga.

On the site, production designer Bruno Rubeo constructed the village of Vine Hill, consisting of almost thirty buildings, including a church, hardware store, blacksmith shop, general store and related buildings, homes, slave cabins and outbuildings for the Sommersby plantation. Four authentic log structures, three for slaves and a larger home, were purchased and assembled.

A further link with *Pretty Woman* was costume designer Marilyn Vance-Straker, who won a British Academy Award nomination for the Gere-Roberts blockbuster. *Sommersby*, however, presented a challenge of a different kind, for the picture's wardrobe consisted of well over 2,000 ensembles. In addition to designing clothes for the stars, she rented rare period attire from costume houses around the world. The inventory even included gowns from *Gone With The Wind*, though in general the clothes were far removed from the urban finery that has marked traditional Civil War-era pictures.

While artisans were creating the canvas for *Sommersby*, the cast assembled in Hot Springs, Virginia. In addition to the customary rehearsals, Gere, Foster and co-stars were kept busy acquiring certain skills for their roles. Foster learned to handle a horse-pulled buckboard while Gere practised guiding a particularly stubborn mule through its chores. All the actors learned period dances, which Gere found somewhat easier than his mule chores. They also worked with dialect coach Julie Adams to pinpoint the unsophisticated, isolated and harsher mountain speech that would accurately identify the roots of the Sommersbys and their story.

Producer Steven Reuther would see the picture as a story in which the war is a metaphor for the tremendous changes that every

character undergoes. 'Some change for the better and some change for the worse, and the upheaval that results is both tragic and uplifting, very much the way America suffered through the Reconstruction and then grew stronger.'

Flagged as an epic tale of love, deception, denial and hope, the script calls for Jack Sommersby to make the ultimate sacrifice, bringing a conclusion that is grippingly tense, emotional and dramatic. The *Sunday Times* declared it to be 'by far the most enigmatic film seen in London this year', while the *Observer* defined it as 'a plodding, confusing narrative that neither does proper justice to the story nor really teases out the complex, historical and psychological issues which it raises'.

In taking the Jack Sommersby role Gere put himself up against the formidable French star Gerard Depardieu from the original version, inviting comparison, particularly since Gere had previously declared that with the new version he wanted something more emotional and juicy. But Gere's performance matched the character well and he typically underplayed the role so convincingly that the comparison was never an issue.

Work on *Sommersby* ended in September 1992 and the picture opened to generally good reviews and a healthy box-office; and was soon widely considered one of Gere's better efforts, a commendable successor to *Pretty Woman* and *Internal Affairs*.

Foster, too, was pleased with the outcome; and with Gere's performance. 'It's a side of Richard that people haven't seen before,' she said. 'He has been prevented from taking more challenging roles in the past because of what his fans might think. I don't know why he didn't try something like this before.'

Eventually the picture made a handsome $150 million with Gere, as executive producer, on a useful additional percentage.

Not so Gere's other picture, *Mr Jones*, which was still languishing, and, had it been practical to do so, it might have been better for all concerned to have abandoned ship on this project there and then.

The storyline was an off-beat affair hardly likely to generate eager queues at the ticket offices, but the relatively simple basic plot about two people who cross barriers and break conventions because of an overpowering love was always calculated to captivate Gere. He was determined to see the picture through, despite its catalogue of disasters. Finally, six writers, two directors and nine producers would struggle valiantly to revive a limp and lifeless project.

*Mr Jones* reunited Gere with Mike Figgis, who had made his

American film debut successfully directing Gere in *Internal Affairs* a couple of years before. Starring opposite Gere was Lena Olin, a Swedish actress who had made her American debut in 1988 opposite Daniel Day-Lewis in *The Unbearable Lightness of Being*. For her work alongside Ron Silver and Anjelica Huston in the critically acclaimed *Enemies, A Love Story*, released in 1989, she received the New York Film Critics Award as best actress as well as an Academy Award nomination. Also cast in *Mr Jones* was Anne Bancroft, who had won a Best Actress Oscar in 1962, on her return to pictures after five years on Broadway.

So there was no shortage of acting talent, though *Mr Jones*, in retrospect, was never likely to be a runaway success. Full-length medical pictures, unlike TV soaps, seldom are and *Mr Jones* turned out to be not even among the best of its kind. In researching his role, Gere spent considerable time with manic-depressive patients from the Los Angeles Veterans Administration Hospital and was amazed by their sensitivity and insight. But even the insight and authority that he brought to the main character was not enough to save a picture, which somehow seemed doomed from the start.

When the picture was finally released in late 1993 after more than two years of stop-start tedium and chaos, Gere tried hard with his official quotes to bring the project to life. Of his own character, Mr Jones, the mental patient, he said: 'He is at once powerful and vulnerable, enormously secure, incredibly sensitive, potentially violent. It's a devastating combination. He dazzles the world with energy and fun and charm.' It was a nice try.

Olin, cast as Dr Libbie Bowen who as Mr Jones's psychiatrist, and despite her professional training, is challenged by him, intrigued by him and finds herself risking her entire career because of him, was a little more persuasive. 'Libbie is lonely,' says Olin. 'She lives in a country foreign to her. Her alienation is intensified because she is fed all day with other people's depression. She is an intellectual being. And then (and here it gets better), Mr Jones stirs feelings the intellect can't process. It's very seductive.'

Even so the hints of there being more in this opus than white coats, mental sickness and even doctor-patient relationships, were not enticing enough to count for very much. Nor were the 20 million or so Americans who were said to be currently suffering from mood disorders. In the jargon it simply was not a hot subject and, even for many punters tempted by the glamour of a Richard Gere castline, not worth the effort of rising from their armchairs in front of their television sets.

It was a lost cause almost from the beginning and the picture, though eventually managing to gross a surprisingly commendable $8.5 million, was quickly set to one side as not one of Richard Gere's pictures you would want to see again.

The last few months had been a hectic and worrying time for Gere and in November 1993, within a month of the release of *Mr Jones*, he left Los Angeles for China to attend a première of *Sommersby* in Canton. From there he travelled to Peking and then headed into the Tibetan heartland, where he disappeared leaving behind just the one message with chosen friends before he left: that he intended to return to Los Angeles on 6 December.

There had been problems in his relationship with Cindy Crawford and once again he had been harassed and angered by the press. He was glad to be away from it all though others not in his exclusive inner circle were concerned about his disappearance. The press carried alarming reports that he had not been seen for some time and speculation grew that something might be wrong.

It was not the first time he had 'gone missing', but never before had he opted out for so long, for he had much to do. Alive and well in the Tibetan capital, Lhasa, he was soon enjoying the spiritual uplifting he always seemed to find in the peace, contemplation and serenity among the Tibetans. His mission had a particular purpose and he spent nine days visiting temples and monasteries to meditate with monks and to pass on messages from their exiled leader. He also went sightseeing around Lhasa on a hired bike, relaxed and content as he wandered among nomadic herdsmen who had never seen a television set, let alone any of his films. He drank yak butter tea; and Tenzin, his part-time guide, said he willingly posed with him for a photograph for no better reason than he asked him if he would. Said Tenzin: 'He was very kind, but didn't want anybody here to know who he was.'

He based himself at Lhasa's Holiday Inn, occupying the £180-a-night Tibetan Suite, though by no means luxurious against his own American standards, and was happy to join the handful of other Western tourists in the hotel coffee shop, the Hard Yak Café, where the speciality is yakburgers. But his free time was limited. Numerous appointments had been made for him with VIPs in Buddhist circles and he had a lot of courtesy calls to make for the Dalai Lama, as it was really a diplomatic or political mission for him.

Once home again and back to reality, Gere could look forward to the release in 1994 of a new picture, which promised to lighten the

depression he was suffering. The depression had three main causes; first was the debacle of *Mr Jones*, which in a sense skimmed away some of the prestige and satisfaction he was entitled to be enjoying from his sensitive performance in *Sommersby*; second was the press and its allegations about his own sexuality, together with an injudicious comment by Cindy Crawford – was she a lesbian or not?; and third was his own faltering relationship with Crawford, which had not broken into outright public debate at this stage.

The press situation had come about at the time Crawford was being pictured by *Vanity Fair* and she had been tempted, almost certainly against her better judgement, into answering the continuing question about Gere being gay. She suggested that the question had come about simply because he had a lot of gay friends. She then added that she wondered how he could manage to be gay, considering all the women he had been with. The question about her own position then came up and, caught off-guard, she was thrown on the defensive when reminded that she had once said that lesbianism was probably a safer way now for young women to explore their sexuality.

Gere was also aware of the disintegrating nature of his marriage to Cindy, which was destined to end in December that year in their much publicised declaration of an official separation, though both refuted the idea of a divorce.

If the darkening clouds over his private life angered or saddened Gere, then the prospects for his next film, *Intersection*, shone through like the proverbial beacon. All the elements were in place and the portents could hardly have been better. For what full-blooded cinema-goer could possibly resist the explosive combination of that provocative and sensual self-starter Sharon Stone and Richard Gere, still occupying a special place among the small elitist group of Hollywood male icons. Never mind what the picture was about. Sharon and Richard together was surely an unfailing combination; the movies' two most charismatic stars together for the first time. All it needed was a half-decent plot and a reasonably good picture.

Gere was cast as Vincent Eastman, a successful architect, who finds he must choose between continuing a marriage with his beautiful wife, Sally, or starting a new one with his equally beautiful lover, Olivia. There is a further vital complication in the form of his 13-year-old daughter, Meaghan (Jenny Morrison), with whom he has a close and special relationship. Then, at the very moment of Vincent's decision, fate steps in to remind us and Vincent that –

unlike one of his award-winning buildings – life cannot be designed or controlled down to the last detail; and the very thing that makes life exciting and unexpected is also capable of producing devastating and deeply ironic consequences.

After her recent knock-out successes in sizzlingly explicit movies like *Basic Instinct*, the top-grossing film of 1992 and for which she received a Golden Globe nomination, and *Sliver*, the following year, it is a shock to find Sharon Stone playing Gere's beautiful and faithful wife, Sally, who is not required to strip at all and has only one love scene in the entire film, while Lolita Davidovich handles the role of Gere's lover. The explanation is that Stone was becoming fed up with being typecast as the sexpot supreme, despite picking up around $5 million a time for the pleasure; and it was she who actually contacted director Mark Rydell to express her interest in the movie when he and Gere were casting the female roles.

Rydell had not even considered her for the role of lover, let alone the dutiful wife, feeling that despite her enormously high profile and her movie experience, which stretched back some ten years, she had yet to prove herself as a more serious actress. He was not at all responsive at first, by all accounts, but she was extremely insistent and he finally agreed to consider her.

At this stage he had the part of Gere's lover (Lolita Davidovich in the picture) in mind for her and only when she arrived for a reading with Rydell, and it became obvious that they were at cross purposes, did the situation sort itself out. Stone made it clear that she did not want that part; it was the wife role she was interested in, saying just how much more interesting it would be, after all her sultry roles and sexy reputation, for her to be cast against type as the wife and mother. Rydell was still not convinced, but when she read for the part all doubts left him, particularly after Stone had given what has been described as a remarkable performance in her character's most dramatic moment in the picture.

Perhaps, already nudging into the high thirties, she was right to leave the role of lover to the younger Davidovich, herself sultry enough in films like *Blaze, Leap of Faith* and *Boiling Point*.

The picture overall was high on talent for director Mark Rydell, whose films had already chalked up twenty-six Academy Award nominations including nine for performers, was himself still basking in the success of the sensitive 1981 classic, *On Golden Pond*, for which its stars Henry Fonda and Katherine Hepburn, along with writer Ernest Thompson, all gained Oscars, while Rydell was an Oscar nomination in the Best Director category. Also working on

*Intersection* was the talented Bud Yorkin, as co-producer with Rydell, while Marshall Brickman, who wrote the screenplay along with David Rayfiel, had won an Oscar for his work on *Annie Hall* back in 1977.

*Intersection* had first been brought to Paramount by executive producer Frederic Golchan, who controlled the rights to the book *Les Choses de la Vie* (the things of life) and the French film it inspired. 'I'd always wanted to make a movie about how ephemeral life is,' says Golchan, 'and how you have to grab it. The structure of the movie is told in a way that gives a unique perspective of the things that we said, the things we meant to say, the things we have done and the things we wish we could do. This is heightened by the fact that the characters are frozen at a major intersection in their lives.'

Rydell further explains: 'The story unfolds in a unique and powerful way. It takes place during a developing automobile accident that flashes back to the story of five characters and what led to this critical moment. As the car begins to spin, we spin into the story.' The flashback routine worked well, adding interest and focus to the story-telling.

Bud Yorkin described it as a film about the dynamics of a man who at the one moment wants to be free and the next moment does not 'You're torn between sympathy and anger for him,' he said.

Typically, Gere had his own views about the story, seeing it in terms of strong human relationships. 'Vincent and Sally didn't work through the mistakes in their relationship, which is what has to happen with all marriages,' he said. 'He is looking for happiness and doesn't quite know how to get it. He's juggling the lives of three women – his daughter, his wife and his girlfriend. He obviously loves all three women and they love him, but Vincent's inability to make a decision causes a lot of pain to the people around him, including himself.' Gere concludes: 'Finally a decision has to be made – no one can bear it as it is any more. Things have to change. Everyone is in a pressure cooker, so he is forced into action.'

So much of that could be, most eerily, a prophesy for his own private life – the forthcoming disintegration of his marriage to Cindy after not being able to work through the mistakes of their own relationship; the elusive happiness, which Gere's attitude, comments and career have almost always suggested; the difficulties in making decisions, which Gere has admitted to on numerous occasions.

The cast and crew moved to Canada and the picture was shot

entirely in British Columbia during the spring of 1993, on Victoria Island and in Vancouver, home to renowned architect Arthur Erickson, who served as a consultant to the production. It was billed loosely as a romantic drama.

Gere is convincing as the wealthy architect, Vincent Eastman, while Stone makes a successful transformation to smooth, respectable glamour, with her clothes on this time, as his wife and business partner. But there's an obvious stand-off between them except when fronting clients and colleagues, which shows just how tepid their relationship has become. It is no surprise when Vincent takes the lovely Olivia as his mistress, leaving his wife behind, though still having to be with her in the office.

Vincent grapples with the complicated situation, made all the more difficult by Sally's often awkward efforts to get him back, and the devotion and love he has for their daughter, Meagham, nicely portrayed by the 14-year-old Jenny Morrison making her motion picture debut. In the end he reaches a decision but changes his mind before crashing his car at speed – hence the explanation in flashback form.

Against *Pretty Woman*, and *Sommersby* even, it was a relative non-starter. However, though based upon a classic situation, it developed interestingly enough even though some critics brandished it as another failure for Gere. The paying public were more optimistic and in the end *Intersection* did reasonably well at the box office, with earnings pushing up in excess of $50 million.

# 12

# Darling of the Tabloids

It would be hard to find an actor who has suffered as mercilessly for his art as Richard Gere. He has fought desperately over many years to keep his private life private. There has been a long and wearying battle waged in public and often sickeningly, over his sexuality. And because he dug his heels in and fought the media, sticking to the principle that as an actor it is only his professional life that should be open to examination and debate, it would be hard to find someone who has antagonized the press more, and agonised as much over doing so.

On the other hand, for someone who is positively territorial over his privacy and goes ballistic even at the thought of a journalist, Gere has not always helped himself over the years. All too often perhaps he has shown himself to be his own worst enemy. But Richard has consistently defended his obsession with privacy. 'I won't have my privacy invaded,' he declared quite early in his career. 'I don't think people have the right to know everything about me.' It was a challenge the press could not resist; and they have relished the battle ever since.

It all started during those early days in New York. On stage in Sam Shepard's *Killer's Head* he was a convicted murderer who spent the whole play strapped into an electric chair with a blindfold over his eyes. Then came those early film parts. He was a street-smart pimp in *Report to the Commissioner*, a shell-shocked psychopath in *Baby Blue Marine*, an animalistic hustler in *Looking for Mr Goodbar* and, a little later, a male prostitute in *American Gigolo*.

Could he really expect the press to ignore all of this? They labelled him a sex symbol, which he hated, but the label stuck. He

saw himself as an actor, not a celebrity. But even today his fans appear to like him best for his handsome looks, pleasing physique and sexy image.

By the time he came to England to make *Yanks* in 1978, and still looking for that major breakthrough in pictures, he hired a press agent, not to get his name in the media, but to keep reporters and photographers off his back. The barrier was already in place as early as that. Later it became an almost unbreachable stockade and in his continuing obsession to secure his privacy he would, in all innocence, act against the best interests of the very thing he held most dear.

For his steadfast refusal to talk to journalists encouraged them to try that much harder, increasingly turning to 'studio insiders' and 'associates' for second-hand titbits. His non-cooperation was a rampant breeding ground for rumour, speculation and innuendo. When he could be persuaded to give press interviews he would often lose his temper, antagonising journalists and photographers. Often he was downright rude, as in the well-documented case of the magazine writer who asked him what it was like to be a sex-symbol. He dropped his pants and showed her! Even today he has not fully accepted that, when visiting Britain for instance, the press will naturally and almost certainly be gathered at the airport when he arrives, scrambling for the odd comment and the sneak picture. It does not matter to them whether he is here on a private visit or to boost his latest picture. If he wants the benefits of media attention for the latter, then he must be prepared to work with them on the former. That is the way they see it. To them Richard Gere is Richard Gere, whatever his reasons for coming. He is a celebrity and he is news. So they need to tell the public what the public wants to know; and that is every bit as much about his life off-screen as on.

Of course no one would deny that Gere has a valid point. Everyone, even a movie celebrity, has the basic right to privacy. Theoretically, there is no question about it. But realistically in the 1990s, in an age of electronic communication and mass media, when newspapers have pandered to a heightened public taste for tittle-tattle, it does not quite work that way and Gere increasingly has been seen to be out of step with reality. A celebrity somehow has to come to terms with all that. Like it or not, Richard Gere is a celebrity as well as a movie actor and, as such, the public feel the right to have a part of him. The simple fact is that Gere represents a media man's dream. His private life has yielded more good news

stories than his film roles, though these certainly have been provocative at times. Whatever he does and whatever he says seems to make news. The potential for good copy is almost limitless and those who work in the media are not prepared to stand by and let all those good stories and revealing pictures go unpublished.

It is not only tabloid journalists who seem to set Gere's teeth on edge. He holds little respect for studio and film company publicists either, often criticising them for being manipulative, which of course in some respects they are. Adding a suitably acceptable gloss to the release of a new movie is part of their job. It is a concept that Gere finds hard to accept. Nor is he fully in tune with television interviews arranged to plug his latest film. It is a difficult situation to control and he knows that sooner or later he will be asked about his private life and sexy image.

His loyal fans and the general public do not always escape his wrath. In his most brooding moments he can dismiss them with contempt, when he feels they behave badly or impinge on his privacy. One incident that made the news pages in 1984 had Gere accused in court of beating up a New York car park attendant in what was described as a 'grudge' attack. Harold White claimed that the star had shouted and sworn at him over a period of eight months each time he drove his car into the garage near his Lower Manhattan penthouse. Gere denied the charge and was eventually cleared of assault, but was later served with a civil writ.

Another time he was reportedly banned from his local corner shop by owner Gil Turner because staff complained that he had been rude to them.

Gere claims that he is often misunderstood. At the same time he has said with some pride: 'Nobody knows who I am and they never will.'

Despite his fundamental conflict with the press he continued to play into their hands as his career developed. Having already been branded a sex symbol, making *Breathless* with its nudity and steamy love scenes was not exactly calculated to encourage the press or the public to alter their views. Nor was his role as a homosexual inmate at Dachau in the dramatic *Bent* on stage in New York. Certainly it helped considerably to confirm his credentials as a serious actor, but the nature of the play did not exactly transport him into another, perhaps more elevated, pigeon-hole. Meritorious though his performance undoubtedly was, it only served to consolidate his image.

Speculation gained momentum as he refused to be drawn into the

debate. He did not deny he was gay. He would not confirm he was gay. He simply avoided the subject. He was perfectly right again, of course. Whether he was or he was not a homosexual simply was not anybody else's business.

But the fact that a denial was not forthcoming inevitably only served to feed the rumour that he was; or might be. The press loved it of course and as it became the subject of an increasing amount of media speculation, Gere himself battled on against all the odds. Some years later, and some years older of course, there seemed evidence that his attitude was becoming a little more temperate. He would admit that celebrity was a hard thing for him to handle and that when he started out he was narrowly focused on his work. 'It was a 24-hours-a-day pre-occupation,' he explained, adding that he had come to realise that acting can be a more spontaneous flow and that you do not have to be so wired-in all the time.

But on the subject of his sexuality, as with being a sex symbol, Gere seemed unable to win, whatever happened. Even when he started going out with Cindy Crawford the speculation continued. But surely anyone who had a relationship with such a female icon must be a full-blooded male in the old-fashioned, traditional sense. Rather than admit defeat, the speculators then started talking about, would you believe, Crawford's own sexuality. The fires of rumour had been stoked again. He had given them, with Cindy's help admittedly, two for the price of one.

OK, but what about his ever-so-straight lover image on the screen? Surely that was powerful enough to convince the most ardent sceptics. But hold on. What about those shock posthumous revelations about some of the biggest male stars from the glory days of Hollywood? If it happened then it could certainly happen now.

His co-stars ought to have settled the issue once and for all. Or his real-life girlfriends. He was reported to have had more spontaneous relationships with the former than any other star you could name. Still the speculation persisted, notwithstanding his long-term relationships with Penelope Milford and Sylvia Martins.

Little wonder that his in-built petulance with the press witnessed little tangible improvement as the eighties advanced. The battle lines were still drawn. Among his enormous following in Britain, his television interview with Michael Aspel in 1989 is still vividly remembered. It happened during a recording of *Aspel & Company*. Aspel, not the most investigative, hostile or cunning of interviewers, caught Gere on a raw edge when he quoted to him a review which referred to him as a 'sexual hand-grenade'. The scenes

that followed were described as 'amazing'. He glowered at Aspel as
the review was read out and at the interval demanded that Aspel
drop all the 'sexy stuff'. At the end of the recording he stormed out
of the studio refusing to have a drink with Aspel or fellow guests
Dame Edna Everage and Lauren Bacall. Aspel was astonished. He
said later: 'Richard Gere is an actor who is disturbed by his image. I
know he was upset when I quoted the review … but I just told him
to look around the audience at all the women … all he wanted to
talk about were his spiritual experiences since he has become a
Buddhist. He went on at some length about the Dalai Lama and his
times in Tibet.'

Whatever may have been said about Richard Gere's obsession
with privacy, his courage is indisputable in both his personal life and
his choice of film role. He will risk tarnishing his screen image if a
role attracts him enough and while it is not altogether exceptional
for a celebrity to take up a cause, Gere's commitment to the issues
that he feels to be important is impressive.

His conversion to Buddhism in the mid-1970s and his meetings
with the Dalai Lama, gave the press even more ammunition. It
simply added to his unconventional, freaky kind of image. No other
screen star had travelled as far as Gere along that particular road,
nor with such positive intent. And while many celebrities held back
from any form of involvement with such contentious issues as
AIDS, sexual differences and political radicalism, Gere confronted
all three of them head-on. He openly supported AIDS education
and care, together with lesbian and gay organisations.

The press picked up the scent again when he agreed to appear in
director Roger Spottiswoode's highly-charged television movie
presentation, *And The Band Played On*. Based on reporter Randy
Shilts's disturbing and controversial best-seller *Band*, it relates the
progression of AIDS, from the beginnings as a distant, almost
irrelevant, threat to its current close and ever-present danger. In the
book Shilts pulls no punches as he tells the story, which includes,
among other issues, gay sexuality and the alleged indifference of the
medical profession in the early days of the disease. Gere's
willingness to align himself with a project of this kind set tongues
wagging once more about his own sexual orientation. The talk was
flippant, hole-and-corner, nudge-nudge, wink-wink stuff when in
fact he saw his own involvement as a serious and relevant
above-the-line contribution to an issue of concern to people all over
the world.

Intended for prime-time TV this contentious issue was always

expected to face problems in getting onto the small screen. Advertisers were reluctant to support TV programming that featured gay characters or themes and it was five years before *And The Band Played On* was shown. ABC turned it down. NBC had it for a couple of years, where it lodged in the development process. Actors and agents gave it the cold shoulder. HBO Pictures finally took it on, but had difficulty with casting. Major names were important to the success of the project, but most backed away from such a close liaison with the subject, which had not been openly presented in this mainstream way before; and especially when no other names had been signed. Gere became the catalyst after Roger Spottiswoode spoke to him at an AIDS fund-raising event. He not only agreed to appear, but shunned a 'hero' role as one of the doctors, insisting on being in the thick of the controversy playing a gay choreographer stricken with AIDS. With Gere committed, other stars followed and the picture was made.

Gere was angry that the project seemed to need the backing of big names. 'It's a good script, a quality piece of work,' he said. In the end Steve Martin, Anjelica Huston, Phil Collins, Sir Ian McKellen and Lily Tomlin were among those who appeared in the movie.

For many thousands of people not close to Gere, his involvement in a project of this kind simply proved once more his exaggerated pre-disposition towards marginal issues to the impairment of his mainstream career. Those closer to him knew only too well just how deeply he felt that something more positive should be done about AIDS, particularly following the death from an AIDS-related condition of Tina Chow, a one-time girlfriend, and of actress Joan Marshall, who had contracted HIV from a transfusion of infected blood. Joan, the former wife of award-winning director Hal Ashby, had been a loyal friend and staunch advocate when Gere made those early Hollywood films. They had been friends for twenty years. She was a socialite in New York and had stood by Gere during those difficult early years. He was said to have wept when he heard the news of her death. There were also other colleagues and friends who had become victims.

In much of the 1980s it was difficult to pin-point Gere's role in life. He seemed to spend as much time trailing the Dalai Lama and fighting battles about the United States' position in Central America as he did in making pictures – yet somehow he managed to fit in an average of almost one movie a year during that decade.

He was by this time a tireless international human rights activist. In mid-1986 he travelled to Central America in active support of El

Rescate, a Los Angeles-based agency providing legal and social services to the Central American refugee community. He took off in the face of considerable personal danger and talked to Latin rebels and revolutionaries, toured refugee camps in Honduras, afterwards visiting the American airforce base at Palmerola to provide moral support to the 1,000 troops stationed there. Back home he campaigned tirelessly for an anti-Contra Democrat, becoming deeply involved in the politics of protest. He investigated ways of improving health care for refugees and peasants. Twice he testified before the Congressional Human Rights Caucus concerning El Salvador and Tibet.

He did not appear bothered that his string of pictures in the later 1980s were not amounting to very much, financially or in any other way. There had been nothing remotely to compare with *An Officer and a Gentleman*. But after discovering Buddhism he would appear to be more than willing to devote most of his time worrying about and working for the beleaguered in unfashionable far-flung places. Nearer home, at Britain's Wembley stadium, he happily stood up to be counted against apartheid and injustice at a Nelson Mandela concert. He was as courageous at home in Hollywood campaigning for the newly launched Save Tibet Fund.

There is no denying that Richard Gere comes over as a complicated, deep thinking individual on many issues. It is not exactly the sort of clear-cut image the media can get their teeth into, but that does not concern him. It is typical of the man that having himself become involved from time to time with political issues over the years, he was at the time also honest enough to signal the dangers of such an involvement for celebrities. 'I think it's dangerous sometimes for celebrities to get involved in political causes,' he said. 'I think it has a tendency to superficialise things, unless you talk about things you really know about.'

That is something that Gere has always known about. Whatever he does he acts from a basis of conviction and with courage. When journalists did find him on a good day and ready to spend some time talking to them, he more often than not still refused to talk about the things they really wanted to hear, i.e. himself and his private life. More than one promising interview has been abruptly terminated when a persistent journalist came face to face with this particular film actor.

Yet in spite of all that, or is it perhaps to some extent because of it, Richard Gere's column inches of publicity are still piled higher than most of his contemporaries.

# 13

# Buddhism, Cindy and
# *Pretty Woman* Triumph

The early nineties confirmed Richard Gere's multi-millionaire status. A clutch of mediocre pictures had been more than overwhelmed by the triumphs of *Pretty Woman* and *Internal Affairs*. Box-office takings from the former eventually topped a massive $450 million and he also benefited from having a financial stake in *Final Analysis* and *Sommersby*.

He also appeared more relaxed and, as a devout Buddhist, meditated every day in a special room in his New York penthouse. The tinsel and trappings of Hollywood, which had never impinged on his personal and committed life-style, seemed even more distant now. He had voiced his new perspective even before going on the set to make *Pretty Woman*. 'I never cared about being a star and I don't care about having a hit movie,' he explained.

Critics again claimed he had jumped on the bandwagon of obscure causes to boost his flagging career. He countered this by reminding them that he had already committed fifteen years of his life to freeing Tibetans from alleged Chinese harassment. That was when he went to Nepal for the first time, before he was a big star. He explained: 'I was appalled by what I saw. The hardship was terrible. The Chinese had just overrun Tibet and destroyed the culture.'

On a more day-to-day level the early nineties also meant, significantly, Cindy Crawford. Since that first meeting their relationship had blossomed into an intense affair. They signalled the news of their relationship clearly enough in March 1990 by appearing at the Academy Awards ceremony together. It was like a

rocket exploding. The tabloid headlines instantly became bigger, bolder and more frequent than anything their individual careers had claimed.

Maggie Wilde, Richard's partner in his production company, put her finger on it some years later: 'Richard and Cindy together in public didn't just double the hysteria – it magnified it a hundred times over.' Cindy handled the unyielding media attention better than Richard. For Cindy it was all new and novel. Richard had long since had enough of it all. Eight months after their marriage, Gere accompanied Crawford to London to help promote her fitness video. The visit proved conclusively that, where his privacy was concerned, marriage had brought no respite. It was still the impossible dream.

They had flown in from India to be confronted by a barrage of photographers at Heathrow. Cindy was all smiles and charm. Gere, unshaven after the nine-hour flight from Delhi, was in a less charitable mood. He stopped and glowered before rounding on an Air India representative: 'Why did you tell them we were coming?' he demanded. She said she had not told them. Her reason for being there was specifically to help smooth their passage through airport formalities. 'It's the only possible way they would know,' he snapped back. Then he became more irritated when he saw that the holdall she was carrying was too heavy for her, asking if she could not get someone to help her with it.

Of course, the poor girl was not at all involved with his problem. The press have their information sources and, about the comings and goings of celebrities, the bush telegraph is extremely efficient. Significant departures from, or arrivals at, airports are seldom missed. But he was much happier and composed in London a few days later attending an exhibition of Tibetan Religion and Culture at the Royal Academy of Arts. After being welcomed by Tibetan monks living in the capital, one of them gave him a personal demonstration of ancient Tibetan crafts. He was totally absorbed.

The new decade signalled a particularly hectic time for Gere and included a good deal of travel. He visited London a number of times. In the capital again in April 1990 to promote *Pretty Woman*, he ran true to form by laying down pre-conditions for an interview with Britain's talk-show host, Terry Wogan. After his confrontation with Michael Aspel the year before, he insisted this time that the recording of the interview be totally editable and that there should be no studio audience. Under these conditions it is perhaps surprising that the interview went ahead at all. It was broadcast on national television on 17 April that year.

A week earlier he had been much less on edge when talking to newspaper journalists. Victor Davis (*Mail on Sunday*) said he was positively skittish, joking and laughing at his favourite London hotel overlooking Hyde Park. He wondered if Gere's two recent major successes, after some seven years of indifferent picture-making, might not have had something to do with his brighter mood. The now 40-year-old Gere deflected the questions while offering his own opinions. 'I don't find myself as angry as I once was. I have found a way so that fame doesn't bother me anymore. I realise now I don't have to fight it.'

It was Gere at his disarming best putting an optimistic gloss on the celebrity mantle of fame with which he had always been uncomfortable. However, his genuine devotion to Buddhism and the needs of the world's oppressed people was providing an increasing depth of commitment. And even the most devout cynics were now more inclined to acknowledge his sincerity as in the nineties, with his financial status relieving him of the pressures to earn, he gave unstintingly of his time, thought and energy to these beliefs. Being a Buddhist had not made him a better person, insisted Gere, but it had made him a happier one.

In between his promotional duties in London, he made time for a meeting with Peers at the House of Lords to discuss the continuing troubles in Tibet. While he never publicly mentioned the fact, it had not gone unnoticed that next to his famous Rolex watch, which had been part of Gere since his early successes, he now wore a red thread around his wrist indicating his initiation into a higher level of Buddhist teaching. He was candid about politics back home, accepting that his campaigning activities were such that in the fifties he would doubtless have found himself hauled in front of the Un-American Activities Committee for his campaigning. He also claimed later that the Bush administration did not want to upset the Chinese and that they did not welcome his support for the Sandinistas and the El Salvador refugees.

Back home in New York, Tibet House, the cultural and educational centre established by Gere, was now solidly and efficiently operational, successfully raising money for the cause of the Tibetan refugees. Gere's involvement was never a remote, arm's-length arrangement. He did not just set it up and leave it at that. He had become its first president and quickly acquired a reputation for his up-front, hands-on commitment. In the nineties he would often put in an eight-hour day in the office there when not making pictures. He involved himself in fund-raising, planning

events and the establishment of a positive public profile for the organization. He made personal donations. His close, ground-level functional engagement with the cause brought profound benefits and his clear public identification with the plight of the Tibetan refugees would increasingly make a wider public aware of the problems. His own public profile was solidly allied to the cause.

Unable to match his enthusiasm and dedication, Cindy none the less took an increasing interest in what he was doing and was impressed by his sincerity. She made a number of trips with him and they were together as much as their individual commitments would allow. The year ended with their unexpected, romantic 'runaway' marriage in Las Vegas in December. It catapulted them to the top of the media tree and set off a phase of unprecedented press attention.

Early in 1992 Gere was shocked when model Tina Chow, his girlfriend for about four months in 1988, died from AIDS. He was devastated by her premature death. Cindy comforted him and towards the end of the year was with him when he was master of ceremonies at an awards luncheon, an event held by the American Foundation of AIDS Research (AFAR) at the United Nations in recognition of World AIDS day.

Meantime, Cindy continued to make news on her own account. As a model girl with fierce ambition, she had never lacked a fine appreciation of the media's role in keeping her in the news and was understandably pro-active in her relationship with the press, perhaps manipulative; certainly more so than Gere. Newspapers and magazines were part of her celebrity status. They had played a decisive role in creating it at an international level. They represented her showcase and shop window. Her marriage had heightened press attention and sharpened the focus, not only as a marriage partner to Richard, but also, as Maggie Wilde rightly said, in the two of them as individuals. But modelling is much more of a day-to-day occupation than film-making, when you can be away from news-making situations for longer periods. So as a supermodel with celebrity overtones, and by this time also a cult-style pin-up, Cindy was now always likely to make the news and feature pages more readily than Richard.

There was strong and startling evidence of this in October 1992 when a pouting Cindy posed seductively on a St Tropez lawn. There had been a taster some months before when a poster of Cindy in skimpy lingerie had been banned in Norway because of the potential danger as passing motorists had their attention diverted.

The picture had been taken by the noted 70-year-old photographer Helmut Newton, who had made his name setting his camera at women after arranging them in what has been termed 'seductive and demeaning' poses.

This latest work, intended by Newton for use in American *Vogue*, ran contrary to Cindy's squeaky-clean, girl-next-door professional image. In one picture Cindy was seen in a two piece swimsuit on her back with feet drawn up and her knees apart. Scarlet nail varnish was said to exaggerate the overtly sexual pose as another famous model, Helena Christensen, standing close to her, looked contemptuously down on her, hand on hip. In another shot Cindy, in a fetching black one-piece swimsuit, is similarly posed with knees apart, but this time sitting on the curb-edge of a street almost under the wheels of a glistening Rolls-Royce and clearly submissive as a man dressed all in black stands aggressively over her. The pictures were all the more surprising since a month or two before, on a trip to London, Cindy had said she did not even like doing her yearly swimsuit calendar pictures. The reason for doing it, she explained, was because she thought it might broaden her image.

The paparazzi pricked up their ears and dusted off their lenses. If this was to be the new Cindy Crawford, they wanted to be part of it. But Gere made no official comment.

It was in London, too, that Cindy dropped another bombshell. She wanted to follow her husband into films. It seems there had been plenty of opportunities to broaden her career by going into movies, but the scripts had not been right. 'They all seem to start with me ripping off all my clothes in the first scene and not even saying anything,' she complained. Her husband, certainly, could hardly have been expected to complain about that, considering his own track record of nudity on film. Though one should remember that Gere always said he would not be exploited. The stripping off must be a natural and logical part of the action. 'But I don't want to end up looking like Madonna,' asserted Cindy.

All this positive career development seemed to sit just a trifle uneasily when set against Cindy's public declaration that same year that she wanted a family. She was reported to be earning an estimated $12 million a year and Gere himself was seeing a substantial financial build-up from returns on *Pretty Woman* and *Internal Affairs*. While Gere might have been happy enough for a while to settle down within the security and seclusion of their magnificent, new $4 million Georgian mansion in exclusive Bel Air, Cindy made no secret of her continued strong sense of

commercialism. She was more in demand than ever and was enjoying it.

Meantime, during much of 1993 and 1994 Cindy continued to make the running as a public figure while Gere remained for a time in the background. He was pleased to see the release of *Mr Jones* after such an agonizingly long gestation period and the successful opening of *Sommersby* in the UK in May 1993 brought him back in the news. That same month Cindy was in optimistic mood explaining that at first Richard thought that staying at home and preparing dinner was too normal and suburban. 'But now I think he realises it's not so bad and that's why a lot of people do it.' The point was that Cindy was more often than not, too busy to share the home life with him, if that is what he really wanted.

Richard was an expert at shunning publicity, having to be persuaded to appear in even the occasional talk show or attend for press interviews. Cindy did not appear able to get enough of them. Inevitably, for no better reason perhaps than their apparent incompatibility in their general attitude to fame, rumours began circulating about difficulties in the marriage; that they just were not being together enough. They were together, however, in July 1993 holidaying in London. They attended the Guards' Polo Club at Smith's Lawn, Windsor, to watch a Cartier-sponsored polo match in which Prince Charles was playing. They were spotted almost on arrival and besieged by the press. With Cindy in tow, Gere took refuge in a nearby marquee, arms waving and voice yelling: 'Leave me alone, I'm on vacation.'

Order was restored at Gere's luncheon table, but after eating he quietly ducked through a back flap of the tent to take his seat in the Royal Box. Both he and Cindy were later presented to the Queen. The press caught up with them again a few days later when they were looking for bargains for their new mansion around the antique shops in Pimlico.

In September 1993 Crawford and Gere were said to have been offered £1 million each to promote a Kodak advertising campaign in Italy and Japan. Not surprisingly perhaps, Gere declined, but Crawford wanted to accept. Meantime, Cindy took off with photographer Herb Ritts and his team to a remote Caribbean paradise retreat for yet another important shoot in Cindy's continuing schedule. She was back in London in October, occupying a luxurious hotel suite with her small entourage of two publicists, an assistant and a couple of minders. In the capital to promote her next fitness video she relished the opportunity to

capitalize on her media persona. By this time there were renewed rumours that Gere was gay. Even more recent had been those magazine pictures of Cindy with Christy Turlington and k.d. lang, which raised eyebrows about her own sexuality. She dismissed all the fuss, claiming that all the so-called scandal in America was simply because of her very prim and proper public image. 'Maybe that's part of the reason I did the pictures,' she said, going on to explain that modelling was all fantasy anyway. 'That's what modelling is all about. I did it because the photographer, Herb Ritts, asked me to do it.' She had said all that before. In Ritts she placed much faith. She had of course known him well for many years and trusted him so much, it was said, that she had let him photograph her naked.

A throwaway comment during the same visit to London gave a serious hint, perhaps for the first time, that her marriage to Richard was not as settled as it might have been. She said that when she first met Richard their maps did not match at all. Should she have waited to find someone whose map fitted hers and hope that feelings developed? Or should she stick with the genuine feelings she had and try to make the map fit? 'Well, we're still trying to make the map fit,' she said.

Three weeks later Gere left Los Angeles for China to attend a première in Canton of *Sommersby*. It was on this occasion that he later travelled to Peking and from there headed into the Tibetan heartland, not to be heard from again for almost three weeks. Only a few close friends knew of his private mission. Whether Cindy knew is not certain. The hotel manager where he was staying said: 'He's very deep into Buddhism and cares a great deal about Tibet and the people. They think he is wonderful because he speaks out for them against the Chinese oppression.'

The obvious rift between Richard and Cindy showed little signs of improvement during the early part of 1994. Her popularity soared. She was much more than a model by this time; much more than a supermodel even. She was energetic and aspirational. Close personal advisers plotted a well-structured course of development that had taken her wholeheartedly into the highly lucrative areas of product endorsements, personal appearances and television. She continued as one of the highest paid models in the world, but now she also enjoyed celebrity status at the highest level. Sales from her exercise videos alone were reported to be valued at almost $100 million. But her rapidly rising fortune did not blunt her natural good sense. Her healthy respect for money was undiminished, a carefully selected donation or two to charity not withstanding.

Gere found much of what was happening abhorrent. He had long-since rejected commercialism for its own sake, but Cindy by this time had her own business affairs handled by specialists who did not include Gere in their reckoning. One concession, which could perhaps have been triggered by Gere's distaste, was the famous Crawford pin-up calendar. Its publication had been a major annual event since 1989 and it was widely known that Gere disliked the idea of the swimsuited Cindy being goggled at in factories, roadside cafés and workshops for twelve months of the year. The 1993 version was announced as the last, and thus an obvious collectors item. Sales soared.

By 1994 there was little doubt that the marriage was being subjected to increasing strain. The ethos of life, which meant so much to Richard and which he held so dear, had become less relevant to Cindy. Her personal ambition, the opportunities for, and enjoyment of, the financial rewards of her growing commercialism held no attraction for Richard. Rumours and speculation about their sexuality were unabated. Indeed they would surge almost out of control on the back of almost worldwide tabloid speculation. It became more and more difficult for them to find the time to be together as Cindy went off on photographic shoots, personal appearances and other daily or weekly assignments while Richard headed off making and promoting his pictures and following a busy programme of commitments related to his various causes.

The pressure was intense despite public denials that their marriage was breaking up, though when Gere opened the Harrod's sale in London early in January that year he appeared more upbeat, relaxed and co-operative than on some earlier visits to the capital. Pursued by a large crowd of women, he proved that Richard Gere was still an attraction. There was so much excitement as he bounced on a brass bed that his grand tour of the famous store had to be halted. He happily posed for pictures with Miss UK, Amanda Johnson, wearing her crown, but the noise was so great that Mr Mohamed Al Fayed, the Harrod's chairman, decided it would be safer to escape and took himself and Gere off to have breakfast.

Gere had arrived to open the sale in a vintage car and accompanied by two Buddhist monks. He had been keen to explain the work of the Gere Foundation (to aid Tibetan refugees) and the Survival International movement (which campaigns for the protection of tribes). But there was such an uproar on his arrival that his Third World concerns had to be abandoned. The same thing

happened later in the Georgian Restaurant when he once again tried to explain what he was doing in London, his pleas drowned by photographers yelling for more pictures of him. The store's director of public relations, Michael Cole, stated later: 'Because of the pressure of such a big turn-out, I'm afraid we had to curtail the tour. Richard was a very good sport and was willing to go on, but we felt we really could not continue.' The crowds were so great at one point that Gere lost touch with the Scottish pipers who traditionally escort the celebrity who opens the sale.

But despite this happy occasion thunder clouds were speeding towards them. The inevitable storm crashed over their heads in April when the French weekly tabloid, *Voici*, carried a hard-hitting piece that stated, among other things, that their marriage was a mockery and was about to end.

Gere was reportedly infuriated. He was so angered by the article that he immediately set about seeing what he could do about it. One possibility was legal action. Another was a counter press statement. The answer came in dramatic fashion on Friday 6 May, in the now celebrated paid-for full-page joint statement in *The Times* in which Richard and Cindy restated the stability of their marriage and declared that they were heterosexual and monogamous, at the same time answering many other reports and rumours about themselves, which had been circulating, including Gere's impending retirement from film-making.

A Personal Statement

by
Richard Gere and Cindy Crawford

For some reason unknown to us, there has been an enormous amount of speculation in Europe lately concerning the state of our marriage. This stems from a very crude, ignorant and libellous 'article' in a French tabloid. We both feel quite foolish responding to such nonsense, but since it seems to have reached some sort of critical mass, here's our statement to correct the falsehoods and rumours and hope it will alleviate the concerns of our friends and fans.

We got married because we love each other and we decided to make a life together. We are heterosexual and monogamous and take our commitment to each other very seriously. There is not and never has been a pre-nuptial

agreement of any kind. Reports of a divorce are totally false.
There are no plans, nor have there ever been any plans for
divorce. We remain very married. We both look forward to
having a family. Richard is not abandoning his career. He is
starting a film in July with others to follow.

We continue to support 'difficult' causes such as AIDS
research and treatment, Tibetan independence, cultural and
tribal survival, international human rights, gay and lesbian
rights, ecology, leukaemia research and treatment, democracy
movements, disarmaments, non-violence and anything else we
wish to support irrespective of what the tabloids try to imply.

Now, that said, we do feel we have a basic right to privacy
and deserve to have that respected like anyone else. Marriage
is hard enough without all this negative speculation. Thoughts
and words are very powerful, so please be responsible,
truthful and kind.

So that, once and for all, was that. There could now be no more
doubts, no more rumours, no more press speculation.

The reality was exactly the reverse of course, as any experienced
PR or press person could have anticipated. Even the very idea of the
advertisement came under scrutiny. There was talk that it had been
Cindy's idea and that Gere had only reluctantly gone along with it.
Another report claimed that Gere's agent, Ed Limato, had revealed
that Gere's advisers had talked him into it. It eventually transpired
that Crawford had been against it all along, but Gere had been so
incensed by the French tabloid's article that he insisted it could not be
left unanswered. Crawford had eventually capitulated.

If Gere had intended the sensational move to hush speculation
about their marriage, he would be dismayed or at least disappointed.
His shock tactic had indeed brought them back centre stage in full
glare of the publicity spotlight. If he was prone to looking back Gere
would almost certainly see it as being a foolish move, if inevitable.
For later it would be perceived, sadly, as a marker to the beginning of
the end in the Gere-Crawford relationship.

The press remained unconvinced and were close at hand over the
following weeks when the cracks began to appear. News filtered
through that Cindy was unhappy. Her high public profile meant a
full schedule of commitments, keeping them apart; seldom were
they seen together. By this time Gere had moved to England to
work on his latest movie, *First Knight*. This latest blockbuster about
King Arthur, with its £30 million budget, 800 extras, 200 horses and

300 suits of body armour, was big news in itself; but the Richard – Cindy story was even bigger.

He was a natural target for the British tabloids and they followed him around day and night. They made the most of a dinner date he had with Uma Thurman, with whom he had co-starred in *Final Analysis*. In the ensuing scramble Uma received a slight cut to the face from a camera lens. He was naturally angry. It was noticed that Cindy visited him only once on the set and she was alleged to have been seen with an old flame, American bar owner Rande Gerber. At Pinewood Studios, Gere was said to have been silent and moody after a Sunday newspaper had spotted him at the palatial Tylney Hall Hotel in Hampshire with English model Laura Bailey. He was seen again with her at La Colombe d'Or restaurant on the French Riviera. One press report pointed out that Laura shared his belief in Buddhism and his interest in philosophy and at first the official line was that they were simply good friends.

But then in November came those candid, distorted pictures of Laura scampering over the back wall of Richard's rented house in Chelsea in the now famous and well documented episode. That same weekend Cindy put their luxury home on the market for £4 million.

And on 1 December 1994 even the cynical press were shocked to receive an unexpected, early Christmas present. Richard and Cindy released a joint statement that confirmed their separation and revealed that 'this painful and personal decision was made between us in July.' The statement continued: 'Since that time we have been trying to work things out, but due to the conjecture in the press we have decided to make a statement at this time.'

But the statement also made it clear that there were no plans at that time for a divorce.

The storybook romance, which had captured the imagination of the world, had finally, and sadly, run out of steam. Yet ironically a year later a morose Gere confessed that he remained 'in deep pain' over the break-up. He told reporters that the hurt of the failed marriage was lasting longer than he ever expected. 'I thought the pain would last maybe six months. But it is a year now and I'm still not over it,' he announced.

Remarkably, not two weeks later a confessional from Cindy had her the darling of the tabloids once again. She said she wanted to give her marriage another try. The basic emotions came out in an interview with *Playboy* magazine in which she revealed how she had pressed Richard to marry her, though he had been happy enough for

them to continue living together and how she had refused his pleas to have a baby. She went on to explain just how difficult relationships are when both partners are not only famous, but busy too. She said that she had wanted to start a family immediately after their wedding, but Richard was not ready to rush into parenthood. Then when he changed his mind about children it was she who wanted to delay it.

# 14

# In London Town for First Knight

The medieval British King Arthur has died repeatedly, but he simply will not lie down. The original mythical tale had Arthur mortally wounded in battle against his sinful and deceitful nephew, Mordred. Later appendages suggested he would return from Avalon, where he had been taken to be healed, to rule Britain again in the time of his country's greatest need.

But movie-makers simply cannot wait that long. They have re-told and re-hashed the story so often that it now seems pointless for Arthur to make all the effort it would take to return. We have never lost sight of him anyway.

Mind you, it is a cracking tale. All the essentials are there in rich abundance – the benevolent and trusty Arthur, who became king of Britain at fifteen; his beautiful wife, Guinevere; the traditional villain of the piece, Mordred, as nasty a wrongdoer as you are ever likely to come across; and, of course, history's spiritual and physical hero, the splendidly handsome Lancelot. Mix in an intense love story, a sub-plot or two, a magician called Merlin (a kind of panto good fairy), a round table of stout-hearted knights, a magical sword called Excalibur, galloping horses and spectacular sword fights and it is hardly surprising that movie-makers are constantly returning to Camelot.

There have been all sorts of versions, from *A Connecticut Yankee* in 1931 and *A Connecticut Yankee in King Arthur's Court* in 1949, to *Knights of the Round Table* (1953) with Robert Taylor, Mel Ferrer and Ava Gardner, and *Lancelot and Guinevere* in 1962 starring Cornel Wilde, Jean Wallace and Brian Aherne.

Disney moved in with their cartoon offering, *The Sword in the Stone*, in 1963 and increasingly off-beat interpretations in the

160

seventies brought *Monty Python and the Holy Grail* in 1975, for fans
of the ridiculous, and for children, *The Spaceman and King Arthur*
in 1979. Probably the most successful of all was the $15 million
Lerner and Loewe movie musical, *Camelot*, based on the long
running Broadway show, which starred Richard Harris and Vanessa
Redgrave.

When film director and writer Jerry Zucker was looking around
for something with which to follow his blockbuster *Ghost* in 1990,
he eventually settled for yet another re-working of the King Arthur
legend. The gimmick this time was that the well-worn story would
be told from the perspective of Sir Lancelot. It would be a more
contemporary offering with what was later assessed by Sean
Connery as 'an original approach to King Arthur'. The result was
*First Knight*, an all-action full-length feature costing $40 million and
released simultaneously in Britain and America on 7 July 1995.

This was to be no hotch-potch of a picture. The classic talents of
Sean Connery had been tempted into the part of King Arthur by
what was reputed to be at least a £6 million payout. A beautiful
young British actress named Julia Ormond, a former Tie-Rack
shopgirl, was cast as the latest Guinevere. Julia had been acting
since her school days at Cranleigh, Surrey, where she began to
develop her career into a serious intention to become a professional
actress. She had taken part in her first play at the age of nine. Well
bred and traditionally middle-class, Julia had the looks, figure,
talent and determination to reach the top. Zucker was not slow to
recognize the potential. She had already been hailed by various
industry big-wigs as the new Audrey Hepburn and the new Julia
Roberts as her career developed through stage work, pivotal roles
on British TV and significant castings on the big screen. But she was
very much her own woman with her own career agenda. *First
Knight*, for a fee rumoured to be around £350,000, would be
another significant notch on Julia's totem pole of recognition and
fame.

But what of Sir Lancelot, the nomadic soldier? Zucker had been
going round in circles trying to cast an actor who combined a strong
sense of purpose with what he called spiritual gravity. Until one day
when, as Zucker recalled later, 'we were sitting around the office
and Richard's name came up. We all looked at each other and said:
"Richard Gere, of course!" ' Not that such unanimity was an
automatic salvation. Gere, remember, had a track record of
handing-off coveted roles. This time there was no hesitation, no
persuading, no asking a second or third time. He was eager to play

the part and straight away agreed, for his own strongly-focused reasons: he saw a parallel between Camelot, as a utopian city of ideals, and Lhasa, the capital of Tibet, before its invasion by the Chinese, he said. Gere's fee was widely reported to be around £5 million.

The picture was made entirely in Britain with production designer John Box, four-times Oscar winner for *Lawrence of Arabia, Dr Zhivago, Oliver!* and *Nicholas and Alexandra*, playing a crucial role in creating the atmosphere by fashioning lavish and authentic location sets. Working with the art department over a period of five months, Box converted a dusty open field into the legendary castle, its fairy-tale towers rising six storeys above the trees of the backlot at Pinewood Studios. A vast open area in Berkshire became King Arthur's battle encampment. A lake and causeway in North Wales were miraculously transformed into the entrance to Camelot while a slate mine suddenly became a fortress hideaway. All the authentic splendour of St Albans Cathedral in Hertfordshire was the historic background to Arthur's marriage to Guinevere.

The picture had taken over much of Gere's life even before shooting began at Pinewood. Lancelot is an expert, swashbuckling swordsman in the Errol Flynn mould of *Captain Blood, Robin Hood* and *The Sea Hawk* and Gere spent two months at his Bel Air home working under the expert personal guidance of British coach and former professional champion Bob Anderson.

During these tough sessions the 72-year-old Anderson, who had been coach to Britain's Olympic Fencing Team for twenty-five years, and schooled Flynn for his 1952 picture, *The Master of Ballantrae*, found Gere 'incredibly disciplined'. He was a virtual novice at the start, revealed Anderson; had hardly used a sword before. But he was brilliant when it was time for his first duel in front of the cameras.

Anderson was impressed by Gere's dedication, explaining how, after three or four hours of concentrated tuition at his home, he would continue to practise on his own for the entire afternoon. The critical test was Gere's performance during filming. Anderson was even more impressed at this stage and although he admitted that during the six months they worked together on the picture he never really got to know him, he judged him to be an even better swordsman than Flynn. Said Anderson: 'Flynn never trained, but he learned quickly and had great flair.' Flynn would rehearse his sequences on a daily basis, giving a superb performance for the cameras. These sequences were then speeded up on film.

Gere's painstaking preparation was in startling contrast and

included a concentrated schedule of fitness training incorporating weights, running and stamina building. Just as well, for in the middle of one of the most demanding physical sequences he smiled and was overheard to jibe that he felt he was getting too old for this type of role.

*First Knight* was badly timed for Gere domestically. His marriage was falling apart as he arrived in Britain for his six-month stay and the announcement of his inevitable break from Cindy came during the final shooting of the picture. The difficulties were common knowledge because of the press speculation, but Gere never talked about the situation and everyone on the set was said to have respected his privacy. But it was clear that the split upset him although he battled on, continuing to throw himself fully into a role that was extremely demanding physically and at times hazardous, even risky.

This was Gere at his most professional. Before shooting began, riding training had been organized at a farm close to Rickmansworth in Hertfordshire. Gere was invited along with others but no one really expected him to do much more than show up for a few token rides. It was typical of his approach to a film role that he attended these sessions each day from eight in the morning until five in the afternoon.

In what became known as his fight to forget Cindy, he immersed himself totally in the role. It was as if he was fighting these medieval battles for real, was how producer Huw Lowry put it. In the process he crushed both hands, cut his head, fell off horses, cracked fingers, collected sundry bruises and badly damaged a foot. In one sequence, filmed at the Duke of Wellington's sumptuous estate in Hampshire, Gere was using his sword for eight hours virtually non-stop. In a separate sequence he badly twisted his back and then chipped a tooth in a fight scene. He was airlifted in a helicopter from the location site in Wales to London where he had treatment from a Harley Street doctor and a dentist before being flown back the next day.

He carried on without complaint working for hours on end and would sometimes wave stuntmen aside. One time he narrowly avoided serious injury as he negotiated a 60ft obstacle course to win a kiss from Guinevere. Hanging from moving beams he was required to dodge 6ft blades, swinging balls and giant axes in a realistic display of strength, courage and athleticism as stuntmen on standby saw him battle his way through.

Co-ordinator Greg Powell, an apprehensive bystander from just a

few feet away, said: 'We just held our breath and hoped he made it. He looked proud and satisfied when it was done without mishap.' Jerry Zucker explained in a later television interview that only one stuntman and Richard could actually do that particular feat.

Gere's so-called reputation had descended on Pinewood ahead of his bodily arrival and many of the crew were hesitant, distant and even prepared to dislike him. But there seemed to be general agreement that in spite of all his problems over his marriage, he won them over by his sheer dedication, co-operation and professionalism.

At first there was some joking and banter on the set about his being married to Cindy, but once the effects of his increasing domestic turmoil began to filter through and were later felt by virtually everyone working on the picture, if for no other reason than that the media were virtually camped outside for much of the time, there was a more serious an understanding of the deep problems he faced. There were intervals between scenes when Gere would sit tucked away, uncommunicative, morose and brooding. It was a particularly difficult time towards the end of the filming when the press splashed the story of his liaison with Laura Bailey. But off the set Gere reportedly found it harder to keep his emotions under control. In November 1994, during what has since become a well-documented incident, he was said to have exploded at a party at Elton John's house. The Princess of Wales was there when a row supposedly flared up between Gere and Sylvester Stallone, certainly not the best of friends anyway.

On the set it was difficult for him to shake off the feeling that the press were permanently close by, waiting to swoop on any morsel of gossip, particularly when shooting was ended for the day or when Gere was required out on location. Reliable reports pointed to the contrived, elaborate, almost bizarre subterfuge engaged to spirit him away at the end of shooting later in November with one decoy Jaguar filled with bin-liners exiting left from Pinewood, with another, also filled with bin-liners but with Gere secreted beneath, turning right. It was not the first time that the bin-liners had played a part in concealing the star. Much earlier Gere's Range Rover had its rear windows blacked-out with them so that no one could see him sitting in the back seat.

Pre-filming speculation had centred on the potentially explosive situation of Connery and Gere working together for the first time. Both were known for being strong and uncompromising individuals; and their views, attitudes and life-patterns were hardly compatible.

As one pundit put it: 'no great collusion of minds here.' Thrust into this potential meltdown was the relatively unknown Julia Ormond. Though only thirty, against the steely Connery at sixty-four and the highly focused Gere at forty-five, she had already gained something of a reputation for being beautiful, striking, composed; and strongly independent. It was said that she took the part only after Zucker agreed to her suggestion to make Guinevere more forceful and liberated. She was determined too and, like Gere, insisted on being fully fit for the role. She did distance running daily and cut out smoking, kicking the habit after ten years.

But any fears there might have been about the three of them working together were proved groundless. The worst comment Connery could make about Gere was, 'We're not seeing very much of him'; and there was an unconfirmed rumour that he had been upset once when Richard was late for a scene. While acknowledging that working together did not make them great buddies, Jerry Zucker said that there was never any friction between them when working on the set.

The worst thing that happened to Ormond was an outer ear infection, which put her in hospital for thirty-six hours. Neither Gere nor Connery could be blamed for that. The worst thing that happened to Gere was a heavily struck slap on the face by an over-exuberant Ormond while on location at Burnham Beeches in Buckinghamshire. Julia stifled her laughter with an instant apology; Gere got off his horse for the make-up girl to re-do his face, camouflaging his rapidly reddening cheek; and director Zucker called 'cut', then politely asked Julia to be a little lighter on the punch please next time.

When the picture was all over Gere was generous in his comments on his co-stars. He said that working with Sean Connery had been a great experience and that his incredible presence made him perfect as the king. 'I'm a huge fan,' he said of Julia Ormond. 'She's really great – adult, smart, funny, knows her craft ... and very beautiful.'

William Nicholson's script would suffer fiercely at the hands of the critics, despite his strong reputation after scripting *Shadowlands*, but with Zucker directing they should have known what to expect. With brother David and their associate Jim Abrahams, Jerry's early recognition had been built around a series of undisguised spoof pictures, which included *Airplane* in 1980, which cost them $3.5 million to make and brought in almost $80 million. *Ghost*, in 1990, was less of a straight spoof and more of a comedy-thriller-fantasy, and was Jerry's first solo effort. It made a

fortune as the surprise blockbuster of the year.

Zucker did not go absolutely wild with his interpretation of this latest Arthur offering, but precedent demanded a different angle or two. So out went Merlin, the Lady of the Lake, the Holy Grail and Sir Galahad. In came Sir Malagant, the archetypal medieval baddy with a fetish for burning down villages, superbly played by Ben Cross. Sir Lancelot was updated. He remained strongly the traditional goody of old, but more modish in a loose-fitting T-shirt, tunic-type top and the countenance of a nineties superhero. You might be forgiven for thinking that the latest Arthur could pass more convincingly as Guinevere's father than her husband, and a pretty elderly father at that perhaps, while Guinevere herself was given a little remodelling. Her main role was still to set male hearts aflutter, but she now came with footballing skills added to her repertoire. The modern-style plot of romantic triangle also featured heavily.

Hardly surprising perhaps that the critics, when the time came, had a field day. They largely forgot about the picture's qualities as a great action movie, the romantic adventure of a lifetime between Gere and Ormond, the subtle blend of passion and fantasy and the full panoply of medieval pageantry from full-scale battle scenes to man-to-man combat, all superbly executed. They talked about Connery's Scottish accent, Gere's American accent, and complained that Zucker's Camelot looked like a Disney theme park. In London the *Daily Telegraph* moaned: 'Anyone who loves language will find their teeth on edge by the tin-eared dialogue.' The *Daily Mail* complained: 'As Guinevere, Julia Ormond has to do little more than look confused whenever Richard Gere crinkles his eyes at her.' Gere was not allowed to escape his history. Reported *Mail on Sunday*: 'but then, in the general mayhem she (Ormond) bumps into Richard Gere. And we know what happens when a girl bumps into Richard Gere. Oh dear' – and the review went banging on about his gallivanting in *American Gigolo*, etc.

Of course these and other mainstream reviews covered the picture's good points as well. For instance, the *Mail* mentioned the professionalism of the big set pieces with Malagant incinerating a village and the final storming of Camelot – impressive, the report said, adding: 'If you like spectacle and swordplay you will not be disappointed.' But press coverage generally on *First Knight*'s opening in the UK did the movie few favours.

Gere devotees had been hoping that *First Knight* would do for their hero what *Pretty Woman* had done for him almost five years

before. It certainly brought him back into the news during the making of the picture and also at the time of its release. Support publicity for the opening confidently proclaimed: 'A swashbuckling saga of passion ... the most romantic swashbuckling movie of the year ... Camelot has never been so sexy ... Sean Connery, Richard Gere, Julia Ormond, their greatest battle would be for her love.' For too short a time hopes of another killing were high, but then *First Knight* began to fall away and in the end made little positive, sustained impact either in the UK or the United States.

Among those who were delighted with *First Knight*, however, was Welsh sheep farmer John Davies. For six months he hired out his land to the film-makers who built Arthur's castle on the shores of Trawsfynydd Lake in Gwynedd, and then took it all down again when the work ended. Neighbouring farmer Thomas Davies also was pleased that the film crews chose Wales for location work. His field housed the temporary caravan homes of Connery and Gere, and was also used for the grazing of many of the horses used in the picture. The wily Thomas had reportedly hired an agent in advance to negotiate a suitable fee with Columbia Pictures.

Back on set Gere was said to have won many friends and a good deal of respect. Both cast and crew spoke highly of him. With his obvious problems aside, the general working atmosphere during the making of the picture was good. Said Julia of Connery: 'Sean is so lovable and self-deprecating. I didn't expect him to be so entertaining.' She and Richard became friends during the shooting and attended the Los Angeles première together. Of Connery, Gere said: 'Everything that makes him Sean Connery made him perfect to be Arthur. He immediately had the respect and command of everyone.'

Other interesting titbits about Gere filtered through from the studio. His friend and business partner Maggie Wilde rekindled memories of the difficulty he often faces when trying to make up his mind about something. It seems that a member of the cast was a talented amateur landscape painter and Richard was impressed by the work. He decided to have one of the paintings but could not really decide between two of them. When filming was completed he was still undecided and ended up with neither.

It would be wrong to suppose that Gere's problems made him constantly miserable on the set. As always he would bury his personal problems when working, but a few light-hearted moments helped to break through the obvious tensions. Sean Blowers, known to British TV viewers as sub-officer John Hallam in *London's*

*Burning*, was cast as Sir Carados, one of the twelve knights of the Round Table. He remembered an unexpected hilarious incident between Gere and Connery. It was a big scene and Richard had to run through a crowd and kiss Julia Ormond. In one take Richard suddenly veered off in a different direction and plonked a kiss firmly on Connery instead. Sean was taken completely by surprise and apparently everyone fell about.

The lighter side of Gere's character also shone through at a dinner party he gave at his hotel. At the end Blowers was leaving the hotel when he looked up and saw Julia Ormond closing her hotel room window. Feeling happy, Blowers began to serenade her with the Everly Brothers romantic hit, 'All I have to do is Dream'. Other guests from the party joined in, including Gere. At the end Julia opened her window and playfully told them all to be quiet and go to bed. A somewhat starry-eyed Sean Blowers said it was amazing. 'There I was, singing with the lads, and one of them was Richard Gere.'

It was an altogether different Gere who returned to Britain some months later when he agreed to attend the London première of Disney's *Pocahontas* on Friday 6 October 1995, in aid of Survival International. Elaborate arrangements had been made for the occasion including live satellite link screenings in ten cinemas across the country ready to give viewers a taste of the glitzy goings on in Central London. A 20-minute song and dance spectacular and speeches from stars including Richard, prior to the showing of the film, was also scheduled.

Notorious for arriving late, Gere would surely make the effort to be on time for this occasion. Sandra Batchford is almost certainly Richard Gere's biggest and most knowledgable fan in the UK and she was comfortably seated in her local cinema on the south coast, excited and eagerly waiting for everything to happen.

She could see that it was a particularly wet night in London and that, by the way the officials kept running out of the cinema at the sight and sound of every car, it was evident that they, just like the huge crowd in Leicester Square, were getting agitated.

Said Sandra: 'Those of us in the link-up never got to see the song and dance show because of Richard's late arrival. Instead, about five minutes into a short Red Cross film on Third World Countries, the satellite suddenly showed him inside the cinema standing at a microphone saying that he had only just arrived from the airport and how he would like to thank us all for supporting Survival International and he hoped we would enjoy the film. His 'speech'

lasted all of one minute.'

He later ignored calls from photographers for some shots and also refused to attend the post-film celebration party. 'This didn't really surprise me,' added Sandra, 'since the food had been laid on by Planet Hollywood and Richard's public arguments with Sly Stallone are well known. I would like to think there was another reason, but there is no denying his sometimes pettish behaviour.'

A far less glitzy occasion, but much more pleasant, took place at the Coliseum cinema in remote Porthmadog, Wales, on 3 July 1995, just four days before the official world release of *First Knight*. A special UK première of the picture was held there to thank one thousand Welsh locals who had worked as extras on the movie.

# 15

# Here's to the Future!

For someone who did not attend stage school and has never had a formal acting lesson in his life, Richard Gere has not done too badly. In the last twenty years he has starred in twenty-three movies, amassed a fan-following unequalled in its emotional intensity, has co-starred with some of the biggest names in Hollywood including Kim Basinger, Julia Roberts, Julie Christie, Jodie Foster and Sharon Stone, and spent three years married to Cindy Crawford.

With only one positively successful movie in more than five years, his asking price per picture is still around the $7 million mark, which places him alongside Clint Eastwood, Keanu Reeves and Dustin Hoffman in 'bankability'; and that figure could well double overnight given another triumph like *Pretty Woman*. In fact, blockbuster two could be just around the corner. The sweeping roller-coaster that has charted Gere's career almost from the start might be heading upwards once again.

The interval is about right, give or take a year or two. It was seven years after his movie debut in 1975 that he crested the peak for the first time with *An Officer and a Gentleman* in 1982. *Pretty Woman* in 1990 secured his colours to the summit once again in flamboyant style after several sluggish years. With *Sommersby* in 1993 he seemed to be moving upwards yet again.

And now, who knows? Maybe 1997 or 1998 could be another 'top Gere' year.

In any event, what his millions of fans throughout the world feared most of all just a short time ago, now appears much less likely. Certainly not for the moment anyway. So disillusioned was he with many aspects of his life as a film actor that he was seriously

questioning whether he would even continue making pictures for much longer.

He has never been obsessional about his art, although no one puts more of himself into making a picture than Richard Gere. Yet despite his impressive portfolio of films he has been an instinctive part-timer for a number of years now, given to opting out into the unknown as the mood takes him. His agent, Ed Limato, tells how he has tracked down his client in the teeming chaos of New Delhi and the slums of Calcutta. He said that he would somehow locate someone who knew what camel driver he hired and manage to get word to him that way. His worst moment was when Gere and Sylvia Martins went missing in the jungle of New Guinea. His private plane ran out of fuel and they had to camp out for a couple of days in a very uncivilized part of the country.

Talking about his often career-dreary 1980s, Gere has often said that he just took off for a couple of years. In the summer of 1995 he claimed that he liked to spend maybe six months of every year away from film-making, going to India or wherever. 'Going back and forth is great,' he said.

For the next few years though, it is likely that Richard Gere will continue to be seen on the big screen. Even before shooting ended on *First Knight* in 1995 he was contracted to make *Primal Fear*, a courtroom drama, which came relatively soon after the famous O.J. Simpson trial. His name has been also tentatively linked to several other projects. But with Gere particularly, nothing is certain until it is signed and sealed. Reported and rumoured sure-fire projects can run out of steam before they have started.

His future life off-screen appears more predictable. There is little doubt that his commitment to the Tibetan problem continues to deepen and has been significantly broadened to bring in many associated causes with active support for the work of Survival International, AIDS research and gay and lesbian issues.

His conviction is profound. A two-week sojourn to a remote outpost in Mongolia towards the end of 1995 consolidated his continually growing proclivity with Buddhism. It continues to affect him professionally and personally. He stayed in a small apartment with few home comforts and where he was happy to make do with a simple, basic life-style, which included showering in cold water. While he was there he continued with his daily Yoga exercises and attended local Buddhist meetings, being a willing scholar among revered monks and teachers. On these visits he melts into the background and in no way sees himself, or is treated as, a VIP.

Gere maintains that life for him, meaning his faith and his instincts, is evolutionary. There has been no bright flash of understanding, inspiration or belief. He now recognizes that when in his twenties his life was in turmoil. He was confused. He believes such a chaotic state is natural and is shared by most men in their twenties. In contrast he now obtains enormous inner satisfaction and strength in travelling to some obscure part of the world, meditating and talking with the local village people, expanding his experience of Buddhism through learning from the teachers; and from the work he does while he is out in India. He calls it exploring the nature of your mind and the nature of your heart.

Nearer home he continues to be outspoken about the issues he feels are important. He claims, for instance, that Bill Clinton, before he became President, made a clear undertaking to the gay community in America and those who were at work on the problem that AIDS would be a priority once he was in the White House. There was to be something called a Manhattan Project. 'But it never happened,' he said. He also criticizes Clinton for a similar attitude toward China. 'We had discussions about human rights in China and, specifically in Tibet, and he walked away from all of that, too,' he was reported as saying.

Despite the emphasis he gives to the disciplines of Buddhism and the plight of oppressed groups, Gere likes the process of making movies and enjoys his huge earnings and the opportunities they provide for personal travel, for instance; for buying the time he needs to do what he really wants to do; and for giving away a good deal of the money he receives.

He sees no conflict in all of that. But for most people the contradictions are sometimes difficult to reconcile. In July 1995 he said he was selling his two luxury homes in California and that, as he got older, having roots was becoming less important to him. He was already looking towards having his own modest place in India, close to the Tibetans; little more than a hut with just one big room that can become a home for whenever he is there. Yet shortly after he was reported to be negotiating for a sumptuous, highly luxurious property in America. It all tends to reinforce the dichotomy that characterizes much of who he is and what he does.

There is little doubt that Gere has grown in stature as an actor over the years, though his critics continue to claim that he tends to underplay his parts and that his voice is often too soft. His slightly arrogant walk is an irritation for some observers, even if it has been well suited to some of the characters he has played. Seldom have

these done much to encourage a welcoming, sympathetic or wholesome image. Diligent Gere watcher Sandra Batchford told me: 'Since *Yanks* I can honestly say I have enjoyed all his films except *Breathless, The Cotton Club, Miles from Home,* and his cameo appearance in *And The Band Played On.* I just didn't like the characters he portrayed in these films and for me it detracted from the enjoyment of the films.'

Of course, movie actors do not always have the chance to play the characters that are of most appeal to them. Gere is on record as saying that, given the opportunity or if circumstances had been different, he would have done almost any of Tom Hanks's films including, particularly, the romantic comedy *Sleepless in Seattle,* in which Hanks starred with Meg Ryan, and the acclaimed drama *Philadelphia,* where he appeared as a lawyer who is sacked when his bosses discover that he has AIDS.

He continues to hold strong convictions – his detractors might say his principles have become dogma – though he has never been dollar-driven. As long ago as *Miles from Home* in 1988, he believed in the picture so much that he took no more than the minimum actor's rate so that the film could be brought in at £3 million. Robert Allan Ackerman, who directed *Bent,* said there was nothing he was not willing to try; he was always available and never showed any temperament.

Gere is often unpredictable and it never does to take liberties when trying to look into his future in films. But there certainly appears to have been less talk recently about his problems and general disenchantment with the unreal periphery of the movie world. He continues to be perhaps overly selective, but making money is never, nor has it ever been, the over-riding issue in making up his mind on whether or not to take on a project.

He started work on *Primal Fear* in 1995 following *First Knight.* The story is about a man who stands accused of a gruesome murder, but who convincingly protests his innocence. Gere plays the media-hungry, self-absorbed defence attorney, Martin Vail. He co-stars with Laura Linney, following her success in *Congo.* She is a hard-boiled prosecutor called Janet Venable who just happens to be an ex-lover of Gere's character.

*Primal Fear,* based on William Diehl's popular novel, marks the full-length feature debut of director Gregory Hoblit, who brought to the small screen such Emmy winners as *Roe vs. Wade, Hill Street Blues* and, of course, *LA Law.* Not unexpectedly perhaps, Hoblit was accused of attempting to cash in on the 'melodramatic

backwash' of the highly-charged O.J. Simpson trial.

He denies it, though admits to giving a passing glance to the real trial once his show was up and running. He said that the real story of his film was how high-profile lawyers thrive on cases like O.J.'s. 'I wanted to look under the skin of a defence attorney who really is as interested, if not more interested, in what a case does for him as what it does for his client,' Hoblit explained. He and Gere also talked to ex-O.J. confidante Howard Weitzman for further insight into Gere's role. Linney said she had looked to the Simpson trial for pointers to her own role and found it useful to be able to switch on the TV. 'I watched and tried to pick up as much as I could,' she added. Edward Norton plays the young man accused of murder and John Mahoney, Alfre Woodard and Frances McDormand are also cast.

Once he had signed to do the picture it was typical of Gere to be instantly involved. Director Hoblit tells the story of how he went to Chicago in the dead-cold of uncharitable January to scout locations for the picture and was astonished to find Gere waiting for him when he and his team arrived. They all reconnoitred the town looking for suitable buildings and locations, which could be used in the picture. Hoblit was astonished by Gere's interest and dedication, and found it in sharp contrast to many other actors who in his experience only become involved when they walk onto the set and are ready to start acting. 'Richard is different,' he said.

The picture was originally scheduled for release in January 1996 and was then put back until July, though with a release date that did not necessarily extend to the UK. It was finally released in America in early April 1996 and in the UK the following month. Gere attended the première of the picture in America with his latest girl friend Carey Lowell and was reportedly all smiles, posing for the camera and never looking happier.

Gere had also been through pre-production talks and further discussions for *The 100th Monkey* directed by Alfonso Cuaron, and something called *The Baron in the Trees*, though was said to be currently unhappy with both scripts.

As early as July 1995 he was said to be near to signing to play legendary comic-strip hero *Flash Gordon* in a new version which has Gordon as a scheming tycoon who has earned his nickname in the Gulf War. Then in November 1995 studio reports suggested that *Sleeping Beauty* was to be turned into a new big-budget feature film in which the snoozing princess is discovered a century later by a handsome archaeologist. One report had both Richard Gere and Mel Gibson talking to producers about starring.

Less speculative perhaps is Gere's interest in doing a sequel to *Pretty Woman*. It appears an obvious choice with a fair chance of hitting the jackpot; and the timing would be about right, though memories would seriously begin to fade if such a project were to be delayed too much longer. A script was produced two or three years ago that Gere and Julia Roberts looked at, but that did not really impress them (or just him perhaps?). Gere has predictably and instinctively rejected any idea of a follow-up, which would cynically attempt to capitalize on the success of the original. Any sequel, to be of interest to him, would have to stand on its own merits. The idea has not been abandoned. It is more a question of further work to be done by the writers. A revised script seeing the light of day in 1997 or even early 1998, and which could spark Gere's interest, is likely to bring *Pretty Woman 2* back into the frame as a serious runner.

Meanwhile, a world away from the commercial business of movie-making, Buddhism and Gere's spiritual mentor, the Dalai Lama, who had received the Nobel Peace Prize in 1989 for his campaign on behalf of Tibet, were moving strongly into the media spotlight. First there was news about the substantial growth of alternative religion, including Buddhism, which in newspaper terms was said to be 'seducing Middle England'. Then followed a reference to Buddhism in a leader article in the UK's national newspaper, *The Independent*. A further, more light-hearted press report, suggested that nowadays you make a dinner-party joke about celebrity Buddhists like Richard Gere and Billy Connolly at your peril.

In July 1995, the Dalai Lama celebrated his sixtieth birthday with a three-day gathering in Delhi in which he called for compassion and non-violence. Yet the prospects for dialogue with China had appeared to suffer a major setback on the Dalai Lama's announcement that he had recognized a 6-year-old Tibetan boy as the reincarnation of the Panchen Lama who died in 1989. The Panchen is traditionally the second most important spiritual teacher of Tibetan Buddhism.

But the most startling news of all for Gere fans and admirers came in October 1995 with the report that Hollywood was already well ahead with plans for two film projects based on the extraordinary life of the Dalai Lama. The story was such a natural subject for a Hollywood biopic treatment that it seemed astonishing that it had not been considered long ago. Now the story of the 2-year-old son of a poor Tibetan farmer who becomes god-king of

the ancient Himalayan state, is to be told not just once, but twice if all plans work out; and both are likely to hit the public at about the same time.

An early 'leak' suggested that some of the film industry's best known names were jockeying over the right to turn the extraordinary story of the exiled guru into a Hollywood blockbuster. Encamped in one corner were Harrison Ford, his screenwriter wife Melissa Mathison and Martin Scorsese, once labelled as probably the most physically exhilarating film-maker alive. In the other corner were Brad Pitt and British producer Iain Smith.

Ford and Mathison were known to have campaigned strongly for the Tibetan cause in the United States and had met the Tibetan leader a number of times. What was not common knowledge was that Mathison, who had penned the *ET* screenplay, had already been working on a film script about the Dalai Lama's early childhood in Tibet under the working title of *Kundun*, the Dalai Lama's childhood nickname. The Dalai Lama was said to have agreed to help them with the film, Ford and Mathison adding that this arrangement was exclusive and that anyone else who tried would be wasting their time.

But hold on. A $50 million project being master-minded by Iain Smith with the French director Jean-Jacques Annaud (who directed *The Name Of The Rose*), who would direct and co-produce, was also rumoured to be underway, to be titled *Seven Years In Tibet*. This version would be based on an autobiographical account of life in the isolated state during the Second World War by Heinrich Harrer, an Austrian mountain climber who taught the Dalai Lama. Brad Pitt was said to have been enlisted to play Harrer.

Both films were originally due to begin location filming in northern India and Tibet early in 1996. It was a highly-charged, extremely competitive situation. The Dalai Lama was said to be supportive of both projects. 'I believe there is room for two films,' he said.

But the obvious question is, where does all this leave Richard Gere? As someone who has had more close and continuing contact with the Dalai Lama over a considerably longer period of time than anyone else in Hollywood, his supporters could reasonably have expected him to have been the natural, obvious candidate to take some part in any story of his spiritual mentor's life.

Harrison Ford has also publicly given strong support to the Tibetan cause for at least five years and as recently as November

1995 joined Gere in urging Congress and the Clinton adminstration to meet the Dalai Lama. Ford, it was reported at the time, was only one of hundreds of world-weary stars and celebrities who had recently joined the cause.

However, Gere's own immediate reaction to the proposed films was predictably low key and characteristically philosophical. He was obviously aware that the Dalai Lama was studying at least one script and added: 'If he asks for my advice, I shall be happy to give it.'

Talking to Sandra Batchford about Richard Gere is to benefit from an articulate, serious and realistic perspective. She admits that his earlier problems and being angry, arrogant, moody, indecisive and immature are hardly 'star quality' traits. 'But when those traits are coupled with a superior acting talent and a face and body once likened to Adonis, it isn't hard to understand why hordes of females, from all age bands, quickly became fans of the young Richard Gere,' she explains.

Sandra first noticed Gere in *Yanks*, but it was not until she saw *An Officer and a Gentleman* that she wanted to know more about 'this new icon'. She read all the film and celebrity magazines she could get her hands on, but, she explained, 'a lot of what I read didn't warm me to him as a person. Nothing, however, could displace my belief in his acting ability.'

It was not until after seeing *Internal Affairs* that Sandra Batchford became a serious student of Richard Gere and her vast library of detailed information and documentation, along with photographs, posters and a wide variety of merchandising items, now extends across the whole of his career and into his non-professional life.

Some of her research is about his clashes with photographers. 'Richard's hatred of photographers and to a lesser extent, reporters, can be justified,' she believes. 'Naturally he wants a private life away from the glare of Hollywood, but very rarely do the paparazzi let him enjoy it.

'American moguls on the other hand, appear to disregard Richard when it comes to Oscars. I am convinced that if any other actor had played the lead roles in *An Officer and a Gentleman*, *Internal Affairs* and *Mr Jones* he would have received at least a nomination if not an Oscar.'

Sandra also talks about Gere being a reserved person, wary of people he does not know well, which often results in him being labelled arrogant. 'Only when he is among his friends and colleagues does he let his guard down and show the kind, thoughtful and funny person he really is,' she explained. 'However, no film star

is bigger than his or her fans. Without one the other wouldn't exist, yet time and again Richard has maligned and ignored his fans.' His recent performance at the première of *Pocahontas* she found to be unforgiveable and led to several well-deserved, unfavourable remarks by his peers.

Richard Gere has not always enjoyed the best of reactions from his associates, co-stars, the industry, the press and his fans. As British film critic Barry Norman observed: 'Life does seem to derive mischievous pleasure in confounding Richard Gere from time to time.'

Currently, though, he appears to be enjoying an easier ride. All the speculation about his sexuality seems to have run its course and the break-up of his marriage, however tragic, sad or disappointing, has eliminated the outpouring of rumour and gossip, which consumed much of Gere's and Crawford's time together. Yet for all that, there are still lingering regrets among friends and supporters of both that they appeared unable to live happily within their marriage. Superficially at least they were the archetypal 'golden couple', hugely successful, glamorous, evocative, and in most distant ways appeared to be so right for one another.

Speculation about a reconciliation was natural while they were apart but still not divorced and in fairy-tale style they should have come together again and lived happily ever after. The sequel would also see them with children. Both of them, when they were together, were said to have wanted to start a family, but at different times, though their individual work commitments got in the way. It is curious that as recently as 1994 Gere's future, according to a statement he himself made at the time, seemed to relate strongly to the possibilities of having a family. But maybe all this is just too much even for the romantics among us to hope for, and it looks increasingly that the reality may well be that he and Cindy will remain apart, since a divorce became absolute in December 1995.

Jerry Zucker of *Ghost* fame and who directed Gere in *First Knight*, once said that Richard always plays the guy without a home. 'It's not so much that he's a wanderer, but he's someone who is always searching for something that he hasn't found yet.' That could perhaps be applied to his private life too. Although he campaigns energetically on behalf of the world's oppressed people and his devotion to Buddhism has brought him spiritual benefit, he does give the impression to be searching ever deeper for even more meaning in what he is doing in the same way that his film roles have to be thoroughly investigated and analysed and have some kind of

meaning to attract him. There also remains the widely-held belief that he has not yet achieved his full potential as an actor, despite his obvious fame and widespread recognition.

Detractors occasionally talk about Richard Gere as being yesterday's man. Yet he is only forty-seven (August 1996) and there is a sneaking feeling that even when he reaches sixty he will not have completely lived down his 'sex symbol' image. Sex symbols rarely do. Just think of the precedents, from Rudolph Valentino to Errol Flynn to Laurence Olivier.

Certainly, a label earned in Hollywood can often last a life-time. As Dudley Moore, star of hit pictures *Arthur* in 1981 and *Arthur 2: On the Rocks* in 1988, once complained. 'I guess, to many Americans, I'll always be bloody Arthur.' He said also that the movie business was transitory and a look at the careers of most Hollywood actors would show that you can only be at the top for five years, no more.

By that yardstick Richard Gere already has much to be pleased about. He is hardly likely to complain if he continues to be thought of as sexy in thirteen years from now: he has already enjoyed more than Dudley's 'star-span' of five years at the top; and there is surely more, much more, to come.

The glamour star who rocked Hollywood with his enormous physical presence on screen in those early startling images from *Looking for Mr Goodbar* and *American Gigolo*, and added to it with his off-screen romances, his wooing of and marriage to supermodel Cindy Crawford, is still very much part of the Hollywood movie-making scene.

In the mid-nineties Richard Gere continued to captivate and confuse, impress and irritate. Maturity as an actor or as a person did not bring conformity. 'Richard has always been very uptight about the press and being asked stupid questions. He's a really complex guy who values his private life,' said Taylor Hackford who directed him in *An Officer and a Gentleman*. Yet the hard, almost confrontational attitude to the press, which was for him at one time the norm, has largely eased. He resolutely continues to defend his right to a private life whenever it is threatened and will stand by issues that he feels to be important. He appears quietly to be unloading most of his worldly possessions and retreating further into his spiritual life, more relaxed and contented. He can still easily alienate people, but the invective has largely disappeared.

To many film-goers he still appears self-opinionated, eccentric, not altogether an engaging sort of character; nor the best movie

actor of all time. As Sandra Batchford says: 'Even after all these years, I still find it difficult, outwardly, to define what it is I like about him. He certainly intrigues me and there is no doubt from all the glamorous women he has dated that he is highly sensuous. It would also not be disputed that he is handsome. But I feel that if he continues to make such films as *Pretty Woman, Sommersby* and *First Knight*, I needn't define it at all. It's there on the big screen for everyone to see.'

He is also charismatic, an impassioned spokesman for Buddhism and tireless in his efforts on behalf of his special causes around the world. As a screen actor he is an outstanding professional and if outspoken, is always candid and honest.

Above all perhaps, Richard Tiffany Gere is an individual; a one-off, in acting, in his personal life and in the way he chooses to live his life. He is a rare and natural paragon of singularity in a world of increasing stereotype and conforming dullness.

For that reason alone perhaps he deserves our applause and a long and successful future. But when you add his obvious acting talent, smouldering good looks and high-voltage presence on screen, then Sandra Batchford and millions more like her would wholeheartedly proclaim – there's no question about it!

# Chronology

1949  Richard Tiffany Gere born (29 August) in Philadelphia, USA, and moved with family when he was very young to Syracuse, New York State.

1963  Plays trumpet in public for the first time.

1965  Appears as guest trumpet soloist in the Syracuse Symphony Orchestra.

1967  Appears as the King of Siam in North Syracuse High School production of *The King and I*.

1967  Graduation from North Syracuse High (wins athletics scholarship to University of Massachusetts).

1968  Chooses to major in philosophy.

1968  Joins the University drama school.

1968  First thoughts about becoming rock musician.

1969  During vacation joins summer stock theatre company at Cape Cod's Provincetown Players in two-week rep at $28.70 a week.

1969  Gives up University scholarship and joins Seattle Repertory Company at $75 a week.

1969  Quits Seattle Rep and heads for New York.

1970  Noted agent Ed Limato agrees to represent him.

1971  Appears on stage for the first time in New York in the rock opera *Soon*.

1971  Meets Herb Ritts, who would become a prominent photographer and friend, for the first time.

1971  Appears in *Richard Farina: A Long Time Coming and a Long Time Gone*, in New York. Penelope Milford in the cast.

1972  Secures replacement lead to Barry Bostwick in Broadway production of *Grease*.

1973  Secures the lead of Danny Zuko in the London production of *Grease* at the New London Theatre.

1973    Takes the part of Christopher Sly in Frank Dunlop's Young Vic production of *The Taming of the Shrew* in London.

1975    Makes his screen debut in *Report to the Commissioner* (retitled *Operation Undercover* in UK) with Michael Moriarty leading the cast.

1975    Acclaimed for his solo performance in Sam Shepard's *Killer's Head* at the American Place Theater in New York.

1975    Features in Frank Dunlop's production of *Habeas Corpus* in New York.

1975    Features in a pilot TV movie *Strike Force*.

1976    Appears in his second movie, *Baby Blue Marine*.

1977    Appears in minor, though important, role in *Looking for Mr Goodbar*, his first significant feature film.

1978    Appears in *Bloodbrothers*, his fourth film to be released.

1978    Stars in *Days of Heaven* with Brooke Adams, Sam Shepard and Linda Manz.

1979    His performance in *Bent* at the New Apollo Theater in New York wins him the *Theatre World* Award.

1979    Stars in *Yanks* with Vanessa Redgrave, Lisa Eichhorn, William Devane and Rachel Roberts.

1979    Meets Maggie Wilde for the first time – the production executive at Paramount.

1980    Stars in *American Gigolo* with Lauren Hutton.

1981    Meets the Dalai Lama for the first time.

1982    Stars in *An Officer and a Gentleman* with Debra Winger. This was his 'breakthrough' picture as a major star.

1983    Stars in *Breathless* with Valerie Kaprisky.

1983    Stars in *The Honorary Consul* (*Beyond the Limit* in the US), with Michael Caine, Bob Hoskins and Elpidia Carrillo.

1984    Stars in *The Cotton Club* with Diane Lane, Gregory Hines, Lonette McKee and Bob Hoskins.

1985    Stars in *King David* with Edward Woodward, Denis Quilley, Jack Klaff and Cherie Lunghi.

1985    Stars in *Power* with Julie Christie, Gene Hackman and Kate Capshaw.

1986    Stars in *No Mercy* with Kim Basinger and Jeroen Krabbe.

1987    Sets up Tibet House, cultural centre in New York.

1988    Stars in *Miles from Home* with Kevin Anderson.

1988    First meeting with Cindy Crawford at Ritts's barbecue party.

1989    Interview with Michael Aspel on British TV.

1990    Stars in *Internal Affairs* with Andy Garcia and Nancy Travis.

1990    Stars in *Pretty Woman*, his biggest hit to date, with Julia

Roberts and Ralph Bellamy.

1990 Appears in *Rhapsody in August* (Japanese film).

1990 Appears at the Academy Awards ceremony with Cindy Crawford – a signal of their rumoured 'togetherness'.

1990 In London to promote *Pretty Woman*. TV interview with Terry Wogan.

1991 Marries Cindy Crawford on 12 December in Las Vegas.

1992 Stars in *Final Analysis* with Kim Basinger and Uma Thurman.

1992 Stars in *Sommersby* with Jodie Foster.

1992 Shocked at the death from AIDS of model and former girlfriend Tina Chow.

1993 Stars in *Mr Jones* with Lena Olin and Anne Bancroft.

1993 Appears in *And the Band Played On* (TV production).

1993 Attends première of *Sommersby* in Canton and then takes off for the Tibetan Capital of Lhasa and is 'missing' for three weeks.

1993 His impassioned speech supporting Tibet at the Oscar ceremony leads to his summary expulsion from the Academy of Motion Picture Arts and Sciences.

1994 Stars in *Intersection* with Sharon Stone and Lolita Davidovich.

1994 Issues joint statement with Cindy Crawford in the form of a full-page advertisement in the London *Times* (6 May).

1994 Issues (December) joint statement with Cindy Crawford that their marriage is effectively over.

1995 Stars in *First Knight* with Sean Connery, Julia Ormond and Ben Cross.

1995 Spends two weeks in remote area of Mongolia, attending local Buddhist meetings.

1995 Brings Dalai Lama over to the United States to open Tibet exhibition in San Francisco.

1995 Working on *Primal Fear* co-starring Laura Linney, to be followed by *The 100th Monkey?*

1995 Cindy Crawford's divorce from him became absolute in December.

1995/6 Rumoured possible film projects include *Julia Patrana*, *Flash Gordon* and *Sleeping Beauty*.

1996 *Primal Fear* released in April (USA) and May (UK).

# Filmography

*Report to the Commissioner* (US) 1975, United Artists (*Operation Undercover* in the UK)
Directed by Milton Katselas. Appeared in sixth place in the cast list. The picture was headed by Michael Moriarty with Yaphet Kotto, Susan Blakely, Hector Elizondo and Tony King.

*Baby Blue Marine* (US) 1976, Columbia
Directed by John Hancock. Appeared in sixth place in the cast list. The picture was headed by Jan-Michael Vincent, with Glynnis O'Connor, Katherine Helmond, Dana Elcar and Bert Remsen.

*Looking for Mr Goodbar* (US) 1977, Paramount
Directed by Richard Brooks. Appeared in fifth place in the cast list. The picture was headed by Diane Keaton with Tuesday Weld, William Atherton and Richard Kiley.

*Bloodbrothers* (US) 1978, Warner
Directed by Robert Mulligan. Appeared in third place in the cast list. The picture was headed by Paul Sorvino and Tony Lo Bianco with Lelia Goldoni and Marilu Henner.

*Days of Heaven* (US) 1978, Paramount
Directed by Terrence Malick. Appeared with Brooke Adams, Sam Shepard and Linda Manz.

*Yanks* (GB) 1979, United Artists/CIP
Directed by John Schlesinger. Appeared with Vanessa Redgrave, William Devane, Lisa Eichhorn, Rachel Roberts and Chick Vennera.

*American Gigolo* (US) 1980, Paramount
Directed by Paul Schrader. Appeared with Lauren Hutton, Hector Elizondo and Nina Van Pallandt.

*An Officer and a Gentleman* (US) 1982, Paramount
Directed by Taylor Hackford. Appeared with Debra Winger, Louis Gossett Jnr, David Keith, Lisa Blount and Lisa Eilbacher.

*Breathless* (US) 1983, Miko/Martin Erlichman
Directed by James McBride. Appeared with Valerie Kaprisky, William Tepper, John P. Ryan and Art Metrano.

*The Honorary Consul* (GB) 1983, World Film Services/Paramount (*Beyond the Limit* in the US)
Directed by John Mackenzie. Appeared with Michael Caine, Bob Hoskins and Elpidia Carrillo.

*The Cotton Club* (US) 1984, Zoetrope/Robert Evans
Directed by Francis Coppola. Appeared with Diane Lane, Gregory Hines, Lonette McKee, Bob Hoskins, Fred Gwynne, Nicolas Cage, James Remar, Allen Garfield and Gwen Verdon.

*King David* (GB/US) 1985, Paramount
Directed by Bruce Beresford. Appeared with Edward Woodward, Denis Quilley, Jack Klaff, Cherie Lunghi, Alice Krige, Hurd Hatfield, John Castle and Niall Buggy.

*Power* (US) 1985, TCF/Lorimar/Polar
Directed by Sidney Lumet. Appeared with Julie Christie, Gene Hackman, Kate Capshaw, Denzel Washington, E.G. Marshall, Beatrice Straight, Fritz Weaver and Michael Learned.

*No Mercy* (US) 1986, Tri-Star/Delphi IV
Directed by Richard Pearce. Appeared with Kim Basinger, Jeroen Krabbe, George Dzundza, Gary Basaraba and William Atherton.

*Miles from Home* (US) 1988, Fox/Braveworld/Cinemcom/J & M Entertainment
Directed by Gary Sinise. Appeared with Kevin Anderson, Brian Dennehy, Jason Campbell, Austin Bamgarner, Larry Poling, Terry Kinney, Penelope Ann Miller, Helen Hunt and John Malkovich.

*Internal Affairs* (US) 1990, UIP/Paramount
Directed by Mike Figgis. Appeared with Andy Garcia, Nancy Travis, Laurie Metcalf, Richard Bradford, William Baldwin and Michael Beach.

*Pretty Woman* (US) 1990, Buena Vista/Touchstone
Directed by Garry Marshall. Appeared with Julia Roberts, Ralph Bellamy, Jason Alexander, Laura San Giacomo and Hector Elizondo.

*Rhapsody in August* (Japan) 1990, Palace/Shochiku (*Hachigatsu-no-Kyoshikyoku* in Japan)
Directed by Akira Kurosawa. Appeared with Sachiko Murase, Hisashi Igawa, Narumi Kayashima, Tomoko Ohtakara and Mitsunori Isaki.

*Final Analysis* (US) 1992, Warner
Directed by Phil Joanou. Appeared with Kim Basinger, Uma Thurman, Eric Roberts, Paul Guilfoyle, Keith David and Robert Harper.

*Sommersby* (US) 1992, Warner
Directed by John Amiel. Appeared with Jodie Foster, Lanny Flaherty, Wendell Wellman, Bill Pullman, Brett Kelley, William Windom and James Earl Jones.

*Mr Jones* (US) 1993, Tristar/Rastar
Directed by Mike Figgis. Appeared with Lena Olin, Anne Bancroft, Tim Irwin and Bruce Altman.

*And the Band Played On* (US) 1993, HBO for television
Directed by Roger Spottiswoode. Appeared in fourth place in the cast list. The picture was headed by Matthew Modine, Alan Alda and Ian McKellen, with Steve Martin and Phil Collins.

*Intersection* (US) 1994, Paramount
Directed by Mark Rydell. Appeared with Sharon Stone, Lolita Davidovich, Martin Landau, David Selby and Jenny Morrison.

*First Knight* (US) 1995, Columbia
Directed by Jerry Zucker. Appeared with Sean Connery, Julia Ormond and Ben Cross.

*Primal Fear* (US) 1996

Directed by Gregory Hoblit. Appeared with Laura Linney, Edward Norton, John Mahoney, Alfre Woodard and Frances McDormand.

# Index

*Index*